A User's Guide to the
VIEW CAMERA

OC

A User's Guide to the
VIEW CAMERA

Second Edition

JIM STONE

Addison
Wesley
Longman

An imprint of Addison Wesley Longman, Inc.

New York • Reading, Massachusetts • Menlo Park, California • Harlow, England
Don Mills, Ontario • Sydney • Mexico City • Madrid • Amsterdam

Acquisitions Editor: Deirdre Cavanaugh
Editorial Assistant: Kwon Chong
Project Coordination and Text Design: Thompson Steele Production Services
Cover Design: Paul Agresti
Electronic Production Manager: Eric Jorgensen
Manufacturing Manager: Hilda Koparanian
Electronic Page Makeup: Thompson Steele Production Services
Printer and Binder: Malloy Lithographing, Inc.
Cover Printer: The Lehigh Press, Inc.

For permission to use copyrighted material, grateful acknowledgment is made to the copyright holders on p. 163, which are hereby made part of this copyright page.

Library of Congress Cataloging-in-Publication Data

Stone, Jim.
 A user's guide to the view camera / Jim Stone. — 2nd ed.
 p. cm.
 Includes index.
 ISBN 0-673-52006-4
 1. View cameras. I. Title.
TR258.S67 1997
771.3'2—dc20 96-19182
 CIP

ISBN 0-673-52006-4

5678910 —— ML—— 050403020100

CONTENTS

PREFACE

WHAT IS THIS BOOK ABOUT?

A User's Guide to the View Camera will tell you how to make photographs with several kinds of cameras referred to by the generic terms *large-format* and *view camera.* Format means the size and shape of the film used in a camera, and large-format refers to any camera using film larger than 2¼-inch-wide 120 roll film. All of the information about film presented in this book concerns large-format film. View camera is a general name for a group of camera designs in which the lens forms an image directly on a *ground-glass* screen so you can view that image before committing it to film. Almost all view cameras are large-format. And most large-format cameras are view cameras, so the large-format view camera is used as a model for most of the examples in this book. Other kinds of large-format cameras, discussed in Chapter 6, are usually view cameras with some of the features left off to streamline the camera for a specific application.

 The characteristic of most view cameras that most differentiates them from other kinds of cameras is that the front and back of the camera are capable of independent movement. And the characteristic of large-format film that makes it most different from small-format film is that it is made and used in sheets, not rolls. A large part of this book is dedicated to an understanding of these unusual features and how they can help you make better pictures. Some view cameras, however, do not incorporate independent movements, and some view cameras that do are not large-format. The province of this book, then, is to introduce you, the photographer, to the use of any camera with large-format film *and* the operation of any camera with a separately adjustable back or front.

WHO IS THIS BOOK FOR?

To get the most out of this book, you should already know something about photography. A one-semester black-and-white photography course or its equivalent is a good prerequisite. The chapter on

film development, for example, assumes that you have had experience developing roll film; it explains what is different about developing the film used in large-format cameras. This book also assumes that you are familiar, or at least comfortable, with the basics of adjusting and operating hand cameras as it introduces you to the differences (and advantages) of view cameras. If you are learning the basics of photography and the view camera at the same time, you will want to have a good introductory photography book to supplement this one.

 In Chapter 2, you will learn about the different parts of the camera—where they are and what they

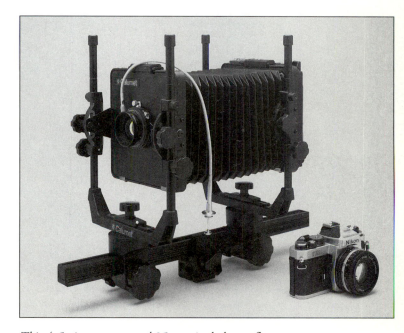

This 4x5 view camera and 35mm single-lens-reflex camera are both representative examples of their families. Only the use of the larger camera is covered in this book.

do. Chapter 3 introduces the operation of the camera in its simplest mode; at this point, you will be able to begin to use your camera. With the last half of Chapter 3, you can, at your own pace, add the sophistication of advanced control. Later chapters give you a thorough knowledge of the film systems used in large-format cameras (including the unique Polaroid products), a complete understanding of the lenses you will use, an overview of new electronic and digital cameras, a survey of accessories for special purposes, and some advice on maintaining all your large-format camera equipment.

Other than occasional highlights from the history of the camera, all the information presented here is intended to be practical. And although this book may be of interest to the scientist, theoretician, or camera collector, it is meant primarily for you, the photographer.

ACKNOWLEDGMENTS

Although this book is credited to a single author, it was a complex collaborative project with assistance, suggestions, and support from a number of generous, capable, and helpful people. Listing them to say thanks is not enough, but it is a start.

In addition to the contributing photographers, and in no particular order, assistance came from Jeff Coolidge, Elaine O'Neil, Stanley Rowin, Bob Bretz, Debi Martin-Kao, Rob Van Petten, Bruce Kinch, Steve Brettler, Chloe Richfield, Jim Scherer, Keith Johnson, Bill Crawford, Fred Picker, Henry Horenstein, Ted Bromwell, Beverly and Jack Wilgus, Jon Goell, and Roger Williams. Sheldon Brown, formerly of S. K. Grimes Camera Repair, made me seem an expert on shutters, and Rudolf Kingslake shared his considerable knowledge of lens design and history. The photographs of historic cameras and lenses were made from the monumental private collection assembled by Jack Naylor, with his gracious assistance. Projecting human kindness from inside their corporations were Linda Benedict-Jones, Barbara Hitchcock, Wilma Woollard, and Lou Desiderio of Polaroid; Peter Gowland; Merle and John M. Deardorff; Robert Otis, David Gremp, Richard Carlson, and Richard Lange of Calumet. And thanks go to the Ilex, Linhof, Sinar, Gitzo, Schneider, and Wista companies and their distributors. Several teacher/photographers read the manuscript and provided early guidance: David Litschel of Brooks Institute, Bob Thall from Columbia College in Chicago, Rick Steadry from Orange Coast College, and Fred Sway, former Director of the New England School of Photography. Barbara London helped get this book started and past an early derailment. Liz Hoffman and Tom Briggs made the essential drawings; not everything can be photographed. Jane Tufts, formerly of Little, Brown, was the editor who gave the first edition of this book form and its author confidence, and made sure nothing was left out.

For this second edition I must add thanks for production and a new design to Andrea Fincke and Ellen Coolidge, and to Kwon Chong, Eric Jorgensen, and Deirdre Cavanaugh at Longman, the book's eighth publisher. Very special thanks for everything are due my parents, Chuck and Sylvia, who started it all, and to Linda, my love.

—*Jim Stone*

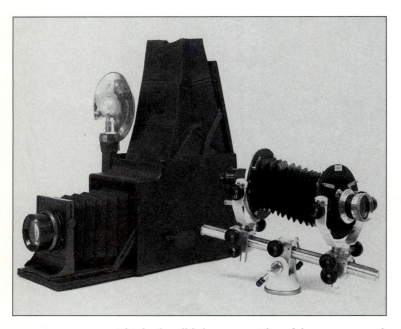

This book will help you use either of these two unusual cameras—a large-format (4x5) single-lens-reflex on the left and a small format (35mm) monorail view camera on the right.

A User's Guide to the
VIEW CAMERA

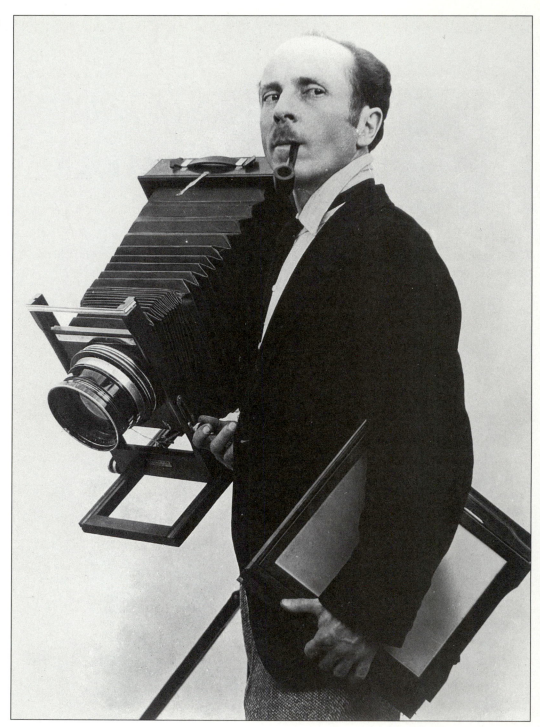

This portrait made by Tina Modotti depicts Edward Weston, whose direct and compelling 8x10 contact prints convinced many of the validity of photography as a fine art. ■

INTRODUCTION

To learn about the view camera, you must first understand what a camera is.

What Is a Camera?

For an object to be labeled accurately a *camera*, it must have certain basic parts. Common to all cameras is the lighttight body that supports the other parts and prevents unwanted light from striking the film. Integrated into the body is a provision for inserting, holding in place, and removing the film. A lens and shutter admit and control the light, a focusing system adjusts the distance between lens and film, and a viewing system allows you to point the rest of the parts in the right direction. These basic parts are present in the simplest snapshooter (although the focus is often fixed), in the most complex 35mm SLR, and in every view camera.

What Is a View Camera?

A view camera shares its essential anatomy with all cameras, but no other camera type reveals itself as clearly. The view camera's functional skeleton is on display without decorative covering and none of its basic operating features is obscured by automation. Using the view camera will give you an appreciation and understanding of the bare bones of photographic practice—the fundamentals of making photographs. We will take advantage of this revealed anatomy by using as our model a modular view camera so that we may inspect each part, feature, and application separately.

The modern view camera is a complex and sophisticated system, but it can be broken down into modules, each of which is an individual camera part. Each part is an elemental building block that is interchangeable with other versions of the same part; each can be used to assemble and rearrange the camera for a variety of photographic tasks. Since an understanding of these elements is necessary to the proper use of any view camera, Chapter 2 describes the parts of a modular monorail view camera. Details on the rest of the large-format camera family are presented in Chapter 6, after a complete explanation of how to use the monorail camera and the chapters on the lens and film systems common to all large-format cameras. If you are using a camera other than a monorail, you may wish to read the appropriate section of Chapter 6 immediately after you read Chapter 2.

A modern modular monorail camera like this Swiss Sinar has a range of interchangeable parts and accessories to help overcome nearly any photographic challenge. ■

WHY USE A VIEW CAMERA?

View cameras are heavier, bulkier, and more obtrusive than smaller format cameras, it is time-consuming to set up and use them, and the camera, film, and accessories can be expensive. There must be some considerable advantages to outweigh all of these drawbacks.

Indeed, two important characteristics influence many photographers to use no other camera. First, large-format film renders an image with the highest possible visual quality. All the common measures of photographic excellence—sharpness, resolution, tonality, and color saturation—increase with film size. And second, a view camera offers more control over perspective and focus than any other kind of camera. By adjusting the independent front and back of the camera, you can rearrange the position of the vanishing point and the location of the sharpest focus. These advantages would not persuade a photojournalist to use a view camera; to capture the news, a photographer must be unencumbered—free enough and fast enough to follow the action. But for the photographer of the landscape, a captive subject that waits patiently for the most flattering light, there is time to set up and use a camera that can deliver the highest possible quality.

The view camera is often considered a professional photographer's tool. Architectural photography, a specialized but well-populated field, demands the control over perspective available only to the user of a view camera. The studio of an advertising, commercial, or portrait photographer is another natural habitat for the view camera. In the studio, everything is arranged for the benefit of the photograph: the scene is assembled, the lighting manipulated, and the moment of exposure selected. After all that, the additional time necessary to set up and use a large camera is slight. The studio photographer leaves nothing in the photograph to chance, and the client who pays for all the care deserves (and usually demands) the superlative quality of an image made on large-format film.

Paradoxically, even the seemingly undesirable characteristics of the view camera are often virtues. Its slow, cumbersome nature forces the photographer to pay close attention to details. Because the entire frame must be studied while focusing, careful composition takes little more time than casual use; the pace encourages care. There are few unpleasant surprises on the processed film. This way of working

prompted photographer and art historian Carl Chiarenza to write of the magic of the ground-glass image for the creative photographer:

> The view camera photographer is forced into a contemplative mood while he works. Seen in this light the disadvantage of bulky equipment and accessories such as tripods becomes an advantage. It sets the pace for the seclusion under the dark cloth. Facing the ground glass, isolated, all of his facilities are centered on the luminous image. He cannot help being absorbed by the many possible relations he can create within the movable frame. He loses himself in this world of light over which he can exercise a measure of control.

Sometimes the conspicuous use of a view camera enables photographers to make pictures that would not have been available to the user of a hand camera. Bruce Davidson, making the photographs for his landmark book *East 100th Street,* chose a 4x5 camera specifically for its cumbersome nature and obtrusive appearance. Working in an African American and Hispanic ghetto where a stealthy photographer, especially a Caucasian, would be suspect, he chose equipment that would announce his presence and serious intent. "Every day I appeared with my large bellows camera, heavy tripod and box of pictures. Like the TV repairman or organ grinder, I appeared and became part of the street life." The view camera photographer is never taken for an amateur.

You probably already have a reason for learning about the view camera. If not, the unique merits of large-format photography with a view camera will make themselves apparent soon after you make your first exposure.

Trees, Montara. *Made electronically in 1994 with a Dicomed Digital Insert in a conventional 4x5 camera, this image shows one startling advantage of direct digital photographs—the capacity to record a much wider range of brightness values than film. Photographer Stephen Johnson made effective use of the extended infrared sensitivity of the recording sensors and emphasized the surreal tonalities by using only the red channel of the RGB file.* ■

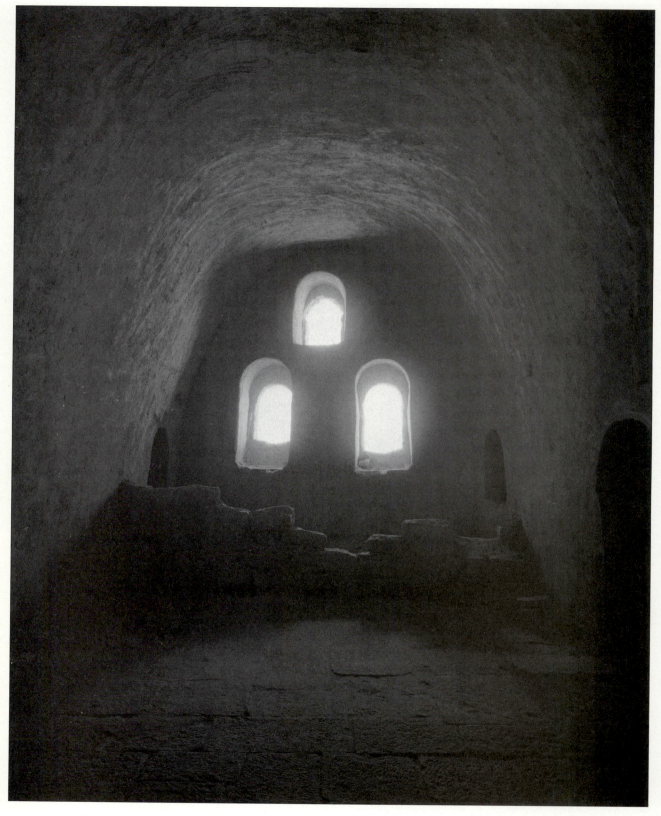

Coptic Monastery, 1989. *Linda Connor has traveled the world with her wooden 8x10 camera making reverential, mystical photographs. The large negative lets her produce exhibition prints outdoors in her sunny back yard by contact printing onto slow printing-out paper. She later gold-tones the prints to achieve a luminosity and color range beyond those of enlarging materials.* ∎

Iris, 1991. *Robert J. Steinberg, whose Palladio company manufactures platinum printing papers, scanned his 11x14 original negative for this image in order to generate digitally a larger (30x40 inches) negative with the correct tonal qualities for platinum printing. Making a bigger negative by traditional enlargement unavoidably compresses delicate highlight and shadow tones.* ■

THE CAMERA

Large-format cameras are categorized by two important features: their format, or nominal film size, and their design. The film size in a camera's designation is usually the largest conventional rectangle the camera can accommodate. These dimensions are given in inches for the United States and United Kingdom and in centimeters for countries that use the metric system. All large-format cameras can be adapted to the use of smaller film, so the nominal film size indicates only the upper limit. A 4x5 camera (called 5x4 in Britain and 10x12 in Germany) can use any size film up to 4-inch by 5-inch film sheets. Other common formats are 5x7 and 8x10.

Two designs dominate today's view camera market: the *flatbed* (in its modern incarnations as

field (p. 100), *technical* (p. 106), and *press* (p. 105) cameras) and the *monorail* (p. 99). The 4x5 monorail has become the archetypal view camera and forms the basis for modular camera systems that can be adapted to smaller film as well as modified to become larger-format cameras. Because the individual features of a monorail camera are more obvious than those of any other design, it will be used in this book to exemplify the structure of the generic view camera.

THE MONORAIL VIEW CAMERA

Named for the supporting shaft at its base, the monorail view camera is the most common of today's large-format cameras. A major characteristic

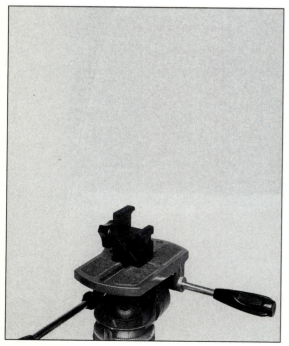

The rail clamp attaches to the tripod and provides a solid foundation for the rest of the camera. ■

of any view camera is that it provides the physical means to adjust the lens and film positions independently. These adjustments may be made with more freedom and greater ease on a monorail than on a camera of any other design. Inexpensive or student-grade monorail cameras make lens and film position adjustments and provide for interchangeable lenses, but a professional-quality monorail view camera has additional features that make it much more useful.

The versatile, but more expensive, professional monorail cameras are all modular. That is, they comprise a system of interchangeable and interlocking parts and accessories that can be used to assemble a camera tailored to a specific photographic challenge. Every interlocking module is an elemental camera part that can be moved, extended, or replaced. These elements, common to all view cameras, are described below and illustrated with a modular camera. Familiarize yourself with these parts of the camera and their terminology before trying to set up or use your camera.

Rail

The *rail* provides a rigid base of support for the rest of the camera. Although rails may be round, square, or triangular in cross section, the design goal is the same: to provide a light, strong, inflexible shaft along which the adjustable front and back of the camera can slide independently. For most modular cameras the rail can be extended by adding sections. Such extensions would be needed for extreme close-

ups and for the use of long-focus lenses. A very short rail for use with short-focus (wide-angle) lenses is also available.

A *rail clamp* holds the rail in place on a tripod and allows you to adjust the position of the rail for balance. The clamp has a threaded hole in its base that matches the corresponding mounting screw on the tripod head (p. 138). The rail slides through the clamp, which may be fixed at any point along the length of the rail. When packing up after a shoot you may choose, if your camera allows it, to remove the camera from its tripod by releasing the clamp from the rail, leaving the clamp attached to the tripod until the next use. This is sometimes easier than removing the clamp from the tripod.

Front and Rear Standards

A *standard* is one of two upright frames attached to the monorail by a sliding geared or spring clamp. Each standard fulfills several functions. The front standard holds the lensboard mounted with lens and shutter at the front of the camera. The rear standard holds the camera's back with its spring back and ground-glass focusing screen, the devices that hold film and determine focus. The bellows is suspended between the two standards. These parts are described in detail later in this chapter. Both standards contain the mechanisms for adjusting independent rotation and movement of the lens or film they hold, and both may be moved longitudinally along the rail. This front-to-back movement is used to

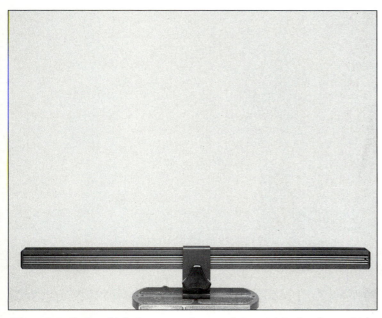

The monorail, for which the camera is named, is a rigid tube along which the rest of the camera can slide while maintaining alignment. ■

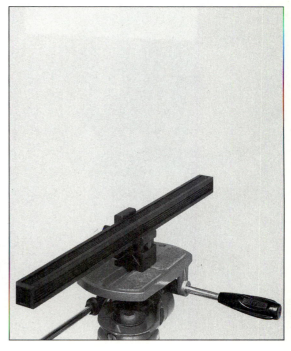

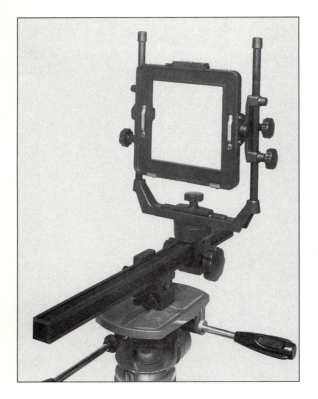

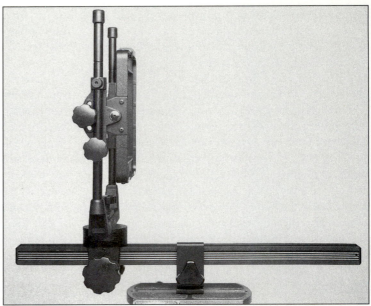

The front standard can move along the rail and contains the mechanisms for adjusting the position of the lens it is designed to support. ■

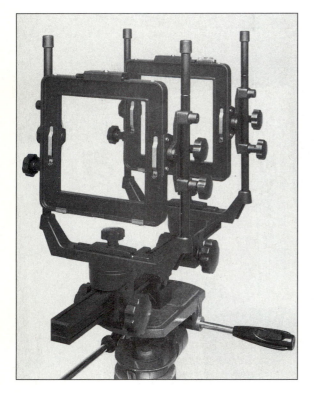

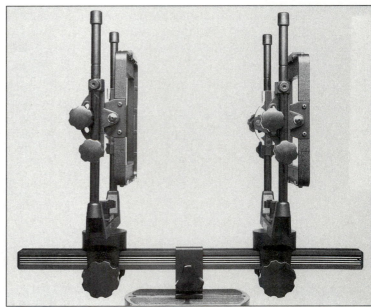

Identical to the front standard, the rear standard supports and adjusts the camera back. ■

vary the distance between the standards and bring an image into focus.

In modular 4x5 cameras the front and rear standards are identical. A monorail camera designed for film larger than 4x5 has a proportionately larger rear standard; its design and function are the same as the front standard's, but the two are not interchangeable. The spring back of a modular camera is a separate piece, attached with clips to the back of the rear standard. The bellows, also a separate piece, is held to the front of the rear standard with similar or identical clips. The other end of the bellows clips to the back of the front standard, and the front of the front standard holds a separate lensboard. If the attachment mechanisms on both sides of each standard are identical, the standards can be reversed on the rail so the controls are more convenient for a left-handed photographer.

Bellows

The *bellows* is a hollow tube of flexible material held in place between the front and rear standards. With the lensboard and spring back in place, the bellows completes a chamber forming the body of the camera. The *standard* or *square* bellows is made from pleated folds of opaque cloth, leather, or a similar synthetic material, and serves to keep the enclosed volume lighttight without restricting movement of the attached standards for adjustment or focus. The interior surface of the bellows is made nonreflective to assist its accordionlike folds in suppressing contrast-reducing stray light. Unwanted light inside the camera body can come from the lens projecting an image larger than the film (see *coverage*, p. 75), or from reflections off the film itself. The standard bellows collapses compactly for storage and can be extended enough for all but the most extreme long-focus lens or close-up work.

Spring Back

The back of a view camera is formed by the *spring back*, a pair of nesting frames on the rear standard. It holds the ground glass in place for focusing and viewing, and it accepts a film holder for exposure. The ground glass is held in the inner frame, which in turn is held to the outer frame by springs. As the film holder slides into place between the two frames, it forces the ground-glass frame away from the rest of the camera back. The holder is pressed securely into place against the inner frame by the springs, forming a lightproof seal. The spring back's dual role—holding both ground glass and film—is important because it enables the position of the film during exposure to correspond exactly to the position of the ground glass during viewing. The image can then be recorded exactly as viewed.

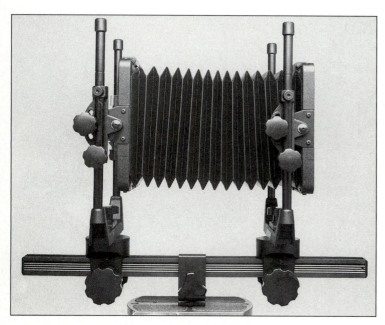

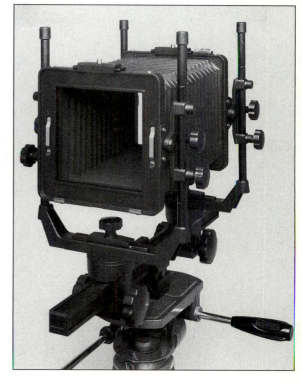

The bellows attaches between the standards and allows them freedom of movement while forming an opaque and lighttight shell. ■

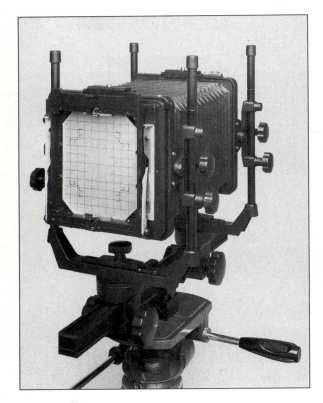

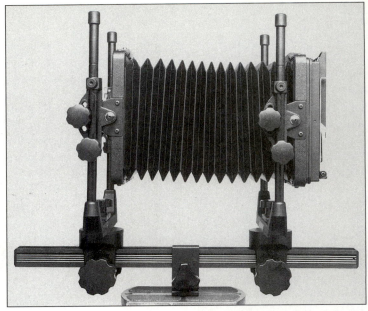

The camera back clips into the rear standard and contains the spring back to hold the film and the ground glass to allow focusing. ■

The lensboard, with its attached lens and shutter, is held in place in the front standard. ■

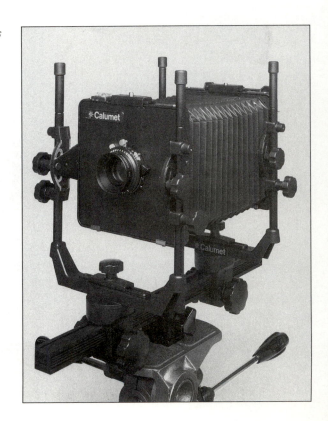

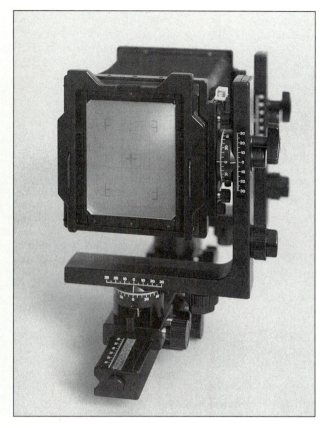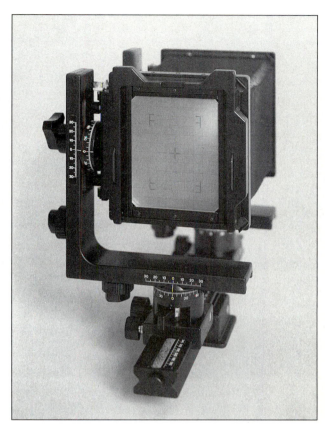

Like many modular view cameras, this Horseman 450 allows its standards to be reversed on the rail for the convenience of a left-handed photographer. ■

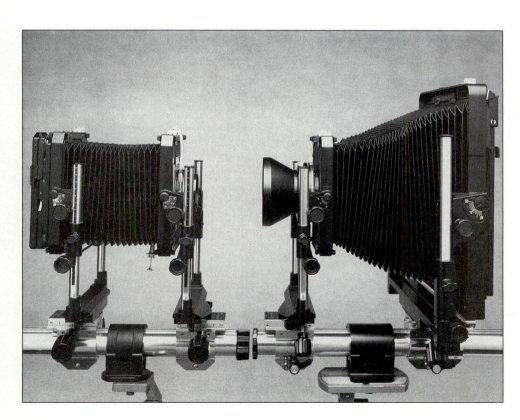

A modular system view camera like this Toyo allows the use of several different-sized film backs with the same rail and front standard. To change formats, the bellows, rear standard, and back must be replaced. ■

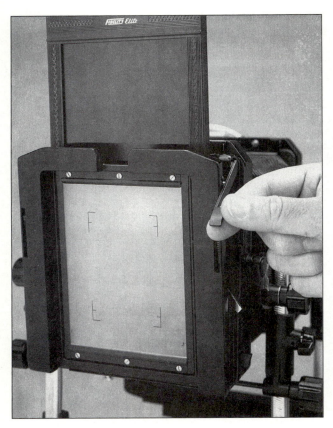

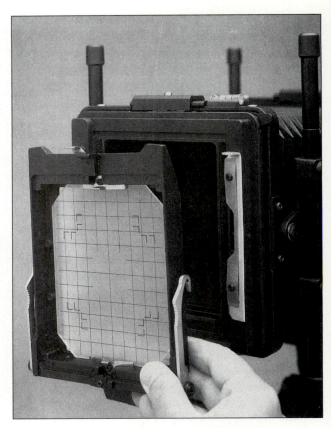

A bail lever is sometimes incorporated into the spring back to facilitate the insertion of film holders. ■

Removing the spring back from this universal (or Graflok) back allows other accessory backs to be clipped into place. ■

Some view cameras have a *bail lever* around the ground-glass frame to force the springs apart and open a path for the film holder. This prevents the unnecessary wear on your film holders that occur if they are forced into place by using them to pry the ground-glass frame away from the camera back.

On many 4x5 cameras, the spring back is held with clips in yet another frame and can be removed to allow the use of various accessory backs and film holders. Graflex introduced this modular design in 1949 as the *Graflok* back on Speed Graphic cameras. Although camera backs bearing the Graflok brand name are no longer manufactured, current *universal* or *international* backs are interchangeable with them and Graflok-style accessories will fit them all.

A *revolving* back allows you to rotate the spring back and ground glass to any desired position in its outer frame. This feature enables you to avoid having to rotate a large camera to frame a photograph exactly as you want. A *reversing* back fits into

the rear standard either horizontally or vertically, but adjustments of the film's orientation for angles in between must be made by rotating the entire camera, using the tripod head. Revolving backs are rare on cameras larger than 4x5; these most often use the lighter and more compact reversing back to save considerable bulk.

Ground Glass

The frame of the spring back holds in place a sheet of *ground glass* on which you view, compose, and focus the image projected by the lens. Ground glass is sheet glass made translucent by grinding, etching, or sanding one surface. The ground side of the glass faces the lens to receive the image, inverted by the lens, and the glass sheet should be the exact size and shape of the film. The position the front surface of the ground glass holds during viewing and focusing should be the exact position held by the film's emul-

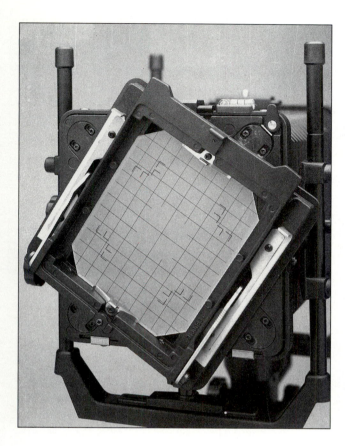

With a revolving back you can position the image between horizontal and vertical without tipping the camera into a precarious position. ■

sion when the ground glass is moved away by a film holder in place for exposure. See Chapter 8 for more information on the ground glass.

Lensboard

A *lensboard* is the rigid, opaque plate that holds the lens to the front standard. Most lensboards are flat square panels of metal or wood drilled with a single mounting hole for the lens. The back or interior side of the lensboard should be nonreflective black so that it can absorb light reflected from the film during exposure.

Many wooden cameras use wooden lensboards, and you can fabricate and drill a substitute yourself with hand tools to save money. The more modern modular monorail cameras have metal lensboards with formed edges that are difficult to duplicate in a home shop. These metal lensboards are rarely interchangeable from one brand of camera to another.

And although you will need one for each lens you wish to use on your view camera, lensboards are sold separately from the lenses.

Lens and Shutter

A *lens* gathers the light in front of it and converges that light to a focus behind it to form an image. The lens for a view camera is recognizable as a lens to anyone familiar with other cameras. It is larger than most other lenses, however, and is usually mounted in a *shutter*. As in other cameras, the shutter opens and closes to admit light to the film for a metered amount of time. Before you can use your camera, the shutter and lens must be mounted to the lensboard in a round mounting hole and the lensboard must be affixed to the front standard. Lens mounting is a job usually left to a specialist in a camera repair or machine shop. If you want more information about lenses at this point, read Chapters 5 and 7.

3

USING YOUR CAMERA

Now that you are familiar with the structure of your camera, you can begin to put it to use. Establishing a familiar pattern of use with your camera will enable you to set it up and adjust it while concentrating on the image you wish to make. Initially, setting up the camera will demand your undivided attention, so before you take it out into traffic, practice setting up and adjusting your camera in a place where you can work comfortably and without distraction.

THE BASICS

This section is designed to get you working with your camera as soon as possible. First we will move through the making of a simple exposure and the sequence of actions you must follow for every photograph. Using the camera this way will be very much like using a bigger version of a camera you already know and you will soon become comfortable with the essentials of view camera use. The latter part of the chapter will introduce you to the way the camera movements influence and control perspective and focus. Mastering the camera movements is difficult and should be left until you are comfortable with the basics of using the camera.

Many of the camera parts and accessories mentioned here are explained in detail later, so you can read through this sequence of steps rapidly, without digression. For more complete information, refer to the page numbers indicated.

MOUNTING THE CAMERA

Before mounting the camera on your *tripod* (p. 136), extend the tripod's legs so that its platform is at chest height. This positioning places the tripod's feet far apart to give you a steady platform for attaching the camera. It also places the ground-glass viewing screen at a comfortable height just below eye level. Save lower camera positions for a time when you are proficient and can set up and work quickly—prolonged viewing in low positions can strain your lower back. After a little experience, you will know in advance how much to extend the tripod's legs for the vantage point you desire. Remember that the height of the platform is much easier to adjust before you have the weight of the camera on it.

Locate the threaded mounting bolt projecting through the platform of your *tripod head* (p. 138) and the corresponding threaded hole in your camera's rail clamp or baseplate. With one hand hold the camera as close to its top as possible while aligning and threading the mounting screw into the hole in the baseplate with your other hand. Make sure the rail, or lens axis, is aligned with the axis of the tripod head before you tighten the mounting screw securely. Many cameras have a carrying handle at the top of the rear standard, which makes the mounting operation much easier. Never hold a view camera in one hand by its monorail—this is an invitation for the camera to invert and crash into the tripod or, worse, onto the ground.

Before you release your grip on the camera and rely upon the tripod for safe support, be sure all the adjustment levers on the tripod head are secure. If just one lever works loose, the camera may tip and capsize the entire tripod. Check also to make sure the lens and lensboard are securely attached before you move or tilt the camera. The most convenient way to move the camera more than a few steps is to lean it over your shoulder, but this rifle-carry position places considerable strain on the mount. If the

camera comes loose, a fall from shoulder height could irreparably damage both camera and lens.

POSITIONING THE CAMERA

Swivel the tripod head to align the axis of the mono-rail and lens with one leg of the tripod. This position, with one tripod leg pointed forward, will give you room to move around behind the camera between the other two legs without continually kicking or tripping over one tripod leg. It will also provide a more stable platform should you tilt the camera downward.

It is not practical to take frequent casual glances through a view camera—the way you might with a 35mm—to decide on the correct camera position for the image you desire. Instead you will need to train your eye to see what the camera sees. With time you will be able to place the tripod in its final position the first time you set it down. For now, place the tripod approximately and point the camera in the general direction for the photograph you plan to make.

Zero Position

Zero position for a view camera means that all of its adjustments are set as though it were a rigid-bodied camera: front and rear standards are parallel to one another and at right angles to the monorail and the rear of the lens is pointed straight at the center of the ground glass. This neutral setting is sometimes called the *normal* position.

Once your camera is mounted on its tripod, set all the movements to zero position and extend the bellows by setting the standards approximately one focal length apart, that is, 150mm (6 inches) apart with a 150mm lens. This setting, called the *infinity focus*, is a good place to start for general work. The bellows will need to be extended further for close-ups. Make sure the camera's movements, standards, clamps, and revolving back are securely locked.

FRAMING AND FOCUSING

To view through your camera, open the shutter using the *press-focus lever* (p. 88) and set the aperture to its widest setting. Then, facing your subject, stand behind the ground glass. Cover your head and the rear standard with the *darkcloth* (p. 141) and look at the image that appears upside down on the ground glass. All lenses invert the image they form but other cameras are designed to reinvert the image (*reflex* cameras) or else provide an alternate upright image for you to look at (such as a *viewfinder*

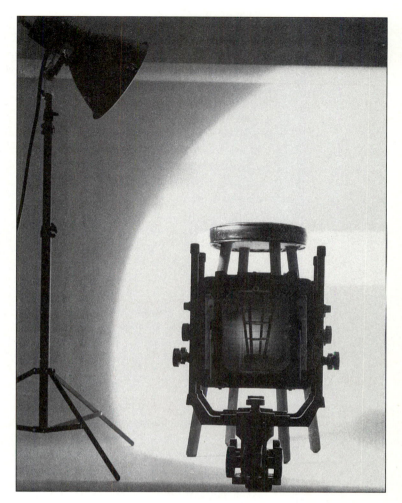

The lens projects an image upside down onto the ground-glass viewing screen. To see it well, your eye should be about the same distance from it as a comfortable reading distance from a book page the same size. ■

image). Remember, in a view camera you are looking *at* the ground glass, not through it, so your eyes will need to be reading distance away from it. In time, you will find it as easy to work with an image upside down as with one right side up.

After you open the shutter, disengage the focus lock on the rear standard and focus on the scene by moving the rear standard along the rail. Your camera will probably have a focus knob to move the standard by very small amounts. Focus by rocking the knob back and forth past the point you think is the best focus a few times, rocking it less and less each time until you settle on the position for best focus. If you have a fast lens, that is, one with a large maximum aperture, it will admit enough light for you to focus unassisted in bright light, but at smaller apertures and for very precise focusing, hold a

magnifying *loupe* (p. 155) against the ground glass to enlarge a part of the image. Make certain the front of the monorail is not visible in the image at the top of the ground glass. If it is, move the front standard forward on the rail, then refocus. If after viewing the image you decide to change it by moving the camera (or, later, if you change the camera movements), you will also need to refocus.

Although under most circumstances you can adjust the focus equally well with either the front or rear standard, get in the habit of focusing with the rear standard. It is especially difficult to focus close up with the front standard because it changes the magnification and makes the image larger or smaller as you focus. This change results from altering the distance from lens to subject—the *object distance*. Using the rear standard to focus allows you to find the appropriate focus for an object in a fixed relation to the lens. With a very short object distance it is often easier to move the entire camera or even the subject to bring the image into precise focus.

Lock the focus knob in place after final focusing. Select your working aperture by stopping down until adequate depth of field is visible in the ground glass. These adjustments are judged strictly by eye, so you will need to manipulate the controls from the rear of the camera while under the darkcloth. When the camera is adjusted and focused and the lens is stopped down to the working aperture, close the shutter. After taking your exposure reading, set and

wind the shutter. You may wish at this point to check exposure, lighting, framing, and focus with a sheet of Polaroid film (p. 146).

Making the Exposure

Once you are certain the camera and tripod have been properly adjusted and all of the parts have been locked in place, open the spring back. If your camera has a bail lever, use it. If not, pry back the ground-glass frame a bit with your fingers and insert a loaded *film holder* (p. 61) against the spring pressure. Hold the camera steady to avoid moving it out of position. With some cameras it may be easier to remove the entire back, insert the holder, then replace the back. If you are using the bail lever, release it gently to prevent the back from snapping shut and cracking the ground glass. The film holder must make a good lighttight seal to avoid unwanted streaks on the film or fogging (*fog* is an even, overall exposure to unfocused light that lowers contrast and degrades the image quality). If you are unfamiliar with your camera, you may have trouble at first finding this proper seated position. Practice inserting and removing the film holder a few times to make sure you know where the holder is supposed to seat.

Double check the shutter to see that it is closed and then gently withdraw the *darkslide* (p. 61) from the side of the film holder facing the lens. In dry

To begin using your camera, set it securely on its tripod, and make sure all the adjustments are locked in zero position and the shutter is opened for viewing. ■

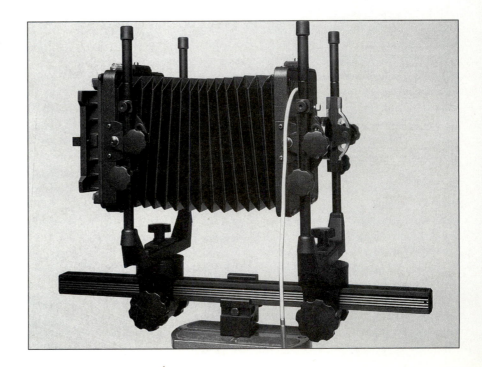

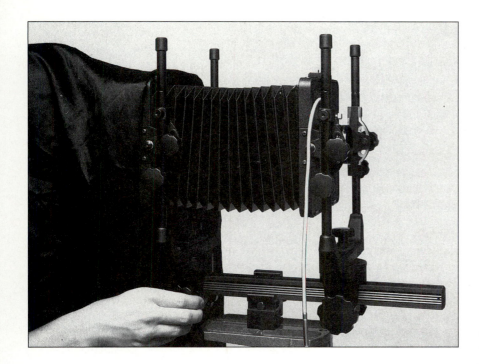

With the darkcloth covering your head and the camera's back, focus the image on the ground glass by moving the rear standard along the rail. ■

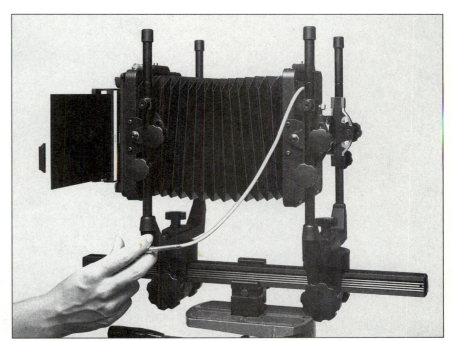

After closing the shutter, insert a film holder and withdraw its darkslide. Make sure the camera is motionless before gently pressing the cable release to make the exposure. ■

climates, too rapid a movement of the darkslide may generate enough static electricity to mark the film. If the sun is shining on the camera back, or if there will be a long delay between removing the darkslide and making the exposure, drape the darkcloth over the camera back to protect against possible light leaks.

Look carefully at the camera for vibration. If you have just taken your hands away from it, give it time to stop moving. If there is a breeze against the bellows, try to wait for a lull. Hold the end of the *cable release* (p.140) in your hand, leaving enough slack in the cable to prevent motion being transmitted from you to the camera. Make the exposure by pressing the cable release to trigger the shutter. After the exposure is made, insert the darkslide back into the holder with the black rim of its handle facing the outside (a safeguard signifying exposed film) and remove the film holder from the camera.

ADVANCED CAMERA CONTROL

Your view camera's unique appearance is in part the result of its separately adjustable front and rear standards. *Camera movements*, the adjustments of these standards, make the view camera unique in function as well as appearance. The importance of adjustable standards is that we can use them to independently alter and control the positions of the lens plane and film plane.

The *film plane* is the position of the film during exposure, or of the front surface of the ground glass without the film holder in place. With a movable rear standard, the film plane can be angled away from its normal position perpendicular to the rail and to the *optical axis*, the path of a ray of light passing unrefracted through the center of the lens.

The *lens plane* is always perpendicular to the optical axis and corresponds roughly to the position of the lensboard (it may in fact be slightly in front of or behind the board, depending on the kind of lens and the thickness of the board and lens mount). With the front standard's movements, the lens plane may be moved away from its normal position perpendicular to the rail. The optical axis moves with the lens.

Moving the lens and film planes away from their normal positions parallel to each other changes the rendering on film of both perspective and focus. Once you are in control of the effects of these movements, you can create images that would otherwise be impossible. Because the idea of camera movements may be new to you, it may seem intimidating at first. Finish reading this chapter entirely before

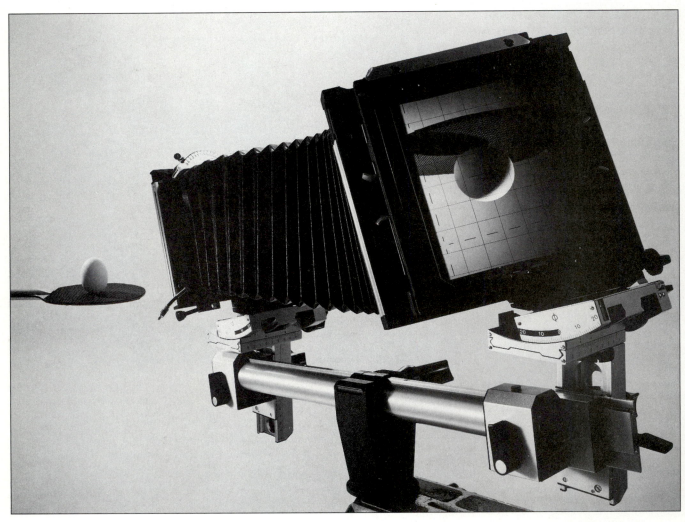

Adding the camera movements to your photographic repertoire will give you pictorial control otherwise impossible, as shown in this photograph by Switzerland's Fred Waldvogel made for Sinar on their 5x7 Model P camera. ■

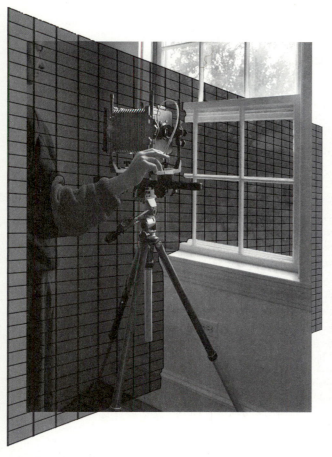

The film plane extends in all directions, continuing outward from the edges of the film, or the front surface of the ground glass. ■

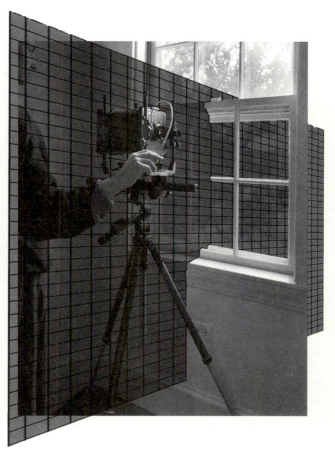

The lens plane extends the surface of the lensboard. It is always perpendicular to the optical axis. ■

trying to apply the concepts it introduces. You will need to understand how the camera movements change an image before you can successfully apply that knowledge. Then put your camera through its paces while rereading this chapter. In a short time you will be able to concentrate on the ground-glass image while setting the movements, using no more conscious thought than you need to adjust the focus.

Always begin with your camera set up in zero (or normal) position with the monorail or camera base horizontal and the lensboard and camera back vertical. The lens plane (lensboard) and film plane (camera back) should be parallel, so that the optical axis will run parallel to the monorail through the center of the lens and the center of the ground glass. Get into the habit of returning the camera to the zero position after each photograph.

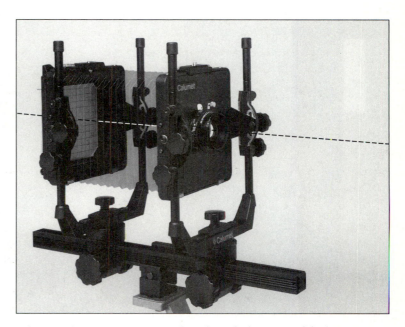

The optical axis is an imaginary line through the center of the lens, perpendicular to the lens plane. ■

SWINGS AND TILTS

Adjusting the front and rear standards to control the image requires some combination of three motions: shift, swing, and tilt. These camera movements are adjustments of the plane and position of the lens and film and are sometimes referred to as "swings and tilts."

A *tilt* is a movement of the lens plane or film plane around a horizontal axis perpendicular to the optical axis. Nodding your head as if to answer "yes" would be a tilt of your face.

A *swing* is a movement of the lens or film plane around a vertical axis perpendicular to the optical axis. Shaking your head to say "no" is a face swing. Swings and tilts are both inclining movements and produce an angular change in the position of the lens or film plane.

A movement of the lens or ground glass that leaves it in the same plane is called a *shift*. For example, in a lens shift you would slide the lens to the side or up or down and produce a lateral or vertical displacement of the optical axis. Opening a sliding door or a sash window is a shift movement. A vertical shift is often called a *rise* or *fall*.

What the Movements Do

The camera movements increase your ability to control two important aspects of a photograph: the rendering of perspective and the position of the plane of focus through the image. *Perspective* means the relative sizes of objects in the image, and the *plane of focus* is that plane in front of the lens in which all points are in focus, independent of depth of field. Although the effects of front and back movements can overlap (shifting the front up gives almost exactly the same results as shifting the back down), and although a single movement of one standard can affect both plane of focus and perspective, the swings and tilts are best understood if you mentally separate the functions of the front and back. As a rule of thumb, *use the position of the lens plane to control plane of focus and the position of the back to control perspective.*

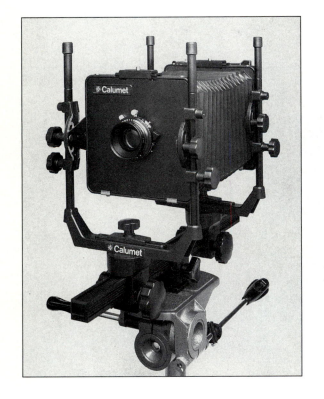

The camera in zero (or normal) position. ■

The illustrations on the next few pages show the camera movements—swing, tilt, and shift—in extreme positions for clarity. In normal use, you will rarely need to adjust your camera so far from zero position. ■

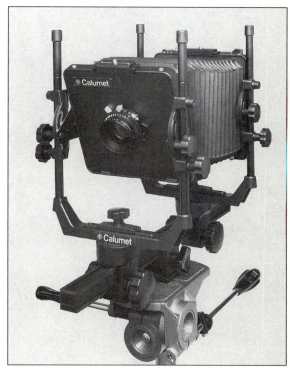

Front tilt, sometimes called lens tilt. ■

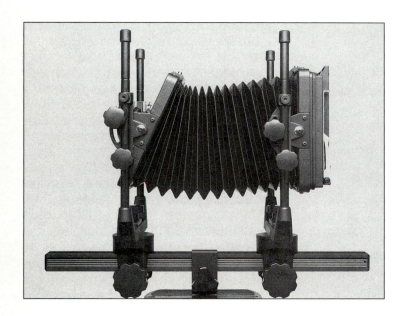

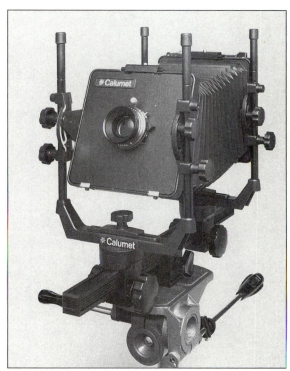

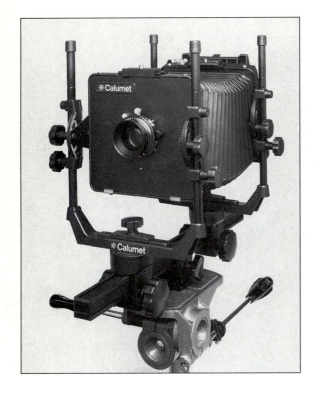

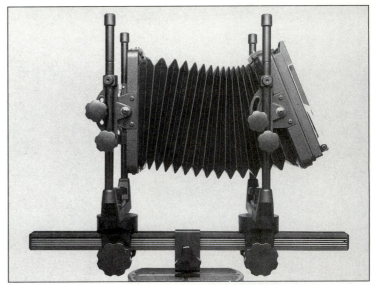

Back tilt. ■

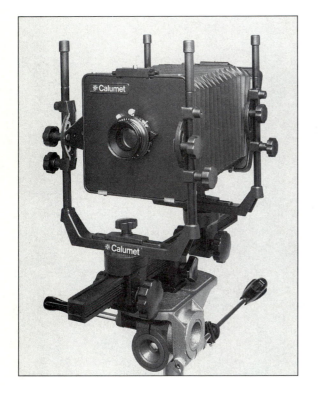

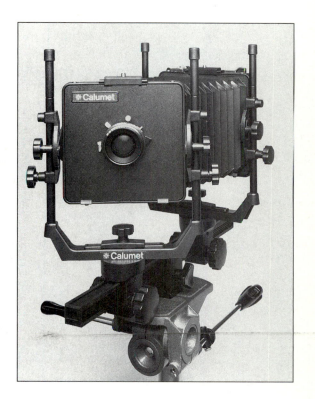

Front or lens swing. ■

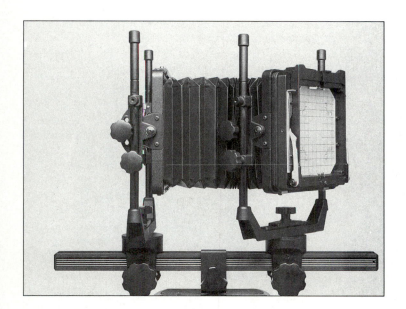

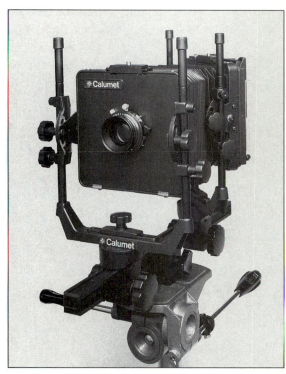

Back swing. ■

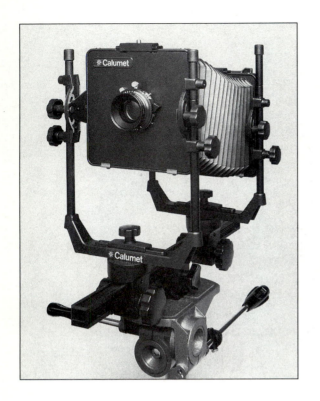

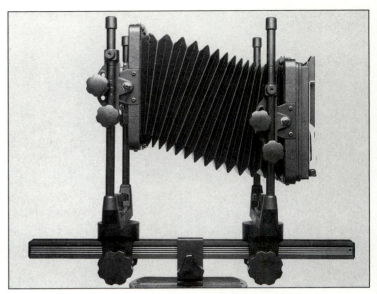

Vertical lens shift, nearly always called front rise. ■

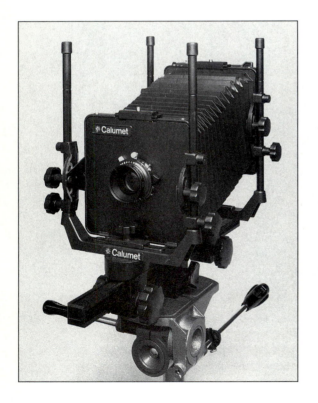

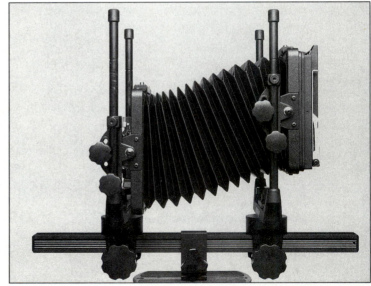

Vertical lens shift: front fall. ■

Front or lens shift. ■

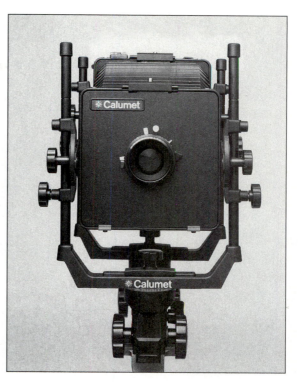

Back rise. ■

The actual positions of the lens and film will affect your photograph, not how you got them into those positions. The effect on your photograph of a front and back tilt on an inclined rail . . .

. . . is exactly the same as the effect from a front rise on a horizontal rail. ■

Controlling Perspective: Back Movements

In your past experience as a photographer you have probably found that one of the most important controls at your disposal is camera placement. This may seem obvious; if you put the camera in the forest, you will make a different photograph than you would in the city. And a photograph made from

above your head will be different from one made at knee level. These considerations of *vantage point* are extremely important to the making of photographs with any camera.

Vantage point is the position of the lens in space and determines *perspective*, that is, the relative sizes of near and far objects in your image. Perspective is also the relative sizes in the image of near and far parts of

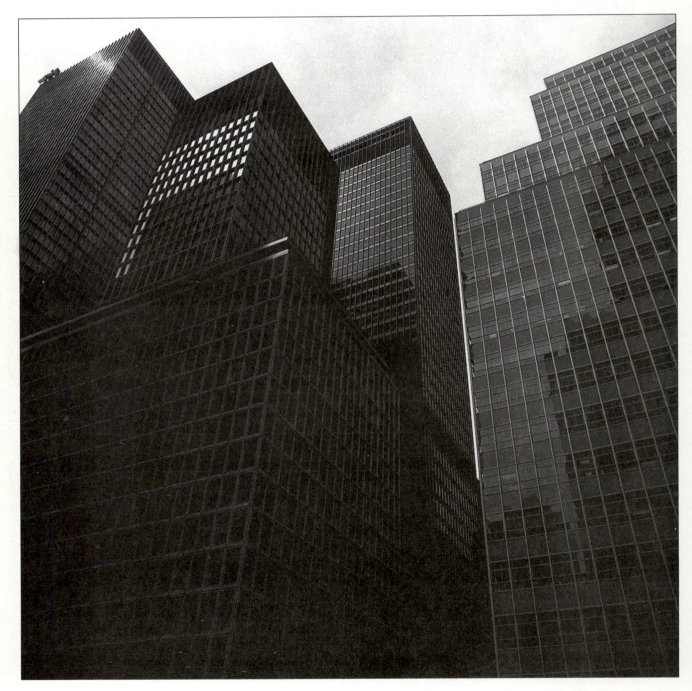

In this 1969 photograph of New York City buildings, Harry Callahan made intentional use of the keystone effect, *the convergence of vertical lines that is a natural consequence of tilting the camera up.* ∎

the same object so, as a direct consequence, perspective controls the appearance of the shape of objects. The perspective in your photograph will ordinarily be the same as what you would see with one eye if it were viewing the scene from the same position as the lens. If you can alter the position of the back of a camera, and therefore the position of the film relative to the optical axis, you can alter this apparent perspective in your photographs. Once you have placed your lens for the desired vantage point, your view camera allows you to control the appearance of the image further by altering the position of the back.

Back Tilt

As an example of the kind of perspective control a view camera can give you, use a 35mm camera (or any camera having back and lens in fixed positions) at ground level to photograph all of a tall building. The building, having vertical, parallel sides, will appear in the photograph to be narrower at the top. This effect, called the *keystone effect*, is the result of tilting the camera up to include the top of the building. The top of the building appears smaller than the bottom because it is farther from the lens and the parallel sides of the building appear to converge toward the top.

To avoid the keystone effect with your view camera, you can tilt, or incline, the back independently of the rest of the camera. When you do, one end or edge of the film ends up closer to the lens than the other. The cone of light projected rearward by the lens (p. 78) gets larger as it moves away from

An earlier photograph by Callahan, from Dearborn Street in Chicago, 1948, exhibits vertical lines of the building carefully made to appear exactly vertical in the photograph. Callahan's mastery of the camera allows him to select and control convergence to his own aesthetic advantage. ■

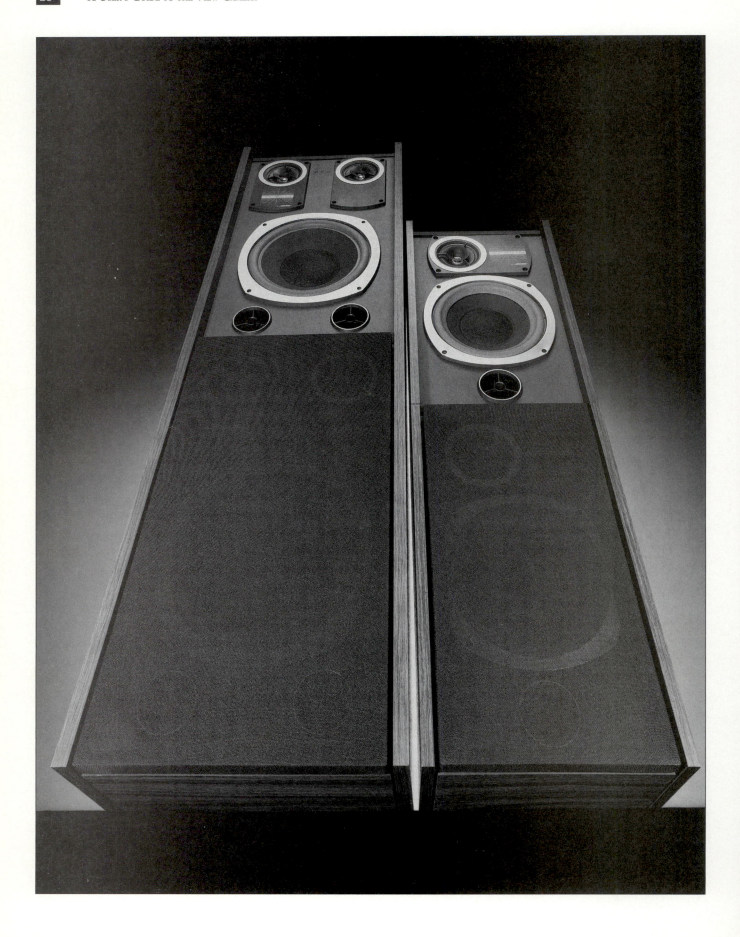

the lens. When you incline the film plane, the image on the part of the film farther from the lens becomes larger than that part closer to the lens. This tilt will diminish the appearance of convergence toward that side of the image.

Because the lens inverts the image, the top of the building in the example above appears at the bottom of the ground glass. Tilting the back, now leaning with its top away from the building, toward a vertical position moves the image of the top of the building (seen at the bottom of the ground glass) away from the lens, making it larger or wider, and the image of its bottom (at the top of the ground glass) toward the lens, making it smaller or narrower. If the back is adjusted this way until the top and bottom of the building appear to be the same width in the image, its sides will appear both vertical and parallel.

This tilting procedure alters the normal perspective of the image. Your eye, like a fixed-back camera, actually forms an image of the building with its top narrower. Your brain usually ignores that data, however, because you *know* the sides of the building are parallel. Some photographers refer to this kind of perspective alteration in a photograph as "correcting" because it makes the image appear as we *perceive* the building, not as we *see* it.

Photographs of buildings are the most obvious examples of the need for this kind of perspective control. When architects and builders carefully design and construct buildings having parallel sides they like to see their efforts clearly demonstrated in photographs of their buildings. This preference is particularly strong when they are paying for the photographs.

The Vanishing Point and Convergence. When you make photographs, remember first that the relative sizes of near and far objects (and of near and far parts of the same object) are determined by where you place your lens. The *vanishing point* is the point at which parallel lines or surfaces receding from the camera position appear to converge. Because tilting the back increases or diminishes convergence, it also moves the vanishing point closer to or farther away from the center of the image. Once you have selected a specific vantage point, you may further modify the perspective by altering the location of the apparent vanishing point with the position of the camera's back.

Tilting the back controls vertical convergence. When the camera back is vertical, all vertical lines in the scene appear as parallel vertical lines in the photograph. If the back is tilted away from vertical, as in the previous example with the tall building, vertical lines in the scene will converge in the photograph. If convergence is desired, as in the photograph of the loudspeakers on the opposite page, it can be exaggerated; the farther from vertical the back is tilted, the greater the convergence.

Note that increased convergence means that the vanishing point moves closer to the center of the image. The results of tilting the back are easiest to understand by looking at vertical lines, such as building sides in an architectural photograph. But even in an image containing no straight lines, such as a landscape, moving the vanishing point profoundly affects the appearance of the photograph.

Opposite: Vertical convergence was exaggerated with back tilt for dramatic emphasis in this advertising photograph made for the loudspeaker manufacturer by Geoff Stein. ■

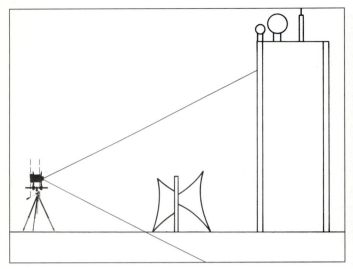

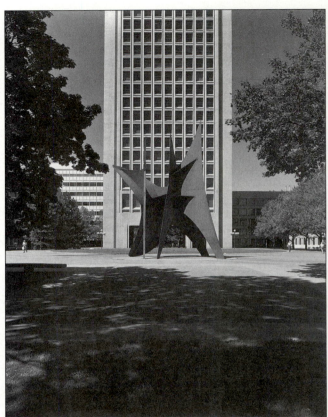

Pointing the camera straight at a tall building from eye level will result in a photograph that includes a great deal of foreground but lacks the top of the building. ■

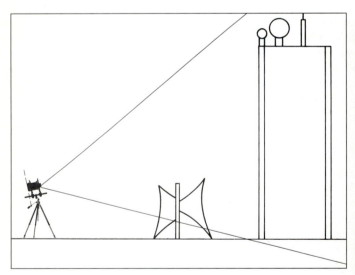

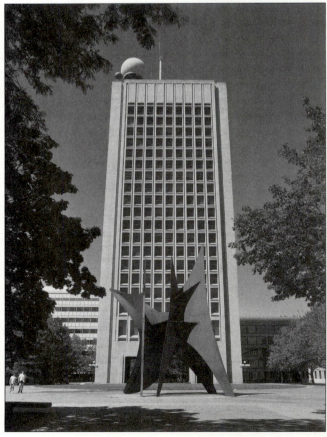

Pointing the camera up to center the building in the frame results in a photograph that shows the sides of the building as converging lines. The bottom of the building is closer to the camera than the top and is represented in normal perspective by appearing larger. ■

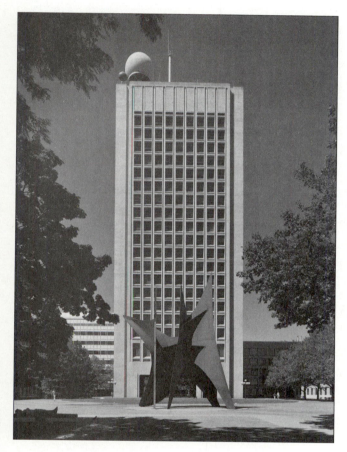

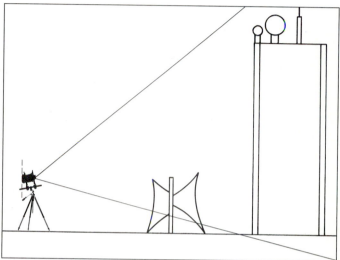

Tilting the back of the camera moves the bottom of the focusing screen, with the image of the top of the building, farther from the lens than the top of the focusing screen with the image of the bottom of the building. The image formed by the lens grows larger as it moves back away from the lens in the projected cone of light, so the image of the building's top is made larger to appear the same width as the image of the bottom of the building. ■

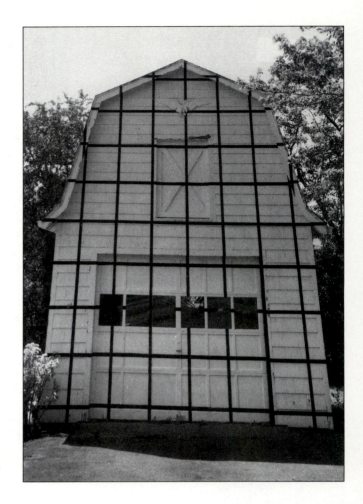

These three photographs were made from the same camera position and show the effects of back tilt on vertical convergence and the location of the vanishing point. ■

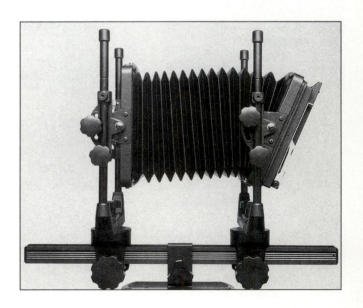

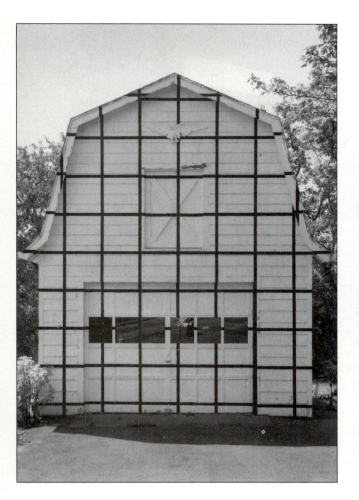

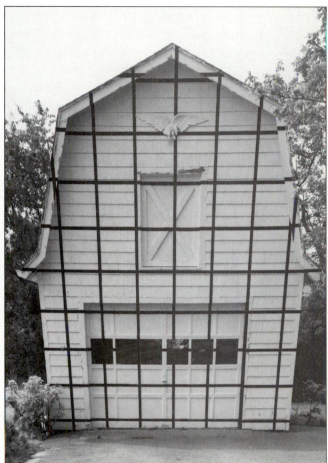

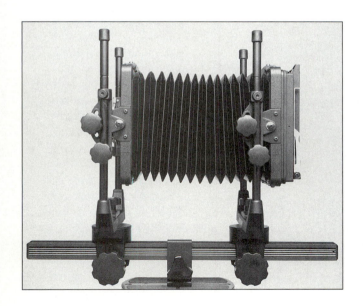

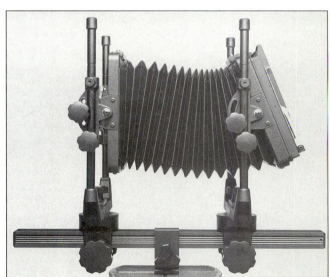

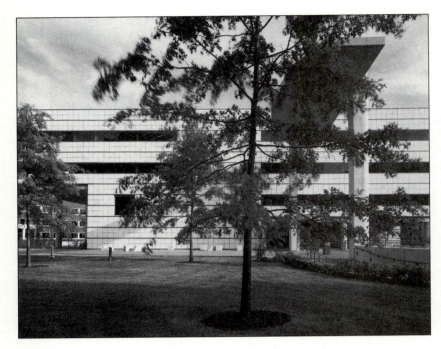

The front of this building shows its horizontal lines parallel (without horizontal convergence) because it was made from a position exactly in front of the building's center. Unfortunately, there is also a tree in a position exactly in front of the building, making the value of this vantage point questionable. ■

Back Swing

While back tilt controls vertical convergence, back swing affects convergence (the position of the vanishing point) for horizontal lines. When a horizontal line on the back of the camera is parallel to horizontal lines in your subject, as in a head-on photograph of a house, the horizontal lines in the image will all be parallel and horizontal. Pointing the camera at the same house from a position on either side of head on, with the camera back at an oblique angle to the front of the house, the horizontal lines will converge away from the camera. Swinging the back from this position to be more parallel with the front of the house will reduce this convergence; swinging it farther away from parallel will exaggerate it.

In the two series of photos on the following pages, placing the camera in position for a head-on photograph eliminates convergence as easily as using the back swing. The swing movement is most useful when your access to a desired vantage point is limited, for example by a tree or car in front of the house. This is why the back tilt is more often used than the swing; a vantage point head-on to a horizontal surface is easier to achieve (say, by walking around a building) than one head-on to a vertical surface (which might require a very tall ladder). Your own mobility is often much greater horizontally than vertically.

The advantages of swing and tilt control are most evident when you are photographing man-made objects because their regular shapes make convergence more noticeable. This is why the view camera is indispensable when photographing architecture or for advertisements. Remember that nature's forms are no less affected by moving the vanishing point, however, and creative control is at your fingertips when using a view camera for landscapes.

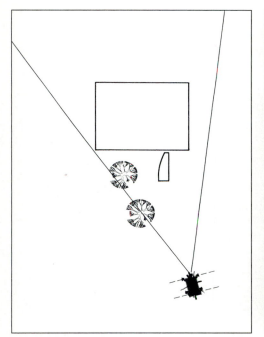

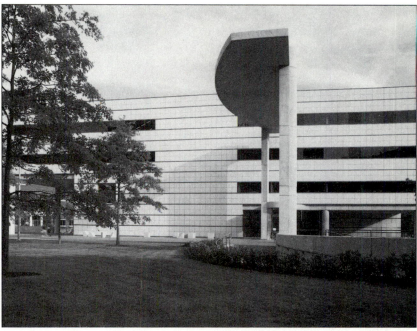

From a vantage point slightly to the side, the building's elevation is clearly visible, the tree is on the left edge of the frame, but the horizontal lines converge to the left. ■

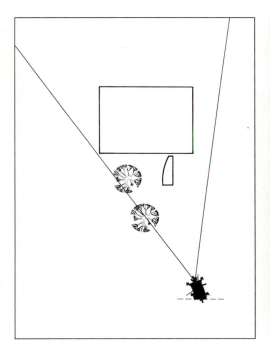

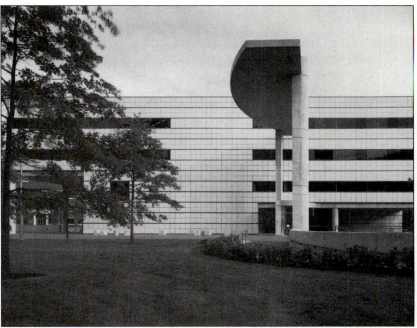

By using a back swing, making the back parallel to the building's facade, the horizontal lines are made parallel in the photograph made from this vantage point. ■

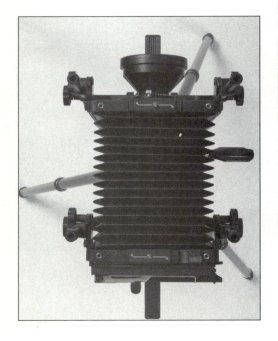

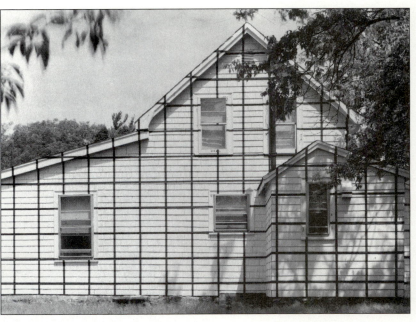

These three photographs made from exactly the same camera position show that back swing can be used to introduce and control horizontal convergence, without altering the vantage point. ■

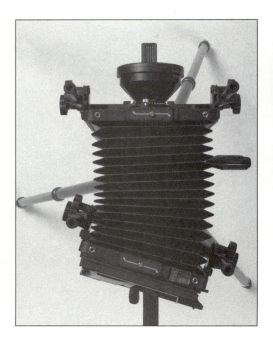

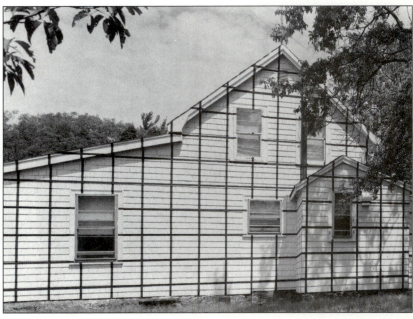

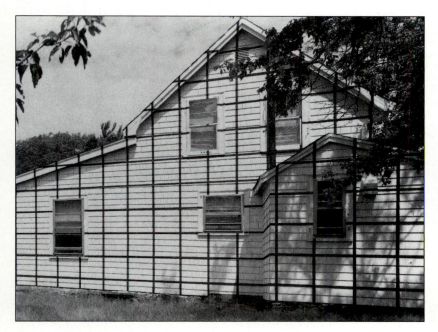

Timothy O'Sullivan made this photograph of Colorado's Vermillion Creek Canyon in 1872 for the U.S. Geological Survey. ■

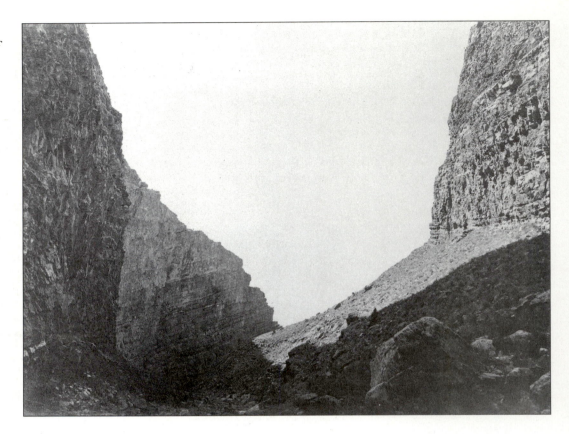

For the Rephotographic Survey Project, Mark Klett made this photograph in 1979 from O'Sullivan's original vantage point showing this particular section of our western landscape to be virtually unchanged in over a century. ■

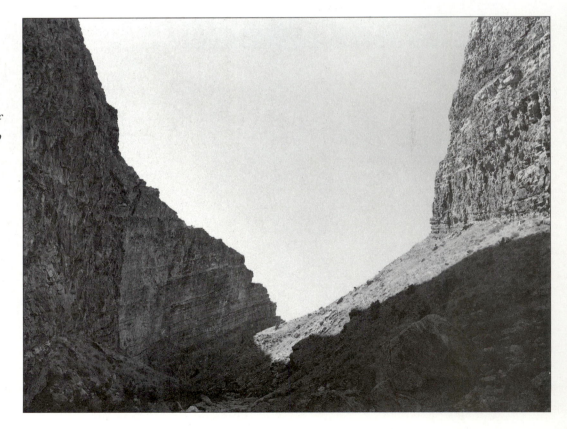

Klett's precise methodology reveals O'Sullivan's use of camera movements for perspective alteration. This Polaroid field check of camera position made without camera movements has the borders of O'Sullivan's photograph drawn in. Their trapezoidal shape indicates that an angular displacement of the camera back is necessary to recreate the perspective shown in the 1872 photograph. ■

Without camera movements, a head-on photograph of this environment reveals the camera's reflection in the mirror. ■

Moving the camera to the side removes the reflection in the mirror; the image circle from the lens is large enough to allow a back shift to adjust the framing of the image. ■

Back Shift

Back shift movements—rising, falling, and lateral shifts—do not alter the perspective of the image, but they do alter the image in other ways. Think of the image projected by your view camera lens onto the film as the one projected by a slide projector onto a screen. If the slide projector is too far from the screen, the image you see on the screen is only part of the image on the slide—the extra spills over the edges of the screen. By moving the screen from side to side and up and down, you can make different pictures appear on the screen, each a different section of the whole slide.

In a similar manner, most view camera lenses project an image somewhat larger than the film (see *coverage*, p. 75) and you can shift the back of your camera side to side and up and down to select the desired part of that larger image. In this way you can make adjustments to the framing of an image without moving the entire camera and with no change in perspective or vantage point.

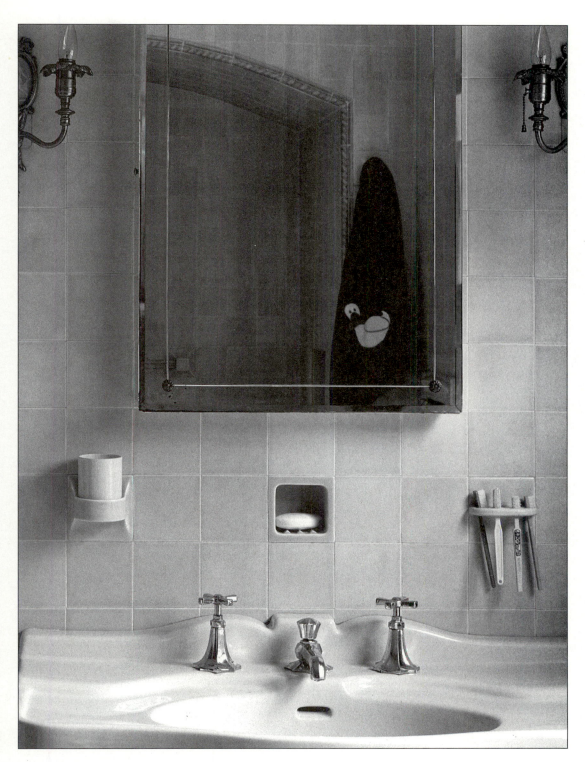

The resulting image avoids the camera's reflection in the mirror yet still allows the pattern of tiles to be reproduced without convergence. ■

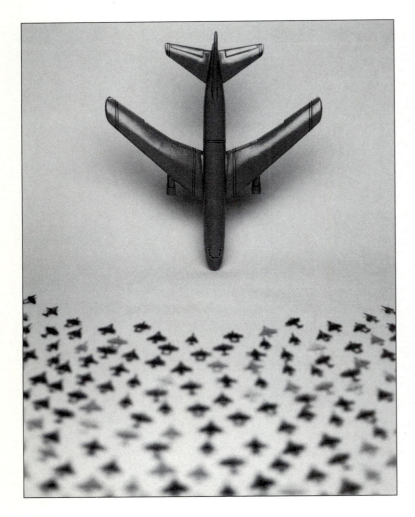

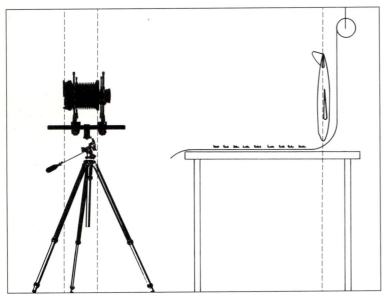

Set up in zero position and focused on the single large jet in the back, the plane of focus is vertical; the limited depth of field throws the foreground out of focus. The appearance and position of the plane of focus are the same as they would be using any hand camera. ■

CONTROLLING PLANE OF FOCUS: LENS MOVEMENTS

With a rigid-bodied camera such as a 35mm, the lens plane and film plane are parallel and fixed in relation to each other. The only relative movement allowed is changing the distance between the two to focus. When this distance is adjusted so that a point two meters from the lens is in focus, an entire plane through that point, parallel to the lens and film planes, is in focus as well. Adjusting the focus to three meters moves this *plane of focus* one meter farther away. This plane of focus is always a two-dimensional surface slicing through a three-dimensional world.

When your view camera's lens plane and film plane are parallel, the plane of focus behaves in exactly the same way as that of any rigid-bodied camera. You have the option, however, to adjust the lens and film planes away from their normal parallel position. A swing or tilt of either lens or back will move the plane of focus to a new position parallel to neither lens nor film plane. Understanding and applying this control will make it possible for you to make great photographs in otherwise impossible situations. If, for example, you were photographing across a tilled field, with your camera aimed at the horizon, tilting the lens plane by moving the top of the lensboard forward would move the plane of focus to cut horizontally across the surface of the entire field. In this way you would have the entire field in focus, foreground to background, without having to use a very small aperture to get great depth of field. The larger working aperture would allow the use of a faster shutter speed, perhaps to stop the action of workers moving in the field. In addition, the wider apertures (but not the widest) of any lens will usually produce an image with greater sharpness than the smaller apertures on the same lens.

In the following section, you will learn how the angle between the lens plane and film plane determines the position of the plane of focus. When you change that angle by moving either lens or film plane, you will change the plane of focus. In the previous section we found that perspective depends on vantage point and can be altered by the position of the film plane. Perspective is not altered by angular movements (swing or tilt) of the lens plane. Because of this, your chosen perspective will be unaffected by adjusting the plane of focus if you make that

adjustment with the lens plane and not with the back. To save steps, select your vantage point first, then adjust convergence with the back, and finally alter the lens plane if you wish to move the position of the plane of focus.

The Scheimpflug Principle

When the lens and film planes are *not* parallel to each other (a situation usually possible only with a view camera), an unusual set of optical conditions exists in which the plane of focus cuts at an angle through the image. The rule governing this peculiar situation was named after a Prussian army officer of the nineteenth century who was presumably the first to quantify the results. The *Scheimpflug* (shīm´-floog) *Principle* states that when the lens plane and film plane are not parallel, neither will be parallel to the plane of focus. Fortunately, the Scheimpflug Principle also tells us where the plane of focus will be: it will meet the lens plane and film plane in a line.

Front Tilt

To visualize the effects of the Scheimpflug Principle, imagine your camera set up in zero position. If you stand close to the camera back, the film plane passes through your toes (remember the film *plane* doesn't stop at the edges of the film). If you tilt the lensboard forward so that its extended surface (the lens plane) also passes through your toes and you adjust the focus properly, then the plane of focus will be the floor. In other words, with the back vertical and the lens tilted forward, the surface of the floor will be entirely in focus—the plane of focus will be horizontal. The planes of the lens, film and floor meet in a horizontal line, perpendicular to the rail, at your toes.

Front Swing

If you set your camera at an oblique angle to a long wall, you can swing the front standard so that the lens plane meets the vertical line where the film plane cuts the wall. The surface of the wall will then be the plane of focus. In this way, the plane of focus may be made to lie along any vertical, flat surface.

Once you get used to the notion that the plane of focus needn't be parallel to the film and can visualize the positions of the film plane and lens plane beyond the edges of the ground glass and lensboard, it will be easy for you to use the Scheimpflug Principle to your advantage.

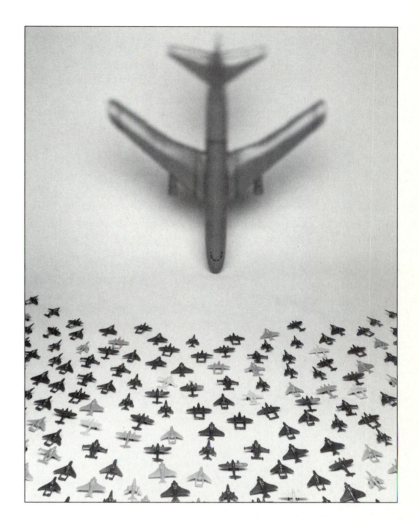

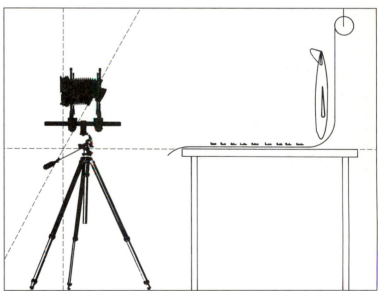

With the lens tilted so that the lens plane and film plane meet in a line with the horizontal plane of the tabletop, the plane of focus is now horizontal, leaving the vertical jet out of focus. The position of the back of the camera and therefore the rendering of perspective remains unchanged. ■

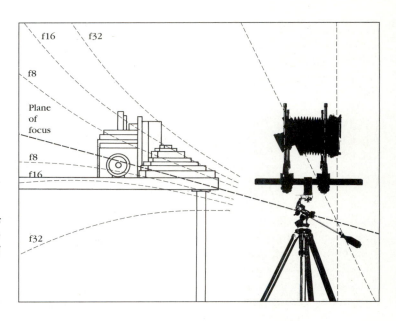

This diagram shows the limits of the depth of field at several aperture settings, around a plane of focus repositioned using the Scheimpflug Principle. Though the plane of focus has been repositioned by a lens shift, as it is here, and this diagram looks quite different from what you might be used to, the behavior of the depth of field is essentially unchanged by the Scheimpflug Principle. ■

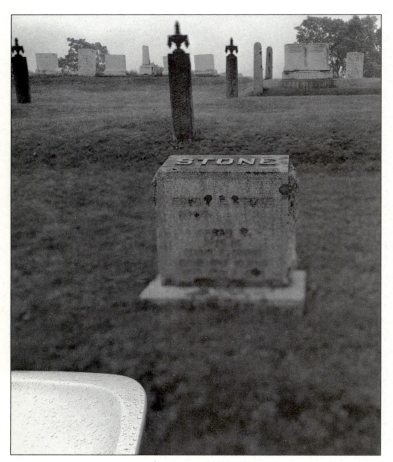

In this 1993 photograph taken near Manchester, New Hampshire, Neal Rantoul tilted the lens of his 8x10 view camera to make the plane of focus run parallel to the ground from the rear deck of his car (spotted with rain in the lower left-hand corner), cross the top of the gravestone in the middle ground, and slice through the center of the gravestones and trees in the distance. With intentionally limited depth of field, the ground is out of focus everywhere and only certain details are highlighted by sharpness. ■

Front Shift

Shifting the front in one direction has almost exactly the same effect as shifting the back in the opposite direction. A lens shift, however, introduces a change in vantage point. For a distant scene, moving the vantage point only a few centimeters will not produce a noticeable change in the image, so you can often use a front rise interchangeably with a back fall. In situations where small adjustments of vantage point are needed, such as close-up work, use the lens shift for exact placement of the vantage point, then use the back shift to adjust the exact framing of the desired image.

DEPTH OF FIELD

Theoretically, a lens can only focus sharply on a flat, two-dimensional surface, the plane of focus. In practice, however, your eye is unable to distinguish between the sharpness in the image formed of a point in the plane of focus and that of one slightly closer or farther which is only slightly unfocused. The distance between the near and far limits of what we see in the image to be in focus is the *depth of field* and it is always measured perpendicular to the plane of focus. Depth of field affects profoundly the appearance of your photographs by determining what appears to be in focus; it therefore deserves careful attention during the making of any photograph.

With your view camera in zero position, the behavior of the depth of field conforms to the same rules it obeys in any rigid-bodied camera. The lens and film planes are parallel, and the near and far limits of the depth of field are planes parallel to the lens plane, the film plane, and the plane of focus.

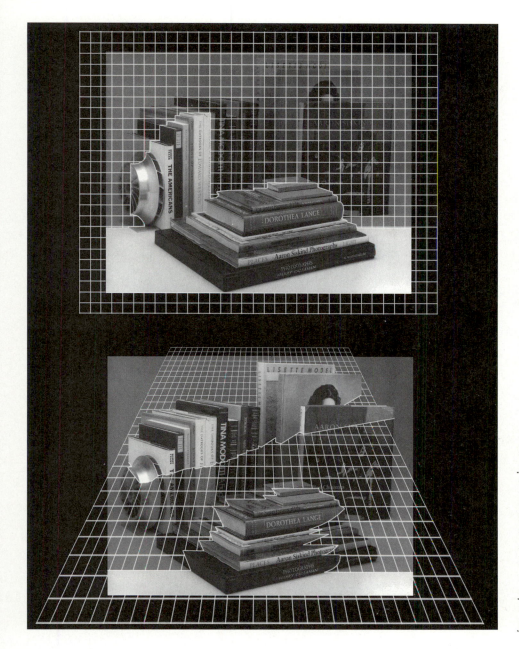

With the camera in zero position, the plane of focus cuts through these books vertically. With a normal lens and at this vantage point, it would be impossible to achieve enough depth of field to include both foreground and background in focus. ■

By tilting the lens according to the Scheimpflug Principle, the plane of focus was tilted to cut through this image from lower foreground to upper background so that all the objects could be brought into focus with the minimum depth of field. In this case, closing the aperture by only two stops was sufficient. Using the Scheimpflug Principle allows you to find and use the most advantageous position for the plane of focus in any photograph. ■

For a given object distance (from the lens to the plane of focus), the distance included in the depth of field will increase with smaller apertures. For a given aperture, depth of field will increase for greater object distances. For very short object distances, the plane of focus is near the center of the depth of field. There is an old adage about the plane of focus having one-third of the depth of field in front of it (toward the camera) and two-thirds behind it; this is generally accurate at middle distances (say, across the room or across the street). At greater distances, the depth of field increases to a much greater extent behind the plane of focus than in front of it.

The behavior of the depth of field is altered by the Scheimpflug Principle, though not beyond recognition. Depth of field still is increased by smaller apertures and greater object distances and still surrounds the plane of focus. Since all parts of the plane of focus are not at the same distance from the lens, however, the depth of field is not the same in all parts of the image. Depth of field increases as the plane of focus recedes from the camera. At smaller apertures, it increases more rapidly with distance.

Depth of field is affected by aperture, object distance, and lens plane adjustments, but it depends especially upon what is considered acceptable sharpness for your use. Judgment of acceptable sharpness is subjective and hinges on such factors as viewing distance and degree of enlargement for the final print. To supplement experience for increasing your ability to make judgments about depth of field, there are standard tables and scales based on average values of the factors affecting depth of field. This information may be found explained in detail in a standard text on photographic optics.

The lens swing was used to line up the plane of focus with one face of this pile of hay bales and then with the other face from the same camera position. A wide aperture limited the depth of field so that the positions of the plane of focus are easily visible. ■

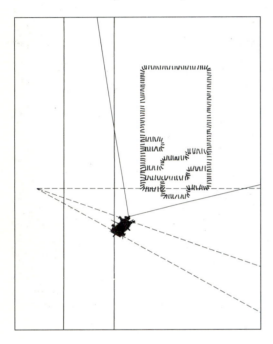
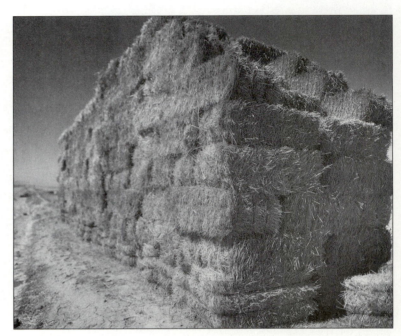

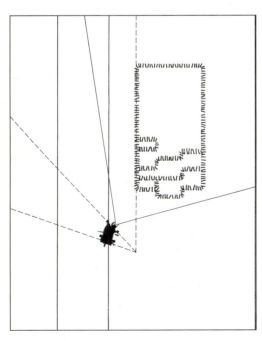
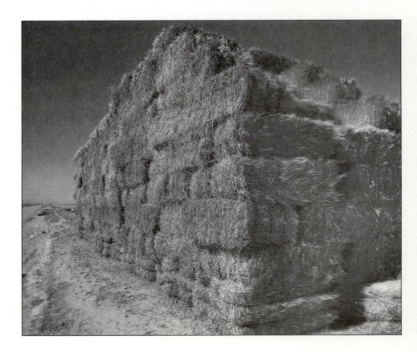

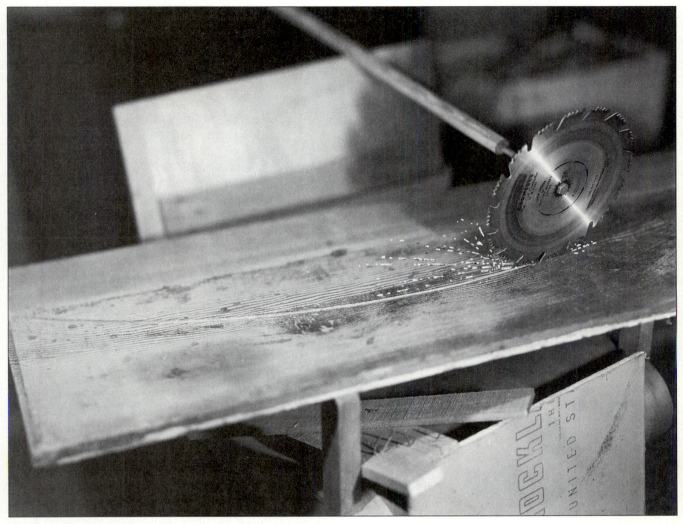

Robert Cumming used lens swing to angle the plane of focus along the saw blade in the whimsical Circular saw cuts 36″ radius *(1974). The limited depth of field allows you to trace easily the position of the plane of focus.* ◼

MORE ABOUT PERSPECTIVE

As in a painting or any other two-dimensional pictorial representation, the illusion of depth in a photograph depends upon four factors: 1. *Atmospheric effect* is the softening of detail with distance, as though the scene were viewed in a haze. In a photograph it is controlled by your selection of film and filters, time of day, and focus. 2. *Lighting* can be controlled in the studio or selected outdoors to give the illusion of compressed or expanded distance. Soft, nondirectional light, for example, compresses distance. 3. *Interposition of objects*, the way a foreground object hides what is behind it, is primary information for the eye in judging relative distances. An object with its contour interrupted by that of another object appears to be behind the object interrupting it. 4. *Linear perspective*, the relative sizes of objects in the image, causes objects in the foreground to appear larger than objects of similar size in the distance.

Linear perspective is wholly the result of vantage point (lens position). The closer you position your lens to an object, the larger it will appear in relation to objects behind it. The effects of linear perspective are independent of lens focal length (p. 79), even though you might assume that a wide-angle lens will render a different perspective from that of a long-focus lens. This misconception results from the fact that a wide-angle lens must be much closer to an object to make the image of that object the same size on a negative. The closer position changes the perspective by making other, distant objects relatively smaller, hence the assumption that shorter lenses exaggerate perspective. From the same camera position, however, all lenses will represent objects in the same relative sizes.

This photograph of the John F. Kennedy Memorial Library was made with a wide-angle lens, in this case a 90mm lens on a 4x5 camera. ■

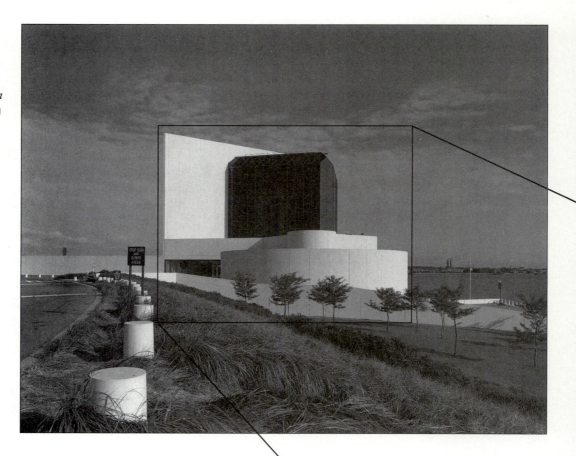

Made with a 180mm lens from exactly the same camera position—therefore an identical vantage point, this photograph shows every part of the image to be exactly twice as large as the one above, made with a lens having half the focal length. ■

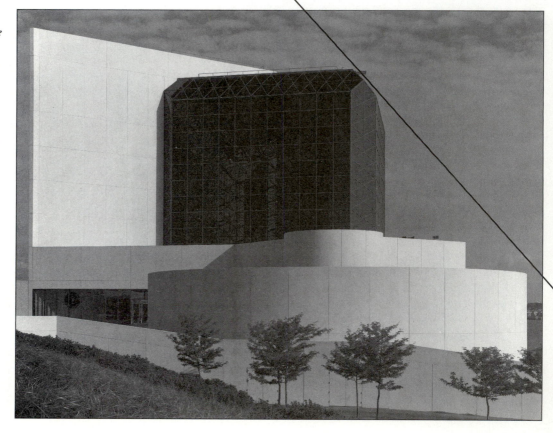

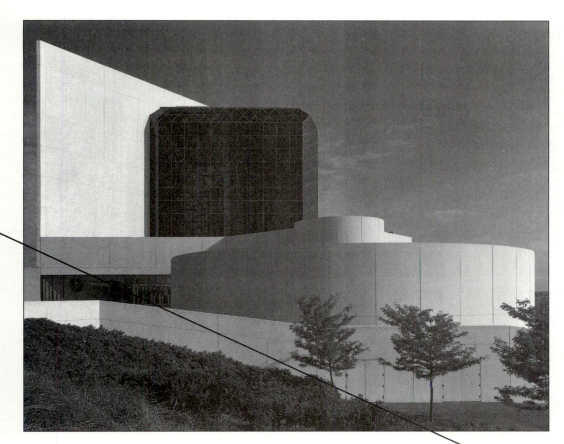

Making a photograph with the 90mm lens to include the same boundaries as one with the 180mm lens requires a much closer camera position (vantage point), therefore the perspective appears completely different. This rendering of perspective is not the result of using a wide-angle lens, but is the result of close position. ■

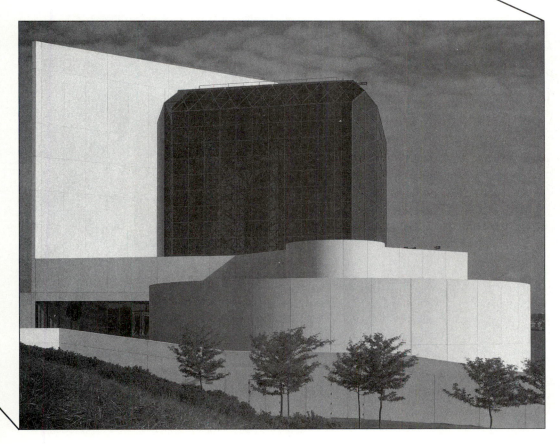

Enlarging the center section of the first wide-angle photograph (upper left) gives exactly the same perspective as that rendered by the longer lens from the same position (lower left). Perspective depends entirely upon vantage point and not at all upon focal length. ■

SETTING UP A PHOTOGRAPH: A COMPLETE SEQUENCE

After you have read the section on lenses (Chapter 5) and if you are fortunate enough to have a selection of lenses from which to choose, a simple sequence of steps can lead you to exactly the photograph you want. You will eventually integrate these steps into your procedure for setting up the camera, and your mind will be free to concentrate on the desired image.

1. Select a vantage point for the desired perspective. Where you put the lens and when you make the exposure are the most important decisions you must make for each photograph. Remember that the selection of a lens is not a factor in the control of perspective; if you close one eye you will see objects in the same relative size—with the same linear perspective—as with any lens you choose. The vantage point is determined entirely by the position of the lens; use the placement of the camera as a rough control and the lens shift for fine-tuning.

2. Select the focal length of the lens for the *angle of view* (p. 80), the section of the scene in front of the lens you wish to include. If you don't have the exact lens you need, you can use a shorter focal-length lens (one having a wider angle of view) and plan to crop out the unwanted part of the image later. If you substitute a longer lens (one with a smaller angle of view), it will leave out part of the desired image or force you to move the camera farther back. If you move the camera, you will change the size relationships you determined in selecting your vantage point.

3. Once you have selected a lens and established a perspective based upon a specific vantage point, adjust the back to contour the perspective to your needs. By combining tilt and swing movements you can adjust convergence (move the vanishing point) not only horizontally and vertically but to any angle in between. More often than not you will want the back vertical. This is such a common working position that many cameras provide a small bubble level—often two—on the rear standard to aid in determining a precisely vertical position. If your camera is not so equipped, bubble levels are available as an accessory.

4. Select a plane of focus. Basing your judgment on the parts of the scene you would like to appear in focus, imagine the plane slicing through the scene in a position that will give you that focus with the least possible depth of field. As with the adjustments of the back, lens swing and tilt can be combined so the plane of focus can cut through the subject at any angle. Select the placement of the plane of focus carefully so you can achieve the depth of field you need without having to stop down the lens beyond its sharpest apertures (see *diffraction*, p. 120). Pick three points in your image to define the desired plane of focus. These points will form a triangle to help you visualize the surface of the invisible plane cutting through the image. The farther apart the three

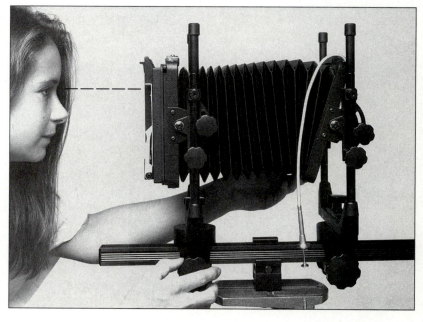

To determine exactly how much to tilt the lens for your selected plane of focus, you should approach the correct setting gradually, in steps. Pick a point in the foreground and one in the background that you would like to include in the plane of focus. Select these points from the scene beforehand, not from the ground-glass image. Keep one hand on the focus adjustment of the rear standard and the other on the tilt adjustment of the front standard. Bring the foreground point into focus and then refocus for the background point. Make a mental note of the amount you had to turn the knob to refocus between them. ■

points, the more accurate you can be in isolating that particular plane when you adjust the lens plane. If your image allows it, one of your selected points should be in the extreme background and the other two on the extreme left and right of the foreground.

5. Adjust the lens tilt to bring two of your selected points, one near and one far, into focus simultaneously. While you are under the darkcloth viewing the ground-glass image, use one hand to tilt the lens and the other to focus with the rear standard. Before you tilt the front away from zero position, focus on one, then the other, of your selected points. Notice

how far you have to move the back to focus from one to the other. Change the angle of the lens slightly in the direction indicated by the Scheimpflug Principle. Adjusting the lens tilt moves the plane of focus away from the vertical around a horizontal axis at right angles to the monorail. Remember, the plane of focus and the lens and film planes will meet in a line. Once more, focus on one point, then the other again, back and forth, and check to see whether the distance you have had to move the back to focus from one to the other has decreased. If so, the two points are closer to being in focus simultaneously, that is, closer to being in the plane of focus.

Continue to adjust the lens tilt by very small amounts. Focus both points after each adjustment to check that the distance between their focused positions continues to decrease. If it has decreased, you are approaching the lens angle at which the focus position is the same for both points, meaning that both points will lie in the plane of focus.

If you adjust the lens tilt by a small amount and find that you must increase the distance you move the focus adjustment between the two points, you have moved the lens past the correct position, or in the wrong direction. For most photographs, the amount you will have to tilt the lens away from normal position will probably be quite small, so use very tiny adjustments of the angle.

6. Use the lens swing to tip the plane of focus left and right. If your two foreground points require a focus plane slanted from side to side, use the same procedure as above to adjust the lens swing until both points are simultaneously in focus. When you have found the correct position of the lens and they are both in focus, check the near and far points again. Unless your lens has been rotated (with the swing) exactly around its rear nodal point (p. 115), you will probably have to readjust the tilt very slightly. The thickness of your lensboard and lens mount will affect the position of the nodal point, and the design geometry of your particular camera (see the next section) decides the exact axis around which the lens swings.

7. Select the working aperture. Once the plane of focus has been properly positioned, close the diaphragm until you see the desired depth of field in the ground-glass image.

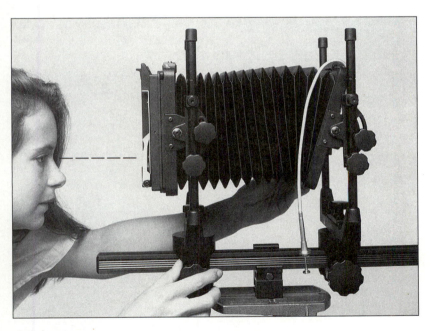

Tilt the lens a few degrees in the direction indicated by the Scheimpflug Principle; for a tabletop plane below camera level, you will need to tilt the top of the lensboard forward. Focus again on the two points, first one then the other. The amount of refocusing needed should diminish. Tilt a little more and then refocus again. As you proceed, the distance between correct focus for the two points will get smaller and smaller until they are both in focus at once. If you find you need to move the focus farther each time, you have passed the correct tilt and are moving away from it. ∎

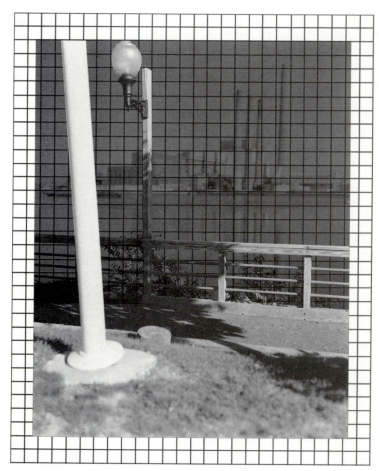

Focusing on the wooden lamppost with the camera in normal position results in a plane of focus that cuts vertically through the scene. It is not possible to bring the entire scene into focus by closing down the aperture for depth of field. ▪

Choose three points in the scene to define the position for your adjusted plane of focus. They should appear relatively far apart on the ground glass and be sharply defined to make your job of adjusting and focusing easier. ▪

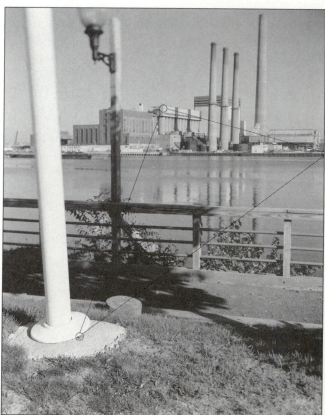

This plane of focus was selected to allow all of the image to be brought into focus with the largest aperture (the minimum depth of field) possible. It required both a tilt and swing of the lens plane. Here, with the lens wide open, it shows the plane of focus cutting through the image. ■

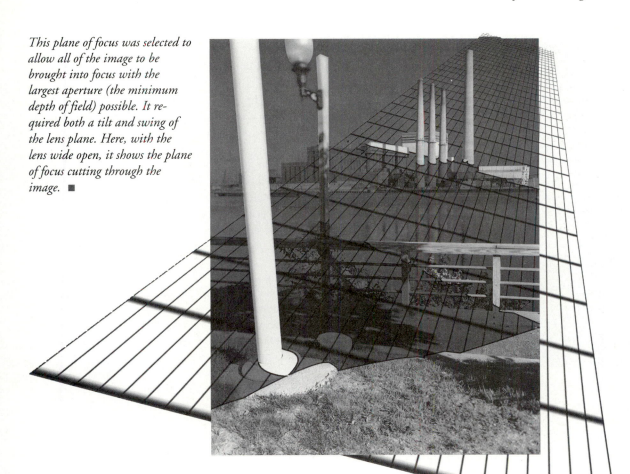

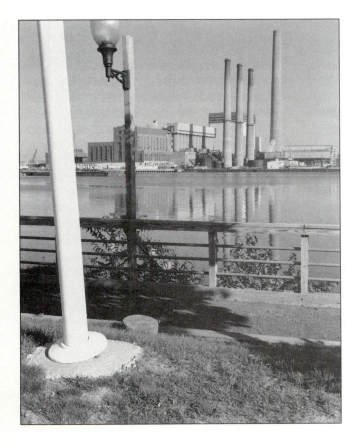

Closing down the lens to a middle aperture created enough depth of field for convincing sharpness in the final image. ■

These two photographs show the results of adding a front rise to a tilted lens with two different cameras. This camera uses axis tilts. ∎

This camera, having base tilts, requires more refocusing after adding one camera movement to another. ∎

Base vs. Axis Tilts

Not all cameras are designed to have the tilt pivot in the same position. Most monorail cameras offer *axis* tilts, meaning the lens and ground glass tilt around their own centers on a horizontal axis. Some use *base* tilts, in which the front and rear tilts pivot around a horizontal axis at the base of the standard. Current flatbed designs—field, press, and technical cameras—have backs that tilt from the base. Although you can make exactly the same photograph using a camera with either base or axis tilts, this design difference can make some unexpected differences in the operational steps needed to achieve that image.

In cameras having either axis or base tilts, a rise or fall is a movement of the lensboard or back along the upright member of the standard. With axis tilts, the standards themselves are always perpendicular to the rail, but the standards on a base-tilt camera tilt along with the lens or back.

Tilting the lens on a base-tilt camera will move it farther from the film, changing the image distance; once tilted, a vertical shift will change the image distance once again. Also, tilting the lens at the base moves the lens away from the swing axis. In other words, adding a swing to a base-tilted lens moves the whole lens in a circular path rather than rotating it around the vertical swing axis. Swinging the lens in an arc moves the nodal point of the lens, thereby requiring considerable readjustments of focus and tilt. Axis tilts have the advantage of requiring less refocusing of the image after each movement, but have the disadvantage that an extreme back tilt can block insertion of the film holder.

At least two monorail cameras, Arca and Rajah, include both axis and base tilts. The Sinar p2 pioneered an unusual system, now available from other manufacturers, that tilts back and lens around an axis between base and center, using a very sophisticated geometry to simplify the focusing and adjustment process. Although many photographers express strong preferences for one system or camera, the technique of adjusting any of the available cameras will rapidly become second nature with practice.

Exposure Compensations

Bellows Extension Factor

The only limitation to focusing on close objects with your view camera is the length of your bellows, and you can remove even that limitation by adding an additional standard and another bellows. This freedom to focus on nearby objects is one of the

great virtues of the camera, but exercising it introduces you to another important photographic principle. This principle, the *Inverse Square Law*, is ordinarily hidden from users of small cameras by the designers of those cameras.

The illumination available from a light source depends upon the distance from it. Imagine a long, windowless corridor with only one light bulb at one end. The farther from that light bulb you stand, the darker it is where you are and, for example, the harder it would be to read by that light. The film in a view camera is also in a long, windowless corridor—the bellows—and the lens is the light source. *Bellows extension* is the length of that corridor. The more closely you focus, the longer the corridor you make for your film—the greater the bellows extension—and the farther the light is from the film. This means that by decreasing the object distance, the intensity of the light reaching the film is diminished.

Most photographers whose experience is limited to small cameras assume the light intensity reaching the film is only affected by the light level of the scene and by the selected aperture. Within certain limits, this is not a damaging misconception. With any camera, a normal exposure is based upon an infinity focus, at which the lens and film are one focal length apart. Focusing on a closer object moves the film farther from the lens, diminishing the light intensity. In order for the light intensity to be diminished by a noticeable amount, however, the object distance has to be less than about seven times the focal length. Since the focusing mounts for most small camera lenses are intentionally designed to prevent their use at object distances less than seven times their focal length, users of these lenses can produce satisfactory work within the limits of their equipment and in ignorance of bellows extension effects.

Your view camera has no built-in barrier to keep you from focusing more closely than seven times the focal length. If you do, you will reduce the illumination reaching the film plane enough to need to compensate for the light loss. The *bellows extension factor* is the measure of this necessary exposure compensation.

You can calculate the bellows extension factor and multiply the measured (uncompensated) exposure by it, or you can make an educated guess at the needed exposure increase. But in order to do either it is important to know how far the film is from the lens. All your normal exposure calculations are based on an object distance of infinity, the shortest bellows extension possible with a given lens. This is your starting point. At infinity focus, the lens and film

are separated by one focal length. With a 300mm lens at infinity focus, the lens and film are about 12 inches apart (remember that 25mm is approximately 1 inch). With this lens, which you might choose for general use on an 8x10 camera, you will need to calculate a bellows extension factor when you focus more closely than about 2 meters, or almost 7 feet. Once you have focused inside this range, measure (or estimate) the actual distance between lens and film.

The Inverse Square Law is the principle of physics governing bellows extension and, like other laws of nature, it cannot be ignored without consequence. It tells us that the intensity of a light source

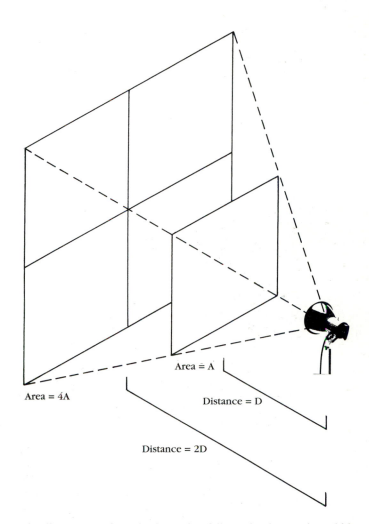

The illumination from this lamp that falls on the close card would have to cover a card four times the area if it were twice the distance away. The area for the same illumination increases as the square of the distance. ■

diminishes with the square of the distance from it. In our long corridor, if you move twice as far from the bulb, you are illuminated one-fourth as much. At three times the distance, you are illuminated with one-ninth the light. Similarly, if you are using a 150mm lens and want to make a photograph with the bellows extended to 300mm (12 inches), you will need four times the normal exposure. With the film twice as far from the lens as the infinity focus on which a normal exposure is based, the illumination is diminished to one-fourth normal and the exposure must be increased by a factor of four, or two extra stops.

There are several methods and formulas for calculating the bellows extension factor and they will all result in the same compensation. The simplest formula is this: the bellows extension factor is equal to the extended bellows length squared, divided by the focal length squared. The indicated exposure (the one determined by metering) should be multiplied (increased) by this factor. You can increase exposure by using a larger aperture or a slower shutter speed.

With most black-and-white work, a careful estimate of the exposure compensation will be sufficient. With color materials, especially reversal film, measurement and calculation will be necessary. Copy work almost always demands compensation for bellows extension because short object distances are common.

Reciprocity Failure

The *Law of Reciprocity* tells us that the correct exposure for a given film in a given lighting situation may equally well be any of several equivalent combinations of aperture (illumination) and shutter speed (time). If we increase the illumination, we may decrease the time by the same amount (and vice versa) without affecting the exposure. Another way of stating this is to say that the film's speed, or *exposure index*, is constant.

Your work with the view camera will eventually introduce you to a characteristic of film rarely noticed by users of small cameras. That is, the Law of Reciprocity is valid only within a limited range of exposure times. *Reciprocity failure*, or the failure of the reciprocity law, is a diminished film speed and increased contrast due to very long or very short exposure times. Most films obey the reciprocity law and have a consistent exposure index only for exposures shorter than 1 second and longer than 1/1000 second. A hand camera is rarely used outside that range. However, because your large-format camera with its longer focal length lenses requires smaller apertures to achieve sufficient depth of field, you will often find yourself making very long exposures. And you will often find yourself having to compensate for the reciprocity failure by making those long exposures even longer.

Compensating for Reciprocity Failure Accurate compensation tables for each different film's reci-

This camera is focused at infinity with its 150mm (6-inch) lens. ∎

procity characteristics are available from the manu-facturer and are sometimes packaged with the film. Since the degree of reciprocity failure depends on how much light actually gets to the film, you must consider light losses such as filter factors and bellows extension *before* figuring reciprocity compensation. Calculating bellows extension, for example, after reciprocity failure compensation will result in underexposure.

In the absence of reciprocity tables, use the fol-lowing as a rough guide for exposures on black-and-white film. With a metered exposure near 1 second, your film loses half its speed from reciprocity failure and needs one stop more exposure. At an exposure of about 10 seconds, it loses half its speed once again, needing two extra stops. At 100 seconds, film speed is one-eighth normal and needs three extra stops. These exposure compensations *must* be added to your measured exposures or your film will be underexposed. To compensate for the increased con-trast that also results from such long exposures, reduce your development time by 10 percent, 20 percent, and 30 percent respectively for the three examples above. These exposure compensations are accurate when increasing the aperture. Giving the film extra exposure time will require slightly more compensation because the film's speed continues to diminish with extended exposure. Three extra stops for a 100-second exposure, which with a constant exposure index would total 800 seconds, should ac-tually be 1200 seconds.

Color film is affected by reciprocity failure more severely than black-and-white film. Not only does the film speed change for long and very short exposures, but it changes a different amount for each of the three color-sensitive layers comprising color film. So reciprocity failure brings a color shift that in many cases cannot be corrected by filtration. Knowing this, film manufacturers make professional color films for different exposure ranges: Kodak's Type S is for short exposures and Type L is for long.

Exposures shorter than 1/1000 second occur so infrequently for the large-format photographer that you probably needn't be concerned with reciprocity failure in that exposure range. Large professional strobe lighting equipment usually produces light bursts of longer duration and the leaf shutters com-monly used with large-format lenses rarely have speeds exceeding 1/500 second. If you do encounter very short duration exposures, take the time to test for reciprocity failure with the materials you plan to use before making any important photographs.

You can test your final calculations for expo-sure, including bellows extension and reciprocity failure, with a sheet of Polaroid film (p. 146). But it is a good practice, and an economical one as well, to avoid using Polaroid tests in place of calculation.

When the camera is focused on a close object, the bellows extension is 10 inches. The for-mula for bellows extension factor (BEF) is:

$$\frac{(BE)^2}{(FL)^2} = BEF, \text{ where } \begin{array}{l} BE = bellows\ extension \\ FL = focal\ length \end{array}$$

The factor is 100/36, or about 3. The com-pensation should be made either by multiply-ing the exposure time by 3 or by increasing the aperture by about $1^1/_2$ stops. ∎

4

FILM AND DEVELOPMENT

If you are familiar with roll film, view camera film and its development will at first seem a little awkward. This feeling will quickly subside as you begin to notice the advantages.

THE FILM SYSTEM

One of the major virtues of the view camera is its unique film system. Large-format cameras use film in flat sheets with dimensions that correspond to the nominal size of the camera. For example, 4-inch by 5-inch sheets are used in a 4x5 camera. Each sheet is loaded, exposed, and processed individually so you will have more steps to follow than with roll film, but you will find that the advantages more than make up for this minor inconvenience.

THE ADVANTAGES OF THE FILM SYSTEM

Film in Sheets

The single-sheet film system used for view cameras gives you more freedom than any other system to shift from one kind of film to another. Once set up, many commercial shots are photographed first on Polaroid, then successively on black-and-white, color negative, and color reversal film. Each use for the photograph can then be satisfied with no sacrifice in quality: color transparency to the printer for a brochure, black-and-white prints from a negative for a press release, and color prints from a negative for the office walls.

A Variety of Film

Kodak lists dozens of different emulsions available in sheet-film sizes—more types than are available in rolls—including special-purpose films for scientific, graphic arts, and aerial photography. Many of the available films are not only useful to their intended fields but also provide raw material for the experiments of inventive artists.

Large Film

Another advantage of large-format film, obvious to anyone who has ever seen a print made from a large negative, is the sheer visual quality that results from the great expanse of film. Sharpness, resolution, and graininess, common indicators of image quality in a photograph, are all related to the degree of enlargement from negative to print. A 35mm negative has less than 9 cm^2 of image area and a 6x6cm negative from 120 film has 36 cm^2. A 4x5 negative (10 by 12 cm), however, yields 120 cm^2 of image. These figures mean that, all other things being equal, a print having the same fineness of detail can be made more than thirteen times larger from a 4x5 negative than a 35mm negative. Or, if the same size print is made from both, the resolution, sharpness, and granularity will be many times better from the larger negative. Larger film sizes, such as 8x10, are most often printed by contact for the highest possible image quality. Many artists have elected to work solely with 8x10 for this reason alone. For the advertising photographer, sheet film is often desirable for a client who wishes to see an original at the full size of its use. Larger film is also easier to retouch, although most commercial retouching is now done electronically.

Separate Development

The Zone System, an advanced technique for black-and-white photography, uses controlled exposure and development as a way of adjusting the contrast of a negative and can be used effectively only if development can be varied from one negative to the next. Once you are comfortable with the camera and can begin to explore its expressive uses, study

These outlines are the actual sizes of frames of 35mm, 120, 4x5, 5x7, and 8x10 film. The potential technical quality of a photograph increases with the size of the film. ■

the Zone System to introduce complete tonal control to your black-and-white picture-making. Several good texts are available on the subject.

SHEET FILM STORAGE

Sheet film, sometimes called *cut film,* may be purchased in boxes that ordinarily contain either 25 or 100 sheets (for black-and-white; color film comes in 10- or 50-sheet boxes). Start with a small box: you will find the box itself useful to store and transport small quantities of film after you have exposed all the film in it. The film is contained in a sealed foil package of 25 sheets; 100-sheet boxes contain four foil packs. Unless you expect to use all the film soon after you purchase it, keep large boxes refrigerated or frozen to preserve the film and transfer one pack at a time to a smaller box as you need it. To avoid condensation on the film's surface, allow the cold film to reach room temperature before opening the packet. Give refrigerated film at least 1 hour, and frozen film 4 hours, to reach room temperature. Sealed foil packs are airtight. If you wish to refrigerate an opened pack, reseal the box in a plastic bag first, preferably on a dry day.

The film is packed inside a box made of three nested lids to prevent light leaks. Store your empty boxes (*only* your empty boxes) with the outer two lids nested in the same direction (see illustration below). This keeps out dust, and a glance at the bottom of the box will allow you to tell by the visible edges of the center lid around the bottom of the inner lid that the box is empty.

Sheet film is sold in three-part boxes, nested to assure lightproof storage. ■

When the bottom of a film box shows only one rim, the third part of the box is nested inside. Do not open it in the light. ■

If you store empty film boxes nested this way, the dust will be kept out and you can tell them apart from the boxes containing film. ■

Loading the Film

The Film Holder

Sheet film is sold as raw stock. Before you can expose the film in your camera, you must load it into a reusable lighttight *film holder*, which is inserted for the exposure into the camera's spring back. To develop the exposed film, you must remove it from the holder. Since the film you are most likely to use is either color or panchromatic black-and-white, you will be loading and unloading film holders in complete darkness.

The standard film holder for sheet film is a *double* sheet-film holder. This holder provides space for two sheets of film and has two identical faces each with a shallow compartment to hold the film. Each face has a hinged flap at the bottom to facilitate film insertion and has its own separate *darkslide*, a flat, opaque plastic sheet that slides through a felt-lined slot at the top of the holder and down in tracks along the sides of the film compartment to seat into the flap and cover the film. When the shallow film compartment is covered by the darkslide, the film inside is protected from the light.

After the film holder has been inserted properly into the camera's spring back, the darkslide must be withdrawn before the exposure is made. The black felt in the slot acts as a light trap to block light from fogging the film when the darkslide is withdrawn. Other styles of film holders that may better suit your purposes are described on p. 144, along with more detail on this standard holder.

The Darkslide

When you are photographing you will want to have several holders with you, since each holds only enough film for two exposures. The film holders are all identical and each has two identical faces, so you will need a foolproof system to avoid exposing the same sheet of film twice. In most film-holding systems for large-format cameras there is a darkslide to prevent unwanted exposure when the holder is out of the camera. For standard double sheet-film holders, the darkslide performs an additional task—it gives you a way to tell whether the sheet of film it covers has been exposed.

The top rim (or handle) of the darkslide is black on one side and white (or polished metal) on the other. Run your finger along the white side and feel the short row of bumps or holes. The black side is smooth. These distinctions of color and texture allow you to indicate to yourself whether the film inside the holder has been exposed. White side out indicates unexposed film; black means exposed film or an empty holder. Before you insert a film holder

This is a standard double sheet-film holder for 4x5 film. One of its two supplied darkslides is withdrawn, revealing the compartment for one sheet of film. ■

The white edge of the darkslide, signifying unexposed film, has bumps for identification in the dark. The black side is smooth. On each side of the holder's top there is a small wire clip to prevent inadvertent removal of the darkslide. ■

Each sheet of film has code notches in one corner that indicate the type of emulsion and the side on which it is coated. ■

'CHES FOR KODAK SHEET FILMS
is at the right hand side of the top edge of the sheet,
faces you.

)AK B & W Films	Code Notch
ation Negative 4131, 1 (ESTAR Thick Base)	
on Negative 4133, 2 (ESTAR Thick Base)	
XX Pan 4142 R Thick Base)	
chro-Press 4146,	
rtho 4163 R Thick Base)	
an Professional 4164 AR Thick Base)	
Color Films	
OME 6115, Type	
)ME 6116,	
ME Duplicating	
R Professional 6101,	
R Professional 6102,	
Internegative 6110	
Print 6109	
'pe S	
e L	

The code notches are your clue to which emulsion is on the film as well as which side of the sheet it is on. Each film manufacturer publishes a list of code notches for identification. ■

for exposure, make sure the darkslide has its white rim out. When you replace the darkslide into the holder after exposing the film, leave the black side out. When loading or unloading holders, use the bumps on the white side for fingertip identification in the dark.

Film Code Notches

Since only one side of the film is coated with a light-sensitive emulsion to receive an exposure, you must load the film holder so that the emulsion side of each sheet will face the lens when inserted into the camera's spring back. Because you will be loading holders in the dark, some nonvisual means of identifying the emulsion side is necessary.

Film manufacturers cut *code notches* into the corner of each sheet for identification in the dark. To locate the emulsion side, hold the film sheet by its edges in a vertical position, like a page to be read. Feel the perimeter of the film for the pattern of cut notches. When the notches are in the upper right or lower left corner of a sheet held vertically, the emulsion side of the film is facing you. Slide the film into the holder with that side facing out, to be covered by the darkslide.

The notches also identify the type of film. Each different sheet-film emulsion for use in a camera bears a different pattern of notches. Graphic arts sheet films and others that can be handled in safelight are not notched. Film manufacturers publish diagrams of the code notch patterns for all their films along with other film data in pamphlets or books; the notch code for the film in a box is also usually depicted on the film box label or in the instructions packed with it. If you need to identify the type of a sheet of film, for example, if you have gotten two unmarked holders mixed up, use a pencil to trace the outline of the notches onto paper while in the dark. After you put the film away, you can match the code to the manufacturer's diagram. Once you learn a film's notch code, your fingertips will be able to identify the film immediately. Because of the way the notches are cut into a stack of film during manufacture, they may not always be the same depth, but the shape and spacing will be the same.

How to Load Film

In your darkroom, prepare a very clean work surface free of clutter. To be comfortable you will need at least a meter's width of counter with nothing nearby to knock over. Wash your hands thoroughly with soap and water and dry them completely. Any fingerprints you get on the film during loading will appear as permanent marks during development.

Have only the box of unexposed film and the empty holders in front of you. If your darkroom is warm, keep a clean towel nearby to wipe perspiration from your hands. Withdraw the darkslides almost all the way and leave the white side facing out. Dust the holders using a vacuum cleaner, compressed air, or a clean camel's hair brush and stack them to one side.

Before attempting to load any film you expect to use for a photograph, practice loading your film holder in the light with a piece of scrap film. You may wish to begin with a small box of Tri-X Ortho, a black-and-white sheet film you can load and develop under a 1A (dark red) safelight. This practice will make your transition to working with sheet film more gentle.

Turn off the light and, if working in an unfamiliar darkroom, wait a few minutes to allow your pupils to dilate so you can make sure there is no light leaking into the room. Phosphorescent clock and timer dials, or even the afterglow of some fluorescent lights, can fog film if they are near enough.

Open the film box and nest the three sections in an open position. Remove the foil pack containing the film, tear it open, and remove the film in a stack, holding it only by its edges. Set aside any paper cover sheets and lay the pack of film sideways across the open box, emulsion side down. This way the film will be easy to find and dust won't settle on the emulsion side of the film while you work.

Handling it by the edges, remove one sheet of film from the top of the stack. *Do not touch the*

Make sure your counter is clean and uncluttered before you try to load film there in the dark. Have your film and holders ready and keep a towel nearby to clean and dry your hands. ■

Lay the stack of film across the box it came in with the emulsion side down so it will be easy to find in the dark and stay dust-free. ■

emulsion side and touch the back of the film only if necessary. Flip the sheet so that the code notches are in the upper right-hand corner; the emulsion side will be facing you. Pull down the bottom flap on the holder to reveal the tracks or channel for the film. With 4x5 film, you can hold the film holder in one hand and the film in the other. Larger sizes will probably require you to leave the holder on the counter and hold the film with both hands. Slide the film in and up to the top of the holder. Run a fingernail lightly along the track above the film on each side to make sure you haven't gotten it in the track for the darkslide instead. Remember that the code notches must be in the upper right or lower left corner of the holder so that the emulsion side will face the lens during exposure. With the film in its proper position at the very top of the holder, the flap will close easily. Dust the emulsion surface of the film with a camel's hair brush or compressed air. Slide the darkslide into its closed position; if it seems difficult to close, you may have the film in the wrong track.

Load a sheet of film in the other side of the holder in the same way, load the rest of your stack of holders, and enclose the remaining film in its box before turning on the lights. Although there is probably no advantage to first returning the film to its foil pack, many photographers do. Store and transport the film holders in plastic bags to keep out dust.

If you do not have access to a darkroom, you can load and unload your holders in a *changing bag* made from an opaque cloth. These bags are available from most camera stores, but they are constricting and uncomfortable and will severe dust problems.

Exposing the Film

Sheet film is no different from roll film during exposure. Your method of determining the correct exposure will be the same. You will probably use a light meter (p. 140). Make sure you have read and understood the section on exposure compensations (p. 54). The film holder fits into the spring back to form a lighttight seal with the camera body, and you need to withdraw the darkslide (p. 61) for the exposure and return it (black side out) before removing the holder from the back.

Holding the film by its edges, slide it into the correct slots at the sides of the compartment in the holder. The emulsion is correctly facing out when the code notches are in the upper right or lower left corner of a vertical film sheet. ■

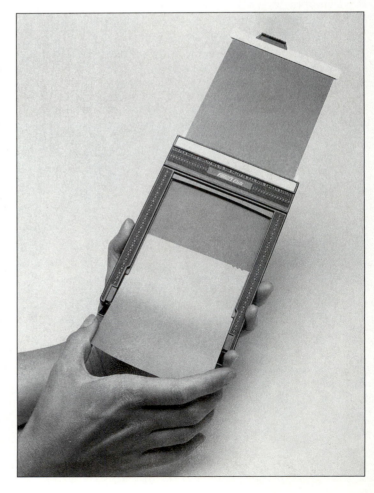

DEVELOPING THE FILM

As you might have imagined, the development of sheet film differs somewhat from that of roll film. The chemical process itself is the same for any size or shape of a specific film, but the procedure for immersing and agitating large-format film in development chemicals will be new to you.

As with any other film format, proper processing of sheet film requires that you: 1. Use the necessary solutions in correct sequence and at a controlled temperature; 2. Agitate the film or solution to promote the same rate of chemical activity over the entire film surface; 3. Wash away all residual chemicals; and 4. Protect the film from extraneous light and physical damage. Several methods of processing will satisfy all of these requirements, and your choice of one will be affected by the kind and quantity of film you use as well as by your equipment and working environment.

The Custom Lab and Quantity Processing

Users of large-format film, particularly color film, often choose to have it processed at a *custom lab.* These commercial darkrooms primarily serve professional photographers and have a large-scale manual or automated film processing setup called a *line.* Named for the linear progression of solutions and for Kodak's brand name of processing chemicals, an E-6 line is for *color reversal* films (positive transparencies, often called *chromes*) and a C-41 line is for color negatives. Most labs also have a black-and-white line.

Color film processing is economical and easily controlled only with large batch processing; only a large-volume studio can justify in-house color development. A discussion of the methods used in processing large quantities of film is beyond the scope of this book, but information on these methods can be readily obtained from retailers serving industrial photographic accounts and from the manufacturers of processing chemicals and equipment.

Many custom labs are now integrated with *service bureaus,* their digital counterparts. Catering to the prepress trade as well as to professional photographers, service bureaus can turn conventional film into digital files, retouch or alter images on a computer, and turn digital files into prints, negatives, transparencies, or color-separation film. Often they also will rent computer time, should you wish to do your own retouching or compositing, as well as digital cameras and adapters (see p. 111). This will give you the opportunity to explore the use of advanced technologies without making a substantial investment in new (and very expensive) hardware.

Small-Volume Methods

Three methods, each based upon a different container, are used for processing small quantities of sheet film: tray development, open tanks with hangers, and closed tanks. At least one of these methods will suit your working habits. The development procedures in this chapter are all tailored for black-and-white film, but may be readily adapted to color. If you expect to develop color film, remember that color chemicals pose a much greater health hazard and require better darkroom ventilation and skin protection. Since most color processes require solutions to be much warmer than ambient (room) temperature, it is more difficult to maintain the chemicals at a constant temperature. Maintaining the temperature of the warmer solution is made even more difficult by introducing room-temperature objects such as film and hangers into it. Since small variations in temperature will produce more noticeable changes in color film than in black-and-white, you will have to pay much greater attention to controlling the temperature when developing color film.

Tray Development

If you already have a working small-format darkroom, you can develop your first sheets of film in your print-processing trays. The technique is much the same as that for developing prints, and you will need no additional equipment. The room must be lighttight, of course, as the film will be in an open tray for several minutes. Even a slight light leak can spoil your results with fog.

Setting Up. Use trays at least one standard size larger than your film: 5x7 trays for 4x5 film, 11x14 trays for 8x10. Until you are experienced in tray development, you will probably be more comfortable with trays two sizes larger than your film. Lay out five trays in the sink so that you can easily find them in the dark and determine which is the first in the sequence. The first tray should be plain water at the same temperature as the developer, followed by trays containing the developer, stop bath, and fixer, and a final tray of water.

Of the three methods used for processing small quantities of sheet film, tray development will allow you to use the minimum amounts of chemicals. Depending upon the capacity of your chosen film developer, you can use as little as 75ml per sheet of 4x5 film (20 square inches), or 300ml per sheet of 8x10 (four times the area). The solution in the tray must be deep enough to allow your hands some freedom of movement below the surface. You will want to practice developing some scrap film to learn how much solution you will need.

Hold the stack of film sheets in your left hand, keeping them under the surface of the liquid but not resting on the bottom of the tray. ■

With your right thumb, gently separate the bottom sheet from the rest by peeling it down slightly. ■

Slide the bottom sheet out from under the stack. Make sure you don't scrape it on the corner of the stack on the way out. ■

The agitation procedure for developing more than one sheet at a time requires you to touch the film constantly during processing. The gelatin emulsion is extremely soft and fragile when wet and you must exercise caution throughout the process to avoid damaging it. Short fingernails and extreme vigilance are advisable. Also, your hands will be immersed in the processing chemicals, so if your skin is sensitive to photographic chemicals, wear surgical gloves. The thinner the gloves, the better; your tactile sense is your only guide in the dark.

The presence of your hands in the developer will change its temperature. Using stainless steel or enamel trays for your chemicals and surrounding them with a water bath will help keep the temperatures constant. If you don't use a water bath, measure the temperature of the developer after processing your first test sheets to determine any change. If the temperature has increased, you may need to decrease development time slightly to compensate. Try using the time from the film's developer/time/temperature chart that corresponds to a temperature halfway between beginning and ending temperatures. You should also set your stop bath and fixer at the higher temperature to prevent minor reticulation, a surface effect of temperature change on the film that resembles increased graininess.

Agitation and Processing. After your trays have been set up, make sure your hands are clean and dry before turning off the lights and removing the exposed film from your holders or storage box. Make a stack of all the sheets you plan to develop and hold the stack by the edges in one hand. With the other hand place the sheets one at a time, emulsion side up, in the first tray—a water presoak. Wait for each sheet to sink below the surface before adding the next. From the time you place the sheets in water until they are hung up to dry, they should be kept moving. If you allow one sheet to settle on another in the tray for very long, even in water, the edge of one sheet can leave a permanent mark on the other.

A water presoak of a minute or longer with agitation will prevent *air bells,* the circular marks caused by bubbles clinging to the film during development. It will also give you time to ensure that none of the sheets have stuck together. If you inadvertently place two sheets in the tray simultaneously, they will indeed stick together. In the developer, this is a catastrophe; in the presoak, merely an annoyance. Slowly peel the two apart, holding them underwater and taking care not to scratch other sheets in the tray.

The agitation procedure for sheet film in a tray (shown in the illustrations on these pages) requires the constant repetition of a series of motions cycling each sheet through the stack from top to bottom. The corners of one sheet, as well as your fingernails, can scratch the soft emulsion on another sheet. Preventing scratches in the film's emulsion is easier when you process fewer sheets and have deeper solutions in the trays. Practice developing four sheets of film in trays at least half full. After you become proficient with four, you will be able to increase the number of sheets you can develop at one time without damage. Although it is possible to achieve satisfactory results with more, eight sheets is a comfortable maximum for most people.

Once the film sheets are all in the pre-soak, gently arrange them into a stack with the emulsion side up. Keep the stack off the tray bottom by holding the fingers of one hand, palm up, under the film. If you are right-handed, you will probably use your left hand for this. For the rest of the process, handle the film only by the bottom (the backing side) and edges.

With the fingers of your left hand under the stack of film, separate the bottom sheet from the rest by pulling down one corner with your right thumb. Carefully slide the sheet out, lift it out of the solution, and replace it on top of the stack. Push the whole stack down gently with your right palm to immerse the top sheet. Repeat this procedure every 3 to 5 seconds for the duration of the 1-minute presoak. At the end of the minute, lift the stack of film out of the water tray and drain it for a few seconds. Place it in the developer, start the timer, and begin the agitation cycle again.

While the film is in the developer, the warmth and extra agitation generated by your fingers in handling the film can be a source of uneven development. Rotate the stack or the entire tray 90° each minute of development so that you handle each corner instead of just one. The more sheets you develop at once, the higher the risk of uneven development; keeping the film in a stack prevents fresh developer from reaching the center of each sheet until it comes around for agitation.

Ten seconds before the correct development time is over, remove the stack of film by the edges and drain by one corner. Place the stack into the stop bath and agitate in the same pattern as you used in the developer. Drain again, transfer to the fixer, and agitate in the fixer for the appropriate time. After fixing, the film will need to be washed.

Place the sheet on top of the stack, taking care not to scratch the sheet directly below it with a corner. ■

Gently push the stack down to submerge all the sheets, then begin the process again with the bottom sheet. ■

Drain the stack by one corner before transferring it to the next solution. Always hold the film by the edges when possible. ■

Washing and Drying. If you wish to wash the film in trays, transfer the stack to a tray of fresh water at the same temperature as the developing solutions. One sheet at a time, transfer the film to a second tray of water. Empty the first tray, refill it with water, and transfer the film back to the first tray one sheet at a time. Empty the second tray, refill, and repeat this sequence for the duration of the wash time. Other methods used to wash sheet film are described later in this chapter.

In a tray, soak the washed film in a wetting agent, such as Photo-flo, mixed with distilled water. Using distilled water with the wetting agent will help prevent water spots. Then hang each sheet by one corner from a clip or clothespin to dry in a dust-free place. Do not use a squeegee on the film to remove excess wetting agent; it is unnecessary and can easily damage the film.

Tank Development

If you wish to keep your hands out of chemicals entirely, consider using the tanks-and-hangers method. The extra equipment you will need includes *sheet-film hangers* and *sheet-film developing tanks*.

A hanger is a stainless steel or plastic frame designed to hold the film by its edges. Different sizes of hangers are available to hold each of the standard film sizes (4x5, 5x7, and 8x10) and to fit inside the readily available sheet-film developing tanks. Hangers that fit 8x10 tanks and hold four sheets of 4x5 film are also available. Each frame has a handle that allows you to agitate and transport the sheets. The handle on each hanger frame is a bar that fits across the top of the tank; the film hangs suspended from the handle into the tank. Since you must fill each tank with enough liquid to immerse the entire sheet, you will use considerably more of each chemical than with the tray method.

Sheet-film developing tanks are made of stainless steel, hard rubber, or plastic in sizes corre-

After washing and then a rinse in a wetting agent, hang each sheet by one corner to dry in a dust-free place. ■

With sheet-film hangers, you can develop film without handling it and without having your hands in chemicals. The empty hanger shows its loading clip in the open position. ■

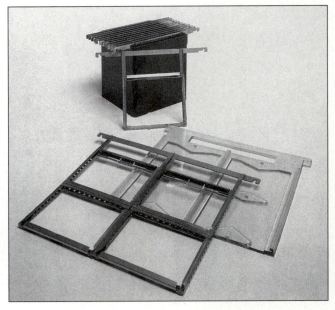

Hangers and tanks are made for each common size of sheet film. Most are stainless steel. The large hangers hold four sheets of 4x5 film and fit a tank made for 8x10. ■

sponding to the hanger sizes. You can also buy water-jacketed stainless steel tanks that use a constant flow of tempered water for precise control of processing temperatures. Tanks are made to accommodate only a certain number of hangers; the smallest tanks hold a maximum of six, larger ones hold up to 12. As you will see when you try tank development, the size of your hands may be the limiting factor on how many sheets you can develop at once.

Tanks are available with airtight tops or with lids that float on the surface of the chemical to reduce its contact with the air. Covering the tank slows evaporation and oxidation (which spoils developers). If you use a developer that can be replenished after each use and if you keep it from oxidizing, you will not need to prepare developer before each processing session. The developer (and the other chemicals) can be left in the tank for storage. If you expect to develop film frequently, tanks-and-hangers processing allows you to have all the chemicals ready for immediate use at any time.

Setting Up. For tank development, you will need one empty tank in addition to the four—presoak, developer, stop bath, and fixer—for processing. Begin by filling the tanks with your processing chemicals at the correct temperature and setting them out in order. The dry, empty tank should be on the counter next to your empty hangers and the film holders containing the exposed film.

Once the tanks are filled and everything is in place, turn off the light and load the hangers in the dark. One at a time, pry back the covering clip on the hanger, slip the sheet into the frame of the hanger, cover it with the clip, and place the loaded hanger in the dry tank (or in a rack designed for the purpose). When all are loaded properly, lift them out by supporting the protruding ends of the handles along your index fingers, palms facing each other, and lower them carefully into the first tank. Because the film sheets won't stick together, a water presoak is not as important here as it is in tray processing, but a presoak with occasional agitation may still be used to prevent air bells and promote even development.

Agitation and Processing. Agitate the film by lifting all the hangers simultaneously, supporting the handles along the sides of your index fingers. Slowly lift and tilt the hangers to one side until all of the film sheets are out of the solution and draining from one corner. Slowly lower them back into the solution again and repeat the lifting and tilting motion, tilting to the opposite side. This operation of two lift-and-tilt cycles should take not less than 15 seconds. It should be repeated continuously for the first minute and once during each remaining minute of

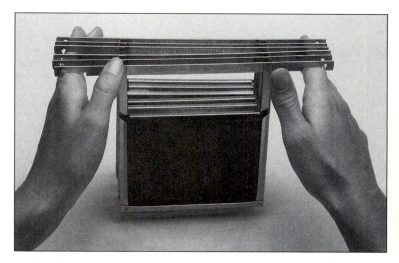

Hold and carry hangers between your hands. Be careful not to scratch the film with a sharp corner. ■

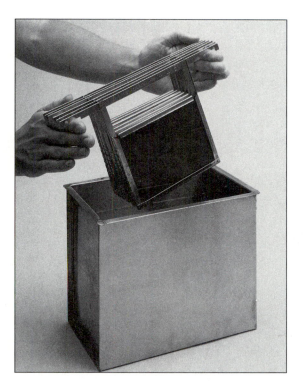

To agitate the film, lift the hangers out of the tank slowly and drain them for a few seconds in this position before returning them slowly into the tank. Then repeat the action, draining them to the other side. ■

development. Moving the film too rapidly during agitation will produce uneven development at the film's edges. Too little agitation can streak the film (the streaks are called *bromide drag*), although this problem is much less common. Use this agitation pattern and your standard times for the stop bath and fixer.

This daylight tank contains two reels, each with a capacity of six sheets of 4x5 film. It can be agitated by a mechanized roller base. The optional loading platform simplifies this tricky procedure. ■

Special-purpose film washers like this one provide a thorough washing to untended film left in them in hangers. ■

Jobo's system of motor-driven processors uses drums like this one that holds up to six sheets of 4x5 film. Drums are available for larger quantities and for other sheet-film and print sizes. The mechanized system provides consistent even development and reduces the potential for physical damage to the film. ■

Washing and Drying. Wash the film with water by repeatedly filling and emptying the tank, or use one of the specially designed sheet-film washers. Many of the vertical print washers on the market can be used for film in hangers if you remove the interior dividers.

After immersing the film in a wetting agent, hang the film to dry and thoroughly rinse the film hangers and tanks with plain water. Wetting agent allowed to dry on the hangers can affect the results of the next batch of film by accelerating development at the film's edges.

Daylight Developing Tanks

If your darkroom will not accommodate tray or tank processing, if you are processing film while traveling, or if you have a strong aversion to working in darkness (and insist on processing your own sheet film), you may use one of the several closed-tank systems available for sheet film.

Similar to roll-film developing systems, these *daylight tanks* allow liquids to be poured in and out through a light trap, and total darkness is needed only for loading them with film. Usually made for 4x5 and smaller sheet film, most daylight tanks will hold a maximum of six or eight sheets. For 8x10 sheet film, you can use a daylight processing drum made for color print processing to develop one sheet at a time. Because each daylight developing tank has its own system for holding the film in place, each requires a different procedure for loading, and all tanks come with directions. Some manufacturers

make and recommend accessory loading devices to make the job easier. Except for adjusting the time in the developer slightly to compensate for the different agitation pattern, your normal sequence of chemicals and times will be correct for daylight tank development.

Intermittent agitation during development in a closed tank is likely to result in uneven development, despite the claims of the tank's manufacturer. For the most even development possible with any closed-tank system, fill the tank halfway and agitate it vigorously, constantly, and in a random pattern, including complete inversion. Using a full tank and an agitation pattern similar to that for roll-film tanks, agitating for five seconds each minute, you will get results with slightly finer grain, but will risk streaks or overdevelopment at the film edges. The instruction sheet packaged with the film will give you development times for trays using constant agitation and for tank development with agitation at one-minute intervals. The time for constant agitation in a tank will be slightly less than that for tray development. Make sure you run tests before developing any important film.

You can wash film in the tank by repeatedly filling it with water and emptying it, or you can remove the film to wash it using any of the methods previously mentioned.

For complete uniformity during development, or for developing larger quantities of film, Jobo makes a system of film drums—like large daylight tanks—that may be used manually or with one of their automated processors. For a modest investment in equipment, they allow you repeatedly to produce evenly developed, scratch-free negatives.

Storing Negatives

Once your processed film is dry, transfer it to a safe package for storage and preservation. Negatives must be protected from heat, humidity, physical damage, and airborne pollutants, particularly sulfur compounds. For the most permanent, or *archival,* storage, only inert plastics such as polyethylene and polyester should touch the film. Currently, the safest material for negative storage is uncoated polyester (Mylar) with a frosted surface.

Special transparent polyethylene storage pages are made to accommodate sheet film in standard sizes. Punched to fit a three-ring binder, each page holds four 4x5 negatives, two 5x7 sheets, or one 8x10. Because the storage sheets are so pliable, a flat box is probably a more suitable container for these pages than a three-ring binder. Negatives stored in transparent polyethylene can be damaged by *fer-*

Your negatives will be protected from most environmental damage if kept inside polyethylene or polyester sleeves inside boxes made of acid-free cardboard or polypropylene. Keeping the boxes inside polyethylene bags will further protect the negatives against accidental spills or leaks. In the foreground at top is a Mylar sleeve with its acid-free paper envelope. These sleeves provide the safest, most inert surrounding for film. ■

rotyping, the tendency for gelatin to conform to a surface in contact with it. Under very humid conditions and some pressure, negatives in polyethylene pages can develop glossy areas from touching the plastic, so don't stack too many sheets together in a box. Acid-free paper envelopes and folders may be a satisfactory option, although those made acid-free by buffering are of questionable long-term value,

A contact-printing frame will hold your negative in close contact with the print material. ∎

This 4x5 negative carrier grips the negative by two sides and stretches it flat for exposure. Larger negatives, particularly ones on thin plastic bases, can swell and buckle from heat during exposure, creating unsharp enlargements. ∎

and sliding negatives in and out of a paper sleeve may cause physical damage. Never use glassine (a translucent paper) or ordinary paper for long-term storage.

PRINTING

After seeing the prints from your first large-format negatives, you will wonder why anyone would use roll film. All the benchmarks of photographic quality—resolution, detail, sharpness, and fine grain—are the visual evidence of your chosen camera. And elaborate enlarging equipment is unnecessary because the negatives themselves are large; Edward Weston's finest prints were made in a simple contact frame under an ordinary light bulb.

Large-format cameras flourished in the nineteenth century when all prints were made by *contact:* placing the negative in direct contact with a sheet of paper to make a positive image on the paper the same size as the negative. The larger the negative, the larger the print. Enlarging reduces quality by spreading the visual information from a negative over a greater area. The greater the degree of enlargement, the lower the image quality. But a print made by contact is faithful to the negative, retaining all the possible delicacy of tone and crispness of edge.

As a user of a large-format camera, you have the best of both worlds. You can contact-print your negatives for the highest quality, or enlarge them to any size with a lesser degree of enlargement (therefore less loss of quality) than with any smaller format. Other than the large size of the negative, all aspects of the printing procedure are identical to those of printing smaller film.

Printing by Contact

In addition to a conventional workspace—darkroom with safelight, trays, and chemicals—all you will need for printing by contact is a sheet of glass and a light source that can be turned on and off to make a correct exposure.

Holding the negative in close contact with the paper is as simple as covering the two, emulsion sides facing, with glass; the weight of a sheet of plate glass slightly larger than the paper should be sufficient. To avoid undesirable marks on the final print, make sure your glass is free of scratches, blemishes, and dust. Occasionally, usually with very thin or very large negatives, some areas of the resulting print will be unsharp from uneven pressure. If this happens, use a thin sheet of foam rubber under the paper, or use a *contact-printing frame.* This simple frame holds a sheet of glass and a backing board (and between them the negative and paper) together with pressure from springs.

Almost any light source will suffice for contact printing. The overhead light in your darkroom, a desk lamp, or even a match can be used, but an enlarger is ideal since it was designed to distribute light very evenly and can be switched on and off accurately with a timer.

Printing by contact allows you to use a broader range of materials on which to print. With a large negative and a brighter light source, you can use slow, rich-toned silver chloride printing-out papers or any of the early printing materials such as platinum, gum bichromate, or cyanotype. These printing materials need exposures to light as bright as the sun and rich in ultraviolet, such as a carbon arc or sunlamp, so an enlarger cannot be used. The amount of light that is safe to use in an enlarger is limited because the negative must be close to the source of light (therefore close to the source of heat). A bright enough enlarger light to expose these slow materials would produce too much heat too close to the fragile negative and burn it.

Enlarging

Most professional enlargers will accommodate film sizes up to and including 4x5. An enlarger designed to produce even illumination and to be sturdy enough for 4x5 film will also usually be more satisfactory for smaller negatives than a smaller enlarger. Because most professionals today use either 4x5 or 8x10, enlargers capable of handling a 5x7 sheet have become uncommon. An 8x10 enlarger is as much an investment as buying a new car, and much more difficult to move.

Most enlargers for film sizes larger than 4x5 have a *diffusion* light source, named for the sheet of opal glass or translucent plastic immediately above the negative that provides even illumination by diffusing the light falling on it from above. The alternative, a *condenser* light source, uses a set of lenses above the negative stage to concentrate the light and project it straight down.

A diffusion light source will produce an image of lower contrast than that of a condenser, and spots on the print from dust and surface defects are greatly diminished. This is a great advantage since the glass-sandwich negative holder that is often necessary to hold a large negative flat during printing adds four dust-collecting surfaces to the two on your film. Some diffusion enlargers use fluorescent tubes instead of incandescent bulbs and are called *cold-light* enlargers. A cold-light source prevents problems due to heat, notably buckling or *popping* of the negative during exposure, but the limited output spectrum of the light can interfere with the effective use of variable-contrast or color enlarging papers.

An enlarger is an ideal light source for contact printing. The light is adjustable and even, and your timer will allow precise and repeatable exposures. ■

LENSES AND SHUTTERS

When you buy a 35mm camera, it is packaged with a lens from the same manufacturer. You will probably, however, use your view camera with a lens made by a different company and a shutter from a third.

LENSES

Selecting a lens, or a set of lenses, for your view camera requires more care and knowledge than for any smaller-format camera. Large-format lenses are among the most expensive objects in any photographer's studio and the array of possible choices can be intimidating, but it is just this variety that makes the view camera an ideal professional tool.

If you are already a serious user of smaller cameras, it will seem strange to you that none of the manufacturers of large-format cameras also makes lenses. When you buy a 35mm "system" camera, you naturally choose from lenses of the same brand. You are assured there will be no mismatch mechanically, optically, or electronically. There are no such guarantees with a large-format system.

It is possible, and in fact common, to use one lens for both a 4x5 and an 8x10 camera, or on a press camera one day and on a monorail the next. It is also possible for another lens to work properly for 4x5 and be almost useless for 8x10. Also, unfortunately, a lens that is suitable for one photographer working with 4x5 may not be satisfactory for another photographer using the same equipment.

Basically, you can mount any lens on your camera by having a hole of the correct diameter drilled in a relatively inexpensive lensboard and threading on a retaining ring. Having a lens mounted correctly, however, does not mean it is the correct lens. To determine the correct lens, you must know your own needs and have a general understanding of the characteristics of lenses.

Information about lenses can fill volumes, most of it incidental to their actual use. This chapter includes everything you will need to know about optics to make photographs with a view camera. When you have read and digested this information and are comfortable with the terminology, read Chapter 7. In it you will find a more in-depth treatment of the design and history of lenses. Many lenses made before you were born are perfectly useful today, and they are bargains as well. You will want to make an informed decision when buying a lens; since many of the lenses made since the turn of the century may be included in your possible choices, the more you know, the less you may have to spend.

The array of lenses you can use on a view camera is wider than for any other kind of camera, but you must know more about them than just how to mount one on the camera. ■

COVERAGE

Before learning anything further about lenses, you will need to be familiar with the term *coverage*. All lenses project a cone of light. When this cone is intercepted by a flat surface, such as film, it forms a circle. To be useful, this circular image must be large enough to "cover" the film size you are using. A lens for a 35mm camera must project a circle large enough to fit around the 24x36mm frame. The smallest circle that will cover 35mm film has a diameter the same as the frame diagonal, about 43mm. In order to photograph onto 35mm film, then, a lens must have a *covering circle* (or *circle of coverage*) with a diameter of at least 43mm and must be mounted so that its center, or optical axis, is lined up with the center of the film frame. This lens position is assured by the design of fixed-body cameras like the 35mm SLR. Your view camera, however, offers no such guarantee.

In Chapter 3 we found that one of the virtues of the view camera is that its movements allow the user to move the film away from the optical axis. With a lens like the one described above, having a covering circle just fitting around the frame, any camera movement would cause the image to miss part of the film's edge. That is, the projected image would fail to "cover" the film. If you wish to take advantage of your view camera's movements, you need a lens with a covering circle larger than the film. The more extreme the movements, the larger an image circle you need. The size of the circle of coverage is affected by aperture, lens design, image distance, and focal length, all discussed below.

Circle of Good Definition

The circle of coverage of a lens can be defined in two ways. The *circle of illumination* is the entire circular image with edges defined by a sharp cutoff of light caused mostly by vignetting (or shading by the opaque parts of the lens). The *circle of good definition* is the useful part of the projected field of a lens. It is concentric within the circle of illumination—smaller and less obviously defined. Although the circle of illumination can be considered a covering circle, most measurements equate the circle of good definition with the circle of coverage because only inside the circle of good definition does an image have sufficient *resolution* to be considered useful. Resolution is a measure of optical quality based on the ability of a lens to distinguish two small, close-together points from a single point (if you wear eyeglasses, chances are it is to increase the resolution of your eyes). For our purposes, we will use the term circle of coverage to mean the circle of good definition.

Because of its fixed position in relationship to the film, the lens of a 35mm camera need only just cover the rectangular frame. ■

The minimum covering circle for a lens for 35mm has a diameter of 43mm. ■

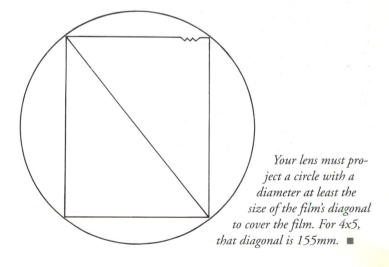

Your lens must project a circle with a diameter at least the size of the film's diagonal to cover the film. For 4x5, that diagonal is 155mm. ■

The lens used by Eugene Atget to make this Parisian street scene in 1924 projected a circle a little too small to allow the slight lens rise he employed. Atget disguised part of the resulting vignette in an architectural detail. ■

Aperture and Coverage

Most lenses project their highest resolution in the center, with the image quality deteriorating as it moves toward the edges. Closing down the diaphragm (stopping down) generally increases resolution off-axis (away from the center) and enlarges the circle of good definition, both of which reach a maximum at a middle aperture, often f/22. Lens manufacturers measure and state in their literature the maximum coverage (or largest circle of good definition). Occasionally they will also list the minimum coverage, at full aperture.

Lens Design and Coverage

The working aperture is not the only factor affecting the size of the usable image circle (or covering circle). Some lenses are designed to have large covering circles while other lenses that may look similar are not. It is common to define the intrinsic coverage of a lens (a measure unaffected by the way the lens is used) by an angular measurement called a *field angle*. The field angle defines the shape of the cone of light projected from the rear of a lens that forms the covering circle at the film plane. Lens designers refer to the field angle as the *full-field angle* because they also use in their measurements the angle measured from the optical axis, called the *half-field angle*. You will probably see only the full-field angle quoted in any lens manufacturer's literature.

Few lenses used for view cameras have a field angle less than 55°, and the most common have field angles of 70°. The widest field angles for off-the-shelf lenses are just over 100°. Using a normal focal-length lens with a 70° field angle will give you a covering circle adequate for all but the most extreme movements. Chapter 7 tells how field angle is related to lens design and what coverage to expect from most of the available lenses.

The circle of coverage that is useful for photographing is the inner circle, slightly smaller than the entire projected circle of illumination. The image in the outer fringes of the circle of illumination can never be brought into good focus. ■

Below: Use this chart of coverage, field angle, and focal length to determine one of these values from the other two. ■

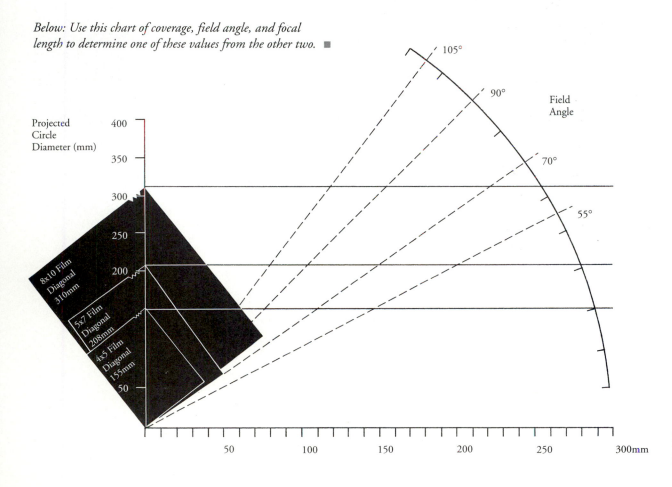

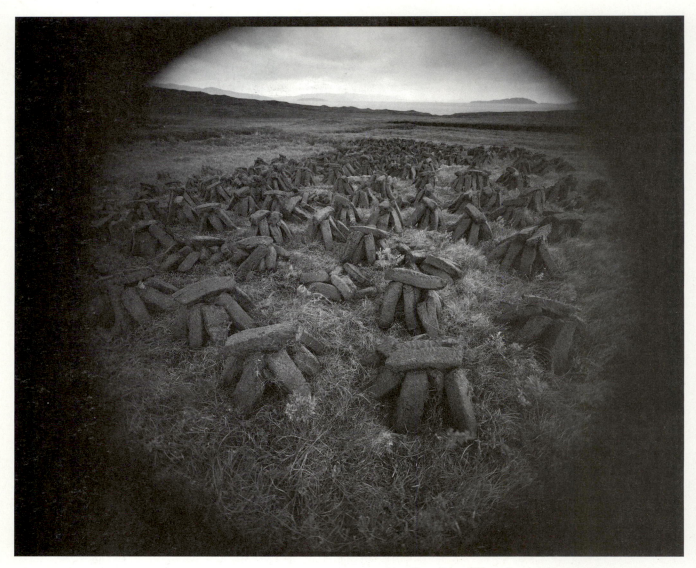

Peat, Isle of Skye, Scotland, 1972. *Emmet Gowin mounted a lens for a smaller camera on his 8x10 to make a series of photographs using the entire projected image circle. He has written that the use "of such a lens contributed to a particular description of space and that the circle itself was already a powerful form. Accepting the entire circle . . . involved a recognition of the inherent nature of things."* ■

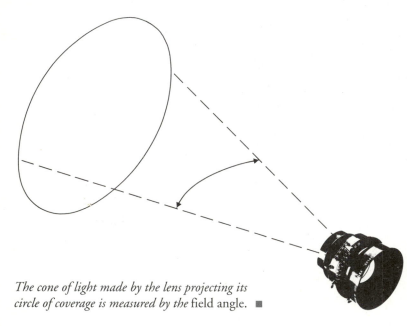

The cone of light made by the lens projecting its circle of coverage is measured by the field angle. ■

Focal Length and Coverage

When a point in front of the camera is in focus, the distance from it to the lens is called the *object distance;* the distance from the lens to the film is the *image distance.* For any object distance, there is a corresponding image distance. Focusing the camera means you are selecting an object distance by changing the image distance—by moving the film closer to or farther from the lens. As the object distance increases the image distance decreases, and vice versa. The shortest possible image distance corresponds to an object at infinity; for any lens this minimum image distance is called its *focal length.* Strictly speaking, the image distance is measured from the *rear nodal point* of the lens to the film (the rear nodal point is the point in the lens from which all the light seems to emanate; see Chapter 7). We cannot locate exactly the rear nodal point without specialized optical equipment, but for our purposes we may use the rear of the lensboard as a close enough approximation of its position.

The focal length of your lens directly affects the size of the image circle. For lenses of the same design, regardless of focal length, the field angle is the same. Therefore, the shape of the projected cone of light is the same. The size of the covering circle, however, is not the same. The longer of two lenses having the same field angle and focused at the same distance will cover a larger area because the film plane slices the cone of light farther from the lens. For example, a 150mm Nikkor-W has exactly the same field angle as a 300mm Nikkor-W: 70° at f/22. Measured also at f/22, the diameter of the image circle for the 150mm lens is 210mm, while for the 300mm lens it is 420mm. In this example, twice the focal length, with the same field angle, gives a covering circle twice the diameter.

Along with object distance, focal length determines the size the image will be on the negative. A longer lens makes a larger image for the same reason it projects a larger covering circle. Slicing the projected cone of light with the film at a greater distance makes every part of the image larger (for example, imagine moving a slide projector farther from its screen). For any object distance, a longer lens has a proportionately longer image distance than a shorter lens.

When a point in front of the camera is in focus, the distance from it to the lens is the object distance *and the distance from the lens to the film is the* image distance. ■

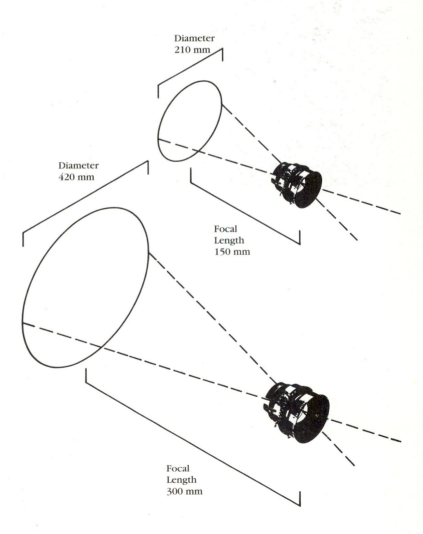

Of two lenses with the same field angle, the one with a greater focal length will have greater coverage. Doubling the focal length produces a covering circle with twice the diameter. ■

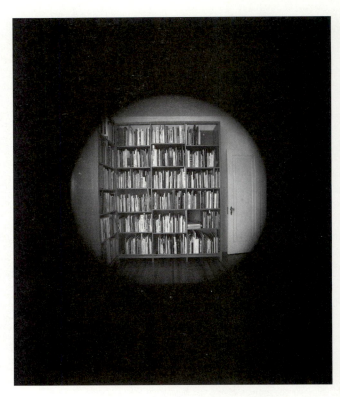

To make these three photographs, a lens from a 120 roll-film camera was mounted on an 8x10. The first photograph was taken from a distance of several meters and the size of the image circle is essentially that of infinity focus. The second photograph, from an object distance of less than a meter, shows slightly increased coverage from the increased image distance. The third, from an object distance about twice the 80mm focal length of the lens, required a much longer image distance. The greater the image distance, the farther the film is from the lens when it slices the projected cone of light and the larger the covering circle. ■

Image Distance and Coverage

Shortening the object distance also has the effect of enlarging the covering circle by increasing the image distance. For any lens, one focal length is its shortest usable image distance, corresponding to the greatest possible (infinity) object distance. As the object distance decreases from infinity, the image distance increases. In other words, as the object you are focusing on moves toward the camera, the distance between lens and film must increase for the object to remain in focus. An increase in image distance increases coverage in the same way that an increase in focal length does; a circle sliced from the projected cone of light gets larger as the distance of the slice from the lens increases. Focused at infinity, your lens has its least coverage.

Magnification ratio is the ratio of the size of the image to the size of the object. A magnification ratio of 1 occurs when image distance and object distance are equal—the image is the same size as the object. This is also sometimes called a 1:1 reproduction ratio. At 1:1, the image distance and object distance are equal and each is two times the focal length, using any lens. The covering circle then is twice its normal diameter. This enlarged covering circle means that for reproduction ratios around 1:1, you can use a lens with half the field angle or half the focal length you would need to use for distance. For closer work—for magnification greater than one—you can use even shorter lenses. For example, a lens with insufficient coverage for landscape use on 4x5 could be a satisfactory close-up lens for 8x10.

Angle of View

Angle of view determines how much of your subject is included in a photograph. Like the field angle, the angle of view is also an angular measurement of a cone, but the cone in front of the lens. Angle of view is a result of both focal length and film size; if you use the same focal-length lens to photograph the same scene from the same place on two different-sized pieces of film, the smaller film will record a smaller piece of the image, and consequently a smaller piece of the world. The smaller film produces a smaller angle of view. If instead you use two different focal-length lenses to photograph from the same place on two pieces of film the same

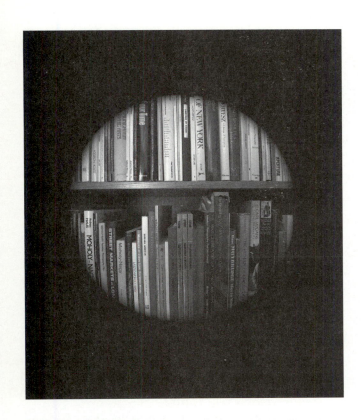

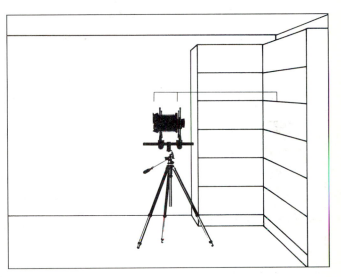

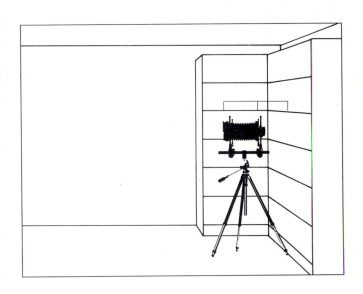

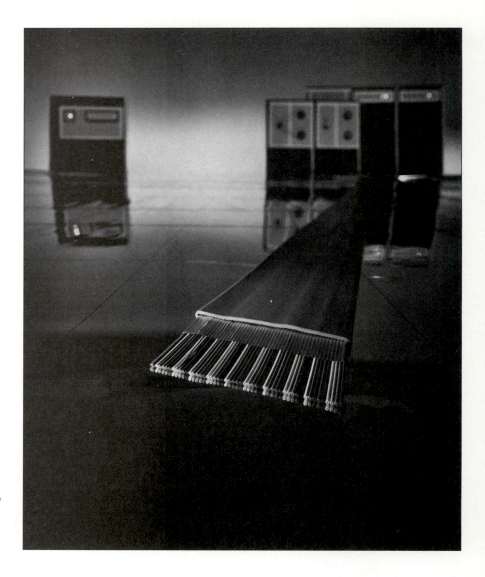

The object distance was so short, less than 100mm, that photographer Steve Grohe could use a 65mm lens designed for 4x5 to make this photograph on 8x10 (originally in color) and still have a covering circle larger than the film. ■

size, the longer lens will record a smaller piece of the world because the image projected on the film is larger. The longer lens produces a smaller angle of view.

For any lens/film-size combination, the angle of view equals the smallest usable field angle for that focal-length lens—this field angle projects a circle with a diameter equal to the film diagonal. To just cover 4x5 film, for example, a 90mm lens needs a field angle of 81.5°, a 180mm lens needs a field angle of 46.6°. These angles tell you how much of the world each lens sees from any camera position. Notice that these two angles are *not* related by a factor of two, even though the focal lengths are. The diameter of the covering circle is proportional to the *sine* (a trigonometric ratio) of the field angle. The angle of view also gives you a clue to how much

extra coverage (to accommodate movements) you have with the lens you are using, for example, a 90mm lens with a field angle of 100° or a 70° 180mm lens. The table on p. 77 shows the relationship between field angle or angle of view and covering circle or film size.

A 90mm lens on 4x5 film has the same angle of view as a 180mm lens on 8x10, the longer lens making an image twice as large on film having twice the dimensions. Having the same angle of view, these focal-length/film-size combinations make images that appear the same, and both lenses need the same field angle to cover their respective films.

Comparisons of angle of view are difficult to make between formats with different *aspect ratios,* or frame shapes. If you try to find the lens for a 35mm

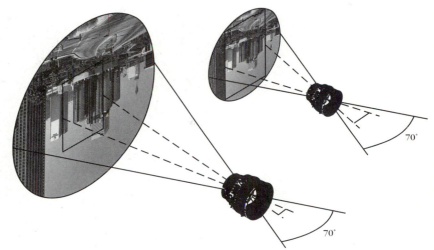

With two lenses of the same design (therefore the same field angle), the longer focal length projects the same image into a larger circle. With a piece of film the same size behind each lens, the one behind the longer lens will have an image of a smaller piece of the world. A longer lens, therefore, has a smaller angle of view than a shorter one in any given format. ■

camera that has the equivalent angle of view of a 180mm lens on 4x5, you will get too many correct answers because the 4x5 frame is a different shape from that of the 35mm. The angles of view across the short dimensions of each rectangle will be equal if you use a 45mm lens on the small camera. The long dimensions will have the same angle of view if you use a 55mm lens, and the diagonals have the same angle of view with a 50mm lens.

How Lenses Influence Perspective

Perspective, as we have found, refers to the relative sizes of objects and depends upon vantage point. Because of the difficulty of exactly translating three dimensions to two, the perspective in a photograph will be exactly the same as the eye would see from the lens position *only* if the angle of view of the lens is exactly the same as the angle of view of the eye viewing the resulting photograph.

The angle of view of the eye viewing a photograph depends on the size of the print and its distance from the eye. So for a given print, the eye's angle of view will match that of the taking lens at only one viewing distance. To reproduce the exact perspective of a scene, then, a contact print—exactly the size of the negative—must be viewed from a distance the same as the lens was from the film when the picture was taken: the image distance. Enlarging the negative will have the same effect on correct viewing distance as using a longer focal-length lens; viewing distance for exact perspective will increase in proportion to the degree of enlargement.

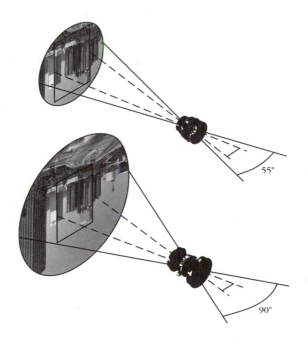

With two lenses of different designs but the same focal length, the one with a wider field angle projects more of the same size image. Using the same size film with each will result in exactly the same picture. For any given film size, all lenses of the same focal length (as long as they cover the film) have the same angle of view. ■

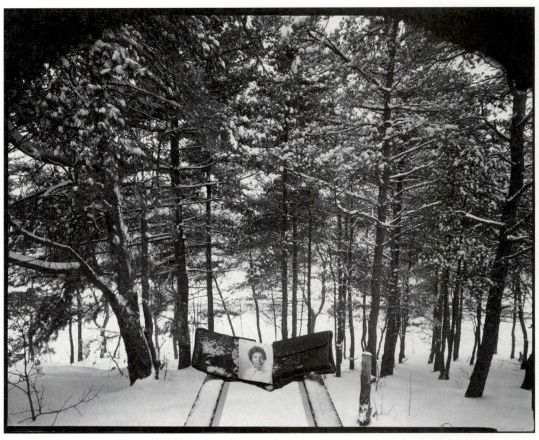

Bart Parker made these two photographs with the 8x10 camera shown below. In each case the object—the Coke can and the wallet with photograph—rests on the end of the camera's base. To include these close foreground objects in the plane of focus required an extreme lens tilt, which is why dark, circular vignettes appear at the top of each photograph. The modern 120mm wide-field lens Parker used is considered a wide-angle lens even on the smaller 5x7 format and the projected covering circle was not large enough for this extreme angular displacement with the larger film. The smaller circle produced the vignetting intended by the artist to enhance the power of the photographs. ∎

It may not seem necessary to think about reproducing perspective so exactly in your photographs, but you should be aware of the interrelationship of focal length, film size, degree of enlargement, and viewing distance and of their effects on the appearance of perspective in your photographs. Most viewers of a photograph will automatically (and unconsciously) adjust their viewing distance to the size of the print, moving farther away from a larger one and closer to a smaller one. Most viewers find a comfortable distance to be approximately the same as the diagonal of the print. From this viewing distance, the exact perspective will be assured by making the photograph with a lens having a focal length equal to the film's diagonal. That is why this focal length is referred to as *normal* for its format. It is important to understand that any photograph will reproduce exact perspective from some viewing distance, but that dis-

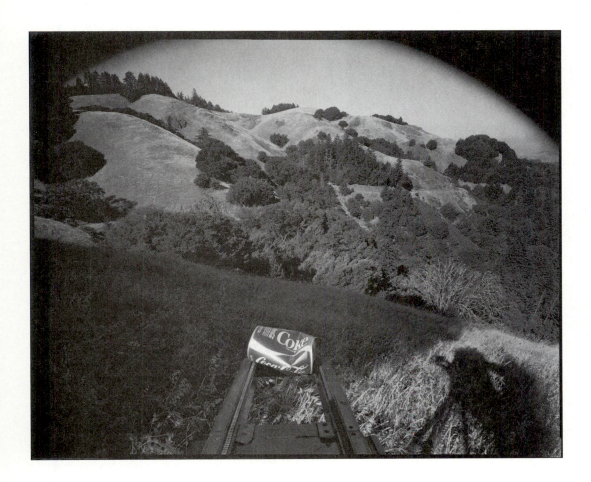

tance may not be a comfortable one for the viewer. Photographs made with wide-angle (short focal-length) lenses are nearly always viewed from too far away for exact perspective, which is why it is often assumed (wrongly) that they distort it.

The Normal Lens

A normal lens for 4x5 film is 150mm (the film's frame diagonal is actually 155mm), normal for 5x7 is 210mm (actually 208mm), and for 8x10 it is 300mm (actually 311mm). A normal design lens (see Chapter 7) with a field angle of about 70°, in the normal focal length for a given format, will offer enough extra coverage for moderate camera movements. Using a longer-than-normal focal length will make the image larger, the angle of view smaller, and the covering circle larger. For general use, many studio photographers use a 180mm (or longer) lens on 4x5 instead of a normal (150mm) because the increased coverage is useful for extreme movements and the slight change to perspective from the necessarily longer object distance is not noticeable. A lens of longer-than-normal focal length is referred to as a

long-focus lens; *telephoto* (a name many photographers mistakenly apply to all long-focus lenses) refers to a specific lens design (see p. 116), rarely used on view cameras.

The Wide-Angle Lens

A *wide-angle* is a lens of shorter-than-normal focal length for the format in use. As the focal length decreases, the field angle must increase to cover a given format. *Wide-field* lenses are those with field angles greater than normal. So a wide-angle lens must also be wide-field. A 165mm wide-field lens makes a good choice for a wide-angle lens for 8x10. The term wide-angle refers to an angle of view, while wide-field refers to a field angle. Although a wide-angle lens must be wide-field, the reverse is not true. On a 4x5 camera, a 165mm Super-Angulon, wide-field because of its 100° coverage, is not a wide-angle. Its focal length makes it a little longer than normal for 4x5. At one time, a lens with a field angle of 70° was considered a wide-field lens. That is now considered good performance for a normal lens, and a wide-field covers at least 90°.

Most view camera lenses use a leaf shutter, which opens and closes by swinging a set of blades out of the light path and back. The leaves of this shutter are in their closed position. ■

View camera lenses are shipped from the manufacturer already mounted in a between-the-lens shutter. The front and rear halves of the lens can be unscrewed and removed from the shutter mount. ■

SHUTTERS

Two major types of shutter are used in today's cameras: the *leaf* shutter and the *focal-plane* (or curtain) shutter. Most small cameras have focal-plane shutters; the leaf shutter predominates in large-format photography.

THE FOCAL-PLANE SHUTTER

The focal-plane shutter is now designed into every 35mm single-lens-reflex (SLR) camera and many medium-format (120 film) cameras. In a 35mm camera, two curtains just in front of the film plane (sometimes called the focal plane) move across the film; one opens, beginning the exposure, and the other closes, ending it. This same shutter was once found in large-format use. The single-lens-reflex Graflex (p. 109), for example, was outfitted with a long spring-tensioned opaque cloth curtain with several horizontal openings, or slits, of varying widths. Positioned directly in front of the film, the curtain was drawn across the focal plane vertically between rollers for each exposure, and the shutter speed was determined by a combination of slit width and spring tension. The Speed Graphic press camera (see p. 105) was also equipped with a focal-plane shutter. Because these shutters had a top speed of 1/1000 of a second, they were especially desirable in a camera designed to be used handheld, as were the Graphic and Graflex. The focal-plane shutter disappeared from large-format use as smaller cameras took over all hand-held photography in the 1950s. The position and size of a focal-plane shutter prevents its practical use on most of today's view cameras; its presence would impede the movements of the back.

THE LEAF SHUTTER

The leaf shutter swings its closed blades, or leaves, outward on pivots until the entire light path of the lens is exposed. After a measured, timed exposure, it then swings them back to their original closed position. Because the blades are small and light, this action is much less likely to jar the camera during exposure than would the motion of a large focal-plane shutter. This sequence of blade movements, accelerating away from the center, stopping, and reversing direction to return, is not well suited to extremely fast shutter speeds; most leaf shutters are limited to a top speed of 1/500 of a second. Larger leaf shutters, such as those found on 8x10 camera lenses, have such large blades that 1/125 of a second

is a common top speed. Fortunately, the use of high shutter speeds is extremely uncommon in large-format work.

Most view camera lenses are purchased already mounted *in shutter,* which means that the lens barrel is separated into two pieces and attached to the front and rear of a *between-the-lens* leaf shutter assembly, which is then mounted as one piece on the lensboard (p. 155). Each lens, then, must have its own shutter. As implied by its name, the between-the-lens shutter is mounted in an air space between the lens elements (see p. 115). The blades, usually five of them in a good shutter, can be seen through the front of the lens when the shutter is closed.

Between-the-lens leaf shutters are most often of the *preset,* or set-and-release, type. Moving one lever winds, or tensions, the spring that provides energy for the movement of the blades. Another lever, usually operated by a *cable release* (see p. 140), triggers the opening and closing of the blades for exposure. An *automatic,* or *press,* shutter has one lever that both winds and releases in one motion. Automatic shutters are limited in their range of fast speeds because the effort required to tension a shutter spring for a high speed would introduce camera movement. These shutters are useful on copy stand cameras (see p. 108) and any time a large number of exposures must be made with few adjustments.

The earliest shutter was a lens cap and exposures were timed by pocketwatch. To assure a motionless portrait in those days, the sitter's head was held in a clamp. ■

Retarding Mechanism

Your shutter has a mechanism that opens the blades to reveal the entire light path and closes them to halt the exposure. A good shutter will complete these movements as rapidly as possible. In between opening and closing, the blades must stay out of the way for a measured, adjustable, and exactly repeatable amount of time—the exposure. Ensuring this precise delay is the job of the *retarding mechanism.*

In the early days of photography, when the shutter was only a lens cap, the only available retarding mechanism was the photographer's pocketwatch. Removing the lens cap began the exposure; covering the lens again ended it. The materials of early nineteenth-century photography in its infancy demanded exposures in sunlight measured in minutes, and it was not until more sensitive gelatin dry plates began to appear in the 1870s that this system finally succumbed to progress. Slightly less primitive shutter designs using gravity or rubber-band power had already been introduced, and tensioned-blade designs reaching 1/100 of a second (a presage of today's leaf shutters) were introduced in the 1880s.

By the turn of the century, the most satisfactory retarding mechanism was a pneumatic delay, which

used a piston to force air through a small hole at the end of a cylinder. Substituting a smaller hole resulted in a longer delay, hence a slower shutter speed. Pneumatic-delay shutters were subject to timing variation from changes in temperature and humidity and were easily immobilized by dust.

The introduction of the Ilex shutter in 1910 rapidly made all other designs obsolete. Its retarding mechanism, based upon the geared escapement of a mechanical watch, provided accurate timing unaffected by humidity and all but the most extreme temperatures. Today's Copal shutter from Japan and the German Compur are direct descendants of the Ilex. Recently, shutters with electronic delay mechanisms have become available; their speed settings are extremely accurate and their timing invariant. These new shutters are still considerably more expensive than those with mechanical delays, however, and the difference in accuracy is inconsequential to most working photographers.

Shutter Speeds

Your shutter is marked with a series of *shutter speeds* and calibrated so that each speed corresponds to an

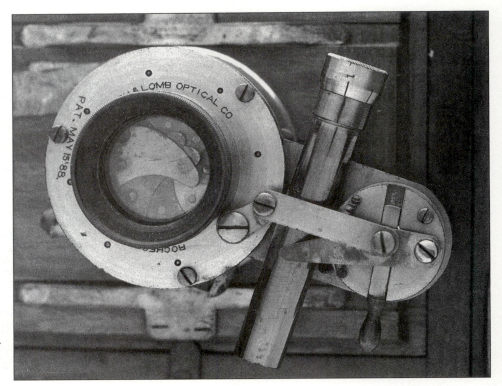

The pneumatic-delay shutter, popular for the last decade of the nineteenth century, relied upon air being squeezed out of a small hole in a cylinder to regulate exposures. ■

exposure time, or the duration that the shutter is open. The markings indicate the denominator in a fraction of a second. For example, 30 marked on the shutter dial stands for 1/30 of a second exposure. Today's shutters, by convention, all have a sequence of speeds like this:

1	2	4	8	15	30	60	125	250	500

This sequence was adopted in the 1950s to conform closely to the exact one-stop interval used for the aperture sequence. Many shutters from before that time, some of which are still in use, had a slightly more irregular scale:

1	2	5	10	25	50	100	200	400

Exposures longer than one second are accommodated by one of two additional settings, T and B. Some shutters provide only the B, which stands for *bulb.* This setting will hold the shutter open as long as the release lever is pressed or the cable release is held. The name refers to early shutters, which were operated by air pressure supplied by a rubber bulb. The shutter opened when the bulb was squeezed,

stayed open while it was held, and closed when it was released. The T setting, for *time,* opens the shutter with one stroke of the release lever and closes it with another. Use this setting if your shutter has no press-focus lever to hold open the shutter for viewing.

The *press-focus* lever (or pre-view button) on your shutter allows you to open and close its blades manually without readjusting the speed selector. Because a view camera uses the same lens for viewing and focusing that it uses to make the exposure, you need to be able to open and close its shutter easily. Use the press-focus to hold open the shutter for viewing and focusing. Some shutters must be tensioned before the press-focus will operate. Automatic shutters are made without press-focus levers and must be set on T (or B, using a locking cable release) for viewing.

Shutter Efficiency

The design of your leaf shutter's mechanism can produce an unexpected inaccuracy in your exposures as a result of variations in *shutter efficiency.* Shutter efficiency is a measure of the difference between the shutter speed you set, or the *indicated shutter speed,* and the actual time of exposure, the *effective shutter speed.* This difference is due to the time the shutter blades take to travel from a closed to a fully open

position and from open back to closed. When you change from one shutter speed to another, you only alter the delay time during which the blades are held open. The blade travel time is additional, and with most shutters it is the same for all settings.

As the blades travel, opening like an iris diaphragm, the center of the light path opens before and closes after its outer edge. The shutter, therefore, fully reveals a very small aperture in a shorter time than it does a wide aperture. With the smallest apertures, the entire light path is open for almost the entire duration of the exposure. With wider apertures the blades must travel farther after their release to uncover the entire light path and they begin to cover it sooner on their return. At any setting, the shutter is therefore giving full exposure for less time at larger apertures than at smaller ones. As you increase the aperture, the effective shutter speed will lag farther behind the indicated shutter speed. This discrepancy means the shutter is less efficient for larger apertures.

If you select a slow shutter speed, the blade travel time is a very small part of the overall exposure and the difference in shutter efficiency between large and small apertures is insignificant. With the faster shutter speeds, however, the blades barely reach their fully open position before they begin to close and they are moving during most of the exposure. At faster speeds, then, the difference in shutter efficiency between large and small apertures noticeably increases.

Manufacturers normally calibrate their shutters to be accurate (100 percent efficient) at their widest aperture by adjusting the delay time between the half-open and half-closed positions to equal the indicated shutter speed. The efficiency difference, then, will give your film more exposure than you expect at the smaller apertures rather than less than you expect at larger apertures. The effects of changing shutter efficiency will probably be noticeable only at faster shutter speeds. In practice, small apertures are seldom combined with fast shutter speeds, but the compounded error can result in as much as a full stop of overexposure. In addition, since shutters are more prone to slow down than to speed up with age, mechanical error often compounds the problem by increasing the overexposure error.

Self-Timer

Although unusual in current leaf shutters, many view camera shutters made in the last few decades (and still in use) included a *self-timer*. After the shutter's release is pressed, a self-timer provides a delay of several seconds before the blades move to allow the photographer to get into the picture or just away

These are contemporary between-the-lens leaf shutters with (a) shutter-speed dial, (b) aperture dial and indicator, (c) press-focus lever, (d) cable release attachment point and release lever, (e) pc synchronization connector, and (f) wind lever. ∎

from the camera. The self-timer was often incorporated into the wind mechanism; by moving a latch, the winding lever could be moved beyond its normal end position to wind the self-timer. An accessory self-timer with a cable-release tip and a selector for several delay times is available today. Remote-control releases operated by radio or infrared are also available.

Shutter Synchronization

When you use an electronic flash, commonly called a *strobe,* or the all-but-obsolete flash-bulbs, the job of *synchronization* falls to the shutter. Because the flash is a short-duration light, an automatic mechanical or electronic switch must be used to trigger the illumination so it appears when the shutter is open, that is, to synchronize the flash with the shutter.

Before the popularity of strobe light for the professional photographer eliminated the common use of flashbulbs, synchronization made shutter design and use very complex. Flashbulbs were manufactured in several sizes and required different shutter delays for proper synchronization. Bulbs, once ignited, take as much as 1/30 of a second to reach maximum brightness, and another 1/30 of a second to die out. In order to efficiently use a shutter speed shorter than 1/15 of a second, a delay system similar to a shutter's retarding mechanism was needed to open the shutter at a specific time after igniting the bulb. Properly adjusted, this synchronization would open the shutter at the time of maximum light output.

Early synchronizers for flashbulbs often were shutter accessories consisting of a separate delay piston attached to the shutter or lensboard, offering three delay settings for three classes of bulbs: F (.005 seconds), M (.014–.020 seconds), and S (.030 seconds). As electronic flash began to appear in the early 1940s, shutters were made with internal synchronization to accommodate it. Because electronic flash reaches its peak light output almost instanta-

neously, proper synchronization needs only to trigger the flash when the shutter is fully open. A simple electrical contact inside the shutter is all that is needed, thus making the shutter less expensive than one with synchronization for bulbs. Also, without the necessity of a timed delay, synchronization is more dependable. The designation "X" is used to indicate triggering at the instant the full-open position is reached. Shutters made today offer only X-synchronization.

Many shutters were made between the introduction of strobe light and the obsolescence of bulbs and have both internal M- and X-synchronization. These shutters have a small selector switch. If you have a shutter with such a switch and you use only strobes, tape the switch in the X position to avoid a possible catastrophe. If you inadvertently use the M position, the light from your strobe will have disappeared by the time the shutter opens and your exposure will be considerably less than you expect. If you have a modern shutter with only X-synchronization, you can still use flashbulbs by selecting a shutter speed of 1/30 or longer so the shutter remains open long enough to capture all the illumination.

Shortly after its introduction, electronic flash earned the nickname "speedlight" from its extremely short duration; flash times shorter than 1/2000 of a second were common. Strobes were used to stop action and could be synchronized with a leaf shutter at its top speed. As electronic flash for the studio evolved, power supplies were made safer and less expensive by using lower internal voltage. The use of lower operating voltage has created a side effect, however. It lengthens the duration of the flash and many studio flash units must now be used with X-synchronization at shutter speeds no faster than 1/125 of a second.

Synch Connectors

Synchronization depends on an electronic signal transmitted from the shutter to the flash to trigger the light at the correct time. Although invisible in-

This remarkable series of photographs was made by Dr. Harold Edgerton of a mechanical shutter opening and closing at a shutter speed of 1/200 second. Thirty-nine pictures were taken in that time at a rate of 4200 per second using a high-speed strobe. These photographs show the problem of shutter efficiency—the shutter was completely open for less than one-fourth of the exposure time. ■

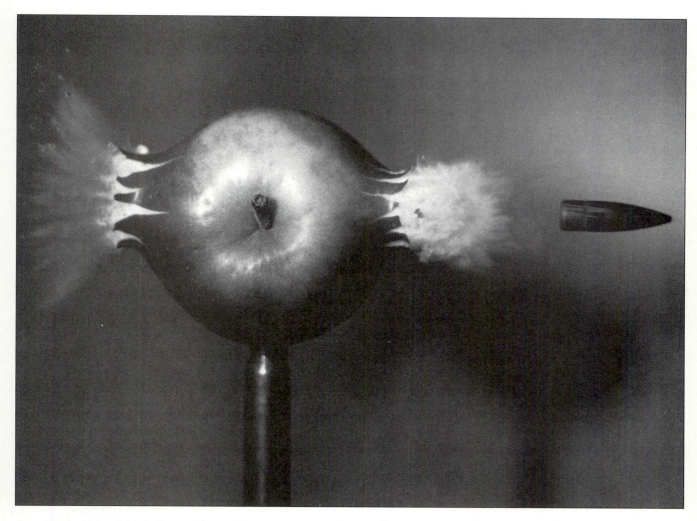

Stopping the flight of this bullet traveling at 900 meters per second required very accurate synchronization with a 1/300,000 second flash. Dr. Harold Edgerton made this photograph at the Massachusetts Institute of Technology in 1964. ■

frared transmitters and receivers are turning up in high rent studios, your signal for synchronization is likely to be transmitted from shutter to flash unit by a wire called a *synch cable*. This wire has a connector at each end—one to plug into a receptacle on the outside of the shutter body and one to join with the strobe. The connectors on your cable must mate properly with those on your shutters and flash. In universal use now is the *PC connector*, and all cur-

rently manufactured between-the-lens shutters have a PC receptacle. An older shutter may have a *standard*, or two-pin plug, for which adapters are available. Most studio strobe power packs accept a standard AC lampcord plug and any household extension cord may be used as a synch extension. You will still need a short PC cord to connect the extension to your shutter.

THE DIAPHRAGM

Your between-the-lens shutter also houses a *diaphragm,* the mechanism that adjusts the light intensity admitted to the film. It is sometimes called an *iris* diaphragm because its function corresponds to the iris of the human eye. With blades similar to those of the shutter, the diaphragm creates a circular opening centered in the light path—the aperture. The aperture is measured by f/numbers, each a ratio of the diaphragm opening diameter to the lens focal length.

The diaphragm's blades pivot and slide over one another to change the size of the aperture. These blades are visible through the rear element of the lens or, when the shutter is open, through the front. They should retract entirely out of view when set to the maximum aperture.

Since there is no distinct advantage to a perfectly circular diaphragm, most have as few as five blades to fit the narrow air space in modern design lenses. The aperture will appear to be a rounded polygon. The aperture settings, or f/stops, are usually indicated on the front and side of the shutter dial on the *aperture ring.* A pointer or mark on the dial may be moved to set and indicate your working aperture. Sometimes the settings and pointer appear twice—180° apart—so they can be seen from above and below or from the right and left.

Some aperture rings are provided with detent (or click-stop) settings at whole-stop intervals, some have detents at ½ or ⅓ stop intervals, and others slide smoothly across their entire range. In all cases, however, the pointer or mark indicates the exact aperture, and settings in between whole stops provide for smaller increments of exposure. With the shutter speeds, on the other hand, selecting a position between two adjacent settings (for example, between 1/30 and 1/60) will cause the shutter to choose one or the other, but will not produce an intermediate shutter speed and may damage the shutter.

The position of the diaphragm along the optical axis is an important aspect of lens design because it controls focus shift. A lens with a *focus shift* changes the image distance with aperture, so if you focus once with the aperture at its maximum and then close down to a smaller working aperture, you must refocus after stopping down. Once refocused, the optical performance of a lens with focus shift is otherwise unaffected by it. Some view-camera lenses, notably nineteenth-century designs, exhibit focus shift because the designer could not place the diaphragm in the optimum position, usually because there was already an element there. Today's computer-designed lenses are mostly without focus shift problems.

The diaphragm is the multibladed mechanism that creates and adjusts the aperture. ■

Before adjustable diaphragms became common, apertures were selected and changed with the use of Waterhouse Stops. Each stop was an individual flat paddle with the appropriately sized opening and was inserted into a slot in the lens barrel for use. ■

BEHIND-THE-LENS SHUTTERS

If you use several lenses with the same camera, it may be to your advantage to have one *behind-the-lens* shutter. This separate shutter is not a part of a lens as are the between-the-lens types; it mounts to the camera and can then be used with all your lenses. With it, you can use lenses mounted *in barrel,* that is, without a shutter. Like a small-format lens, barrel-mounted lenses have all the glass parts (elements) of the lens enclosed in a single tube rather than separated into two pieces to be mounted in the front and back of a shutter. As a result, you don't buy a shutter with each lens and the lenses are less expensive.

A behind-the-lens shutter will give you exactly the same shutter speeds for each lens. If your work demands exact calibration of shutter speeds—necessary for the Zone System—the speed variation between shutters when each lens has its own can add enormously to already ponderous calculations. This is not to say that the accuracy of behind-the-lens shutter speeds is any better—they are subject to the inaccuracies of any mechanical shutter—but the inaccuracies are more predictable since you are always using the same shutter.

This sophisticated behind-the-lens shutter allows you to adjust the shutter speed and aperture and to open and close the lens without leaving your viewing position behind the camera. ■

The anachronistic Packard shutter is inexpensive, practical, and dependable and may save you money when you buy lenses. ■

The studio photographer who controls exposure with aperture and strobe brightness uses a shutter only to synchronize the flash and to open the lens to focus. Any shutter will suffice for these basic applications, but the Sinar behind-the-lens shutter allows you to adjust the aperture from behind the camera and couples with the spring back to close the shutter when the film holder is inserted. These features save time and streamline camera operation, particularly when a studio setup requires that lights, stands, reflectors, or shades be next to the lens. Such a setup often obstructs access to the shutter's controls.

The behind-the-lens shutter does have some limitations. Its mounting position prevents its use with some wide-angle lenses. These lenses have such a limited back-focus distance that there is inadequate space to fit the shutter between the rear of the lens and the ground glass. Another disadvantage of the mounting position is that the light path through the shutter is wider than through a conventional between-the-lens position and necessitates larger shutter blades. The increased inertia of heavier blades lowers the possible top speed and aggravates the exposure errors resulting from variations in shutter efficiency. And even though barrel-mounted lenses are less expensive than those in shutters, don't expect an overall savings—a good behind-the-lens shutter can cost as much as six of the between-the-lens shutters it replaces.

Although an anachronism, the venerable Packard shutter is still available. A throwback to the mid-nineteenth century, this bulb-only behind-the-lens shutter is still surprisingly useful. Simple and inexpensive, the Packard shutter allows you to use older barrel-mount lenses that are usually a fraction of the cost of new lenses. The Packard restricts you to the use of two shutter speeds: B for a second or longer, and approximately 1/25 of a second. Long exposures are very common with large-format photography and the Packard at a second or more is every bit as accurate as any other shutter. If you use strobes, a professional repair shop can adapt an X-synch connection to the 1/25 speed to give you a simple, inexpensive shutter suitable for most studio uses.

6

CAMERAS

All cameras are descendants of the *camera obscura,* an optical curiosity predating the Renaissance adopted by artists to aid in realistic drawing. As its Latin name ("dark chamber") suggests, it is essentially a box or room with a pinhole or lens in one wall to form an image on the opposite wall.

THE DEVELOPMENT OF THE VIEW CAMERA

The earliest photographic cameras on record were made by or for the inventors of photography. Joseph Nicèphore Nièpce of France and England's William Henry Fox Talbot, two men with reasonable (but not exclusive) claim to be photography's inventor, used simple wooden boxes. These boxes evolved gradually into today's view camera. It occurred to Talbot in 1839 to cut holes in the camera's back to

enable him to see if the paper calotype negative was in focus. In the same year, L. J. M. Daguerre, a Frenchman who invented the Daguerreotype and claimed himself to be the inventor of photography, designed the first camera to be commercially produced. Made by Alphonse Giroux in Paris, it was also a wooden box, but assembled from two nesting boxes made to slide in and out of one another for focusing and featuring a focusing screen at the back.

The Flatbed

In 1851, an American camera introduced the bellows to common use and became recognizable as an early view camera. As a result of the bellows, the early 1850s gave rise to a number of folding camera designs. The use of a flexible bellows required cameras to have a baseboard to support the camera and until the monorail began to gain popularity in the 1940s, virtually all view cameras were a variation on the *flatbed* camera.

The cameras Alphonse Giroux made for his brother-in-law L. J. M. Daguerre were the world's first production cameras. This is a photograph of an exact working replica. ■

The camera obscura predated the invention of photography by centuries. It projected an image that could be traced and was used as an artist's aid for naturalistic drawing. ■

William Henry Jackson was one of several photographers who documented the topography of the American West in the latter nineteenth century as the land was being tamed by settlement. He used flatbed view cameras and glass-plate negatives as large as 20x24 inches in rugged terrain. ■

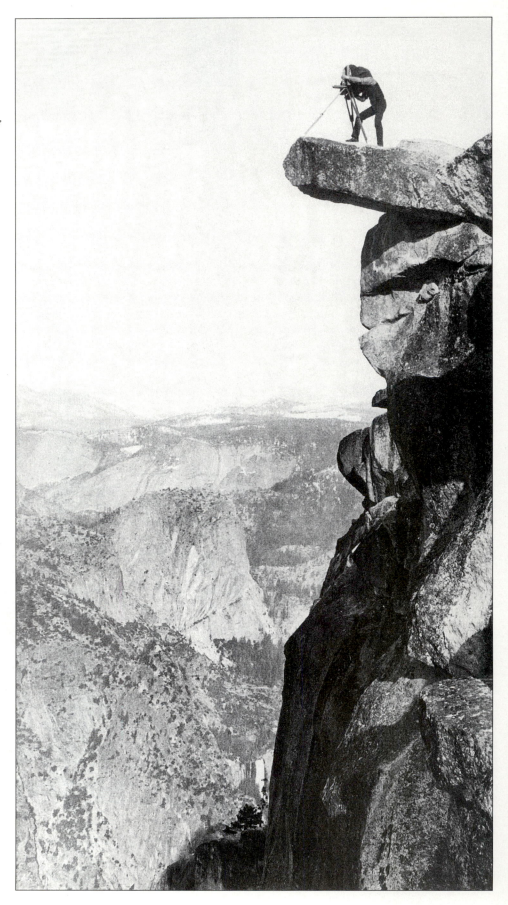

The desire for ever larger photographs gave rise to some absurdities in the days before enlarging. This camera was evidently assembled for only one use—to photograph a steam train onto plates 4½ x8 feet. ■

The enlarger appeared in the 1860s, but, until the beginning of the twentieth century, its practicality was severely limited by the slow speed of the available printing materials. Without enlarging, photographs can only be made the same size as the negative, so to the early photographers, making large photographs meant using a large camera. To produce photographs in a scale appropriate to the grandeur of the American West, William Henry Jackson, Carleton Watkins, Timothy O'Sullivan, and others spent the 1860s, 1870s, and 1880s climbing pinnacles and fording streams with cameras large enough to produce 20x24-inch negatives. If a camera the size of a steamer trunk seems enough of a burden, remember that negatives in those days were made on glass plates, so the pack animals (and photographers) were also saddled with bundles of heavy fragile glass.

By the 1880s flatbed cameras had evolved into what remained the standard professional's tool for the next 70 years. The most common form of flatbed camera had a base made of a double wooden supporting track with metal gears for focusing and used track extensions to extend the bellows for long focal-length lenses. Although many are still in use, no cameras of this type are made today. A good used flatbed camera can be an economical way to begin working in large format.

This half-plate Daguerreotype camera, made around 1850 by H. J. Lewis in New York, displayed the first use of a bellows in a camera body. ■

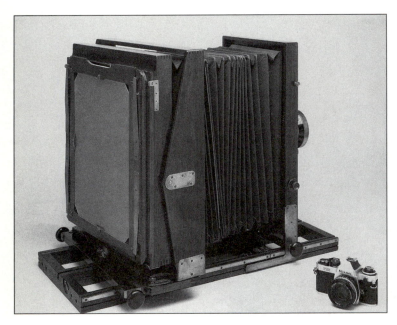

This 11x14 Sky Scraper camera made by Folmer and Schwing at the time of their merger with Eastman Kodak in 1905 is a classic example of the flatbed view camera. The back swings and tilts with no lateral movements, and the front has a vertical shift. The body parts are mahogany and brass. ■

By the end of the nineteenth century, three different designs for flatbed cameras were in common use. Most popular was the *tailboard* camera, with a front standard fixed to the front of the baseboard and a focusing track behind it. The fixed lens position made close-up work easier and the design eliminated obstructions to the field of view in front of the lens. Folding versions were made for portability; the track folded up on hinges just behind the rear standard. William Henry Jackson used a very large tailboard camera to make his mammoth landscape photographs in the latter half of the 1870s.

The second flatbed style, for which there is no generic name, had a focusing track, often hinged, fixed to the back of the camera and extending forward. The front standard was made to slide along this track for focusing. Often the bellows were tapered to collapse into a smaller space than did those with parallel sides. The only flatbed cameras currently produced—technical, press, and field cameras—evolved from this design.

More versatile than either of the other early flatbed designs and appearing in the 1870s were models featuring movable front and rear standards and front and rear base rails that folded up from a fixed center section.

Mahogany was the favored material for camera bodies and time has proven it a wise selection. Given reasonable care, most wooden cameras have lasted in nearly original condition. Special versions of standard designs were made of teak to withstand heat and humidity in tropical climates. Before the postwar popularity of monorails, metal construction

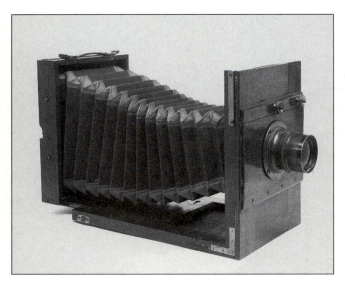

This German Leubel camera from around 1880 is a version of a flatbed view. Because the front is fixed on the focusing track and only the back moves, it is called a tailboard *camera.* ■

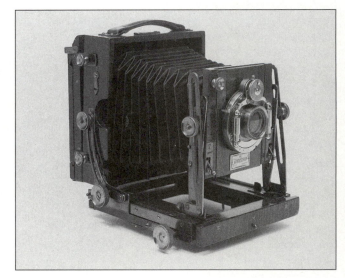

Teak was used in this tropical camera for its resistance to the effects of hot and humid climates. ■

was an occasional curiosity in large-format camera construction.

Monorail Cameras

The first monorail cameras were probably patterned after the *optical bench,* a straight rail used in optical research to hold elements in precise alignment. Although several designs appeared in the 1850s, no monorail of lasting popularity surfaced until nearly a century later. All-metal monorail designs originated in the United States with the Graphic View, introduced in 1941, and in Europe with the Swiss Sinar, first sold in 1948. Current models include Japan's Horseman (made by Komamura), Toyo, and Wista, Cambo from Holland, Arca and Sinar from Switzerland, Germany's Linhof and Plaubel, India's Rajah, and the American Calumet.

Some interesting variations on the basic monorail design have shown up in recent years. Toyo's VX125 is a very compact and light camera featuring a telescoping monorail and base tilts. Linhof's Kardan GT offers similar features. Their Kardan Master GTL, Sinar's p2, the Toyo GX, and the Cambo Master pc feature "yaw-free" movements and easy-to-use scales for exact calculation of swings and tilts.

Design and manufacturing differences create a wide range of prices, but the essential function of photographing is little different from one monorail camera to another. Beyond the design variations, basic differences show up in ease of use, availability of accessories, and sturdiness. The quality of your images will be entirely dependent upon the quality of your optics and your abilities as a photographer.

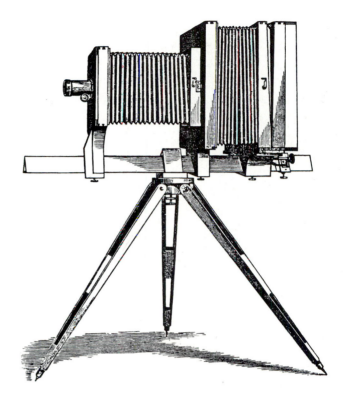

Certainly the progenitor of the modern monorail view, Joseph Petzval's 1857 camera had a double-extension bellows and a triangular wooden rail. ■

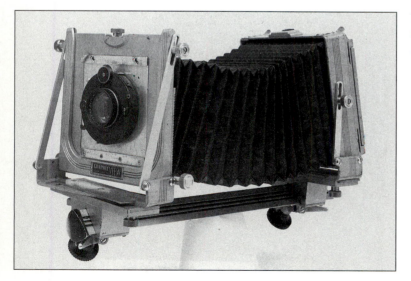

The first all-metal view camera, this Graphic View 4x5 was produced from 1941 to 1948. ■

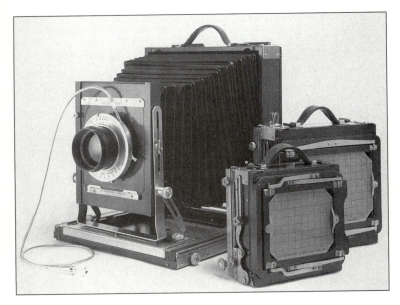

The Deardorff cameras, the best-known field cameras, were manufactured virtually unchanged from 1923 until recently. ■

DESCENDANTS OF THE FLATBED CAMERA

Field Cameras

Like a harpsichord in an era of electric pianos, the *field camera* seems a charming anachronism. It is the last vestige of a long tradition of wooden cameras; the beauty and warmth of the materials belie the down-to-earth practicality of this professional tool.

A field camera is a folding flatbed camera designed specifically for compactness and portability. The bed folds up into the back, creating its own storage compartment for the bellows and front. Most designs offer swing and tilt on both the front and the rear, as well as a rising and falling front. Almost unchanged from its turn-of-the-century design, the field camera is our closest link with the numerous folding flatbed cameras that were the mainstay of photography from the mid-nineteenth century until World War II. The venerable Deardorff, the name almost synonymous with wooden field cameras, had been made in Chicago continually and virtually without change since 1923; recently the marque has sputtered with failed resurgence. Deardorff's 4x5 camera had a reversing back. The slightly larger 5x7, called a 5x7 Special, could be used as a revolving-back 4x5. Deardorff also made an 8x10 and an occasional 11x14 in the same design as the 4x5. For years, the only field

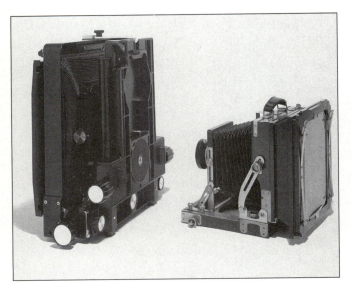

The 8x10 Toyo is the only metal field camera available in that format. The 4x5 Calumet has the unusual option of a format-increasing 5x7 back. ■

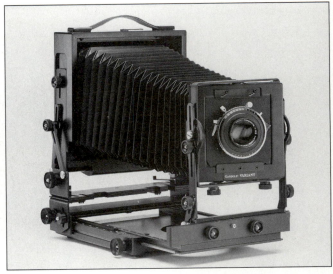

The British Gandolfi is an example of a current field camera, its still-serviceable design unchanged for decades. ■

cameras available were the Deardorff and the similar Gandolfi, crafted in Britain and recently made available in the United States. A recent surge of interest in folding cameras has caused the introduction of American-made Zone VI (4x5 and 8x10) and Wisner Technical Field (in sizes up to 20x24), and the import of wooden Wista, Ikeda, Nagaoka, and Tachihara (sold as Calumet) cameras from Japan, and Rajah field views from India. Wista makes a 4x5 and an 8x10 available in rosewood or cherry. Toyo, in Japan, makes a sturdy metal-bodied field camera in 4x5 and 8x10 formats. The Toyo Field 8x10 is the only field camera to accept interchangeable bellows. If you need a camera with full movements, yet want one that is light and compact enough to pack and transport easily, a field camera is your best choice.

Banquet and Panorama Cameras

In 1913, a curious offspring of the flatbed view camera appeared when Folmer and Schwing introduced their *Banquet* camera in Rochester, New York. This was a view camera of normal design which made abnormally shaped photographs. The long horizontal image was not, however, without precedent. From the time of Fox Talbot, the desire to depart from the classic proportions of the golden rectangle and the problem of how best to produce a wide panoramic photograph led photographers to seek some unusual solutions. Some photographers pieced together several photographs of ordinary shape, while others tried special cameras with rotating lenses, rotating cameras, curved glass plates, conical reflectors, and spherical water-filled lenses.

The simple solution, it seemed, was an ordinary camera design, altered to take a flat sheet of ordinary film in a long rectangular shape. This was the Banquet camera, made in 7x17 and 12x20-inch formats, and intended to use 13- and 16-inch wide-field lenses. The 5x12, 7x17, and 8x20 Korona Panoramic Views were introduced in 1926, the year Folmer and Schwing discontinued the Banquet. All the Banquet and Korona film sizes correspond to half (lengthwise) of one of the then-common standard sheet-film sizes. The photographer with an 8x20 Korona, for example, could cut down sheets of readily available 16x20 film.

Used Banquet and Korona cameras are frequently available from antique camera dealers, but early film holders are scarce. Recently, several manufacturers have sprung up to fill the void. Among them since 1991, the Wisner Company has manufactured new panoramic view cameras and film holders in 4x10, 6x10, 7x17, 8x20, and 12x20 sizes.

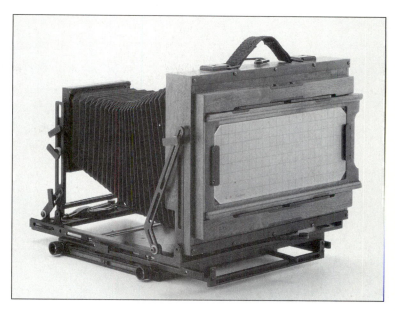

A simple elegant solution to the problem of how to make a long rectangular photograph is a Panorama camera—a long, rectangular camera. This one is new, made by K. B. Canham in Arizona. ■

One of the most curious solutions to the wide-photograph problem was this Goerz Hypergon wide-field lens. It attempted to correct off-axis light falloff with a center-weighted propeller mounted in front of the lens. A squeeze of the air bulb set the propeller in motion just before exposure. ■

E. O. Goldbeck's photograph of a human insignia was made in 1926 at Kelly Air Force Base in San Antonio, Texas, with an 8x20 Korona Panoramic View. ∎

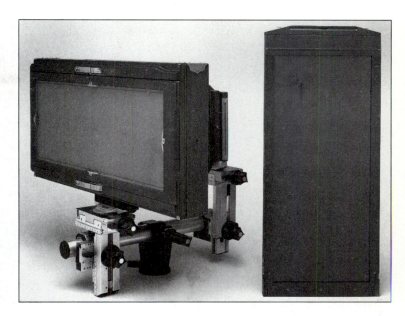

Allen Hess made Mrs. Evelyn, Lafitte, Louisiana, *with the camera shown above. He attached a back from an 8x20 Korona to the accessory bracket of his Sinar Monorail to give him all the advantages of a modular banquet camera.* ■

This self-portrait by "Weegee the Famous" shows him with his Speed Graphic in 1942. ■

There was no press camera but *the Speed Graphic when Mrs. Frank Sinatra gave birth to Frank, Jr., in 1944. Len Detrick used his to get the picture for the* New York Daily News. ■

Press Cameras

Until the middle of the 1950s the archetypal press photographer (now called a photojournalist) was clutching a Speed Graphic. Almost unchanged from its introduction in 1912 until production ceased in 1970, this ubiquitous press camera recorded celebrations and disasters, World Series and world wars. Once film emulsions became fine and fast enough to make quality enlargements from "miniature" (an early nickname for 35mm) negatives, the press corps shifted its allegiance en masse to the smaller format. As a result, the once-proud workhorse of the front page is now in the classified ads. Versatile, durable, and inexpensive, the used press camera is undoubtedly the best value in photo equipment. At least one manufacturer still produces a Speed Graphic look-

alike, but like the plush splendor of "Detroit Iron" cars of the 1950s, the halcyon days of the press camera's popular appeal have passed.

Designed for portability, press cameras offer features useful for work outside the studio. The focusing track, on which the front standard rides, nests into a bed that folds on hinges into the rear of the camera body. When shut, the camera body itself forms a protective box—a built-in carrying case. A normal lens can be left in place with the front folded for quick setup. The ground-glass back has a hinged cover that often doubles as a focusing hood and helps further protect the closed camera against damage.

Because press cameras were used for a variety of assignments, they were often fitted with multiple viewing and focusing devices. It was not uncommon

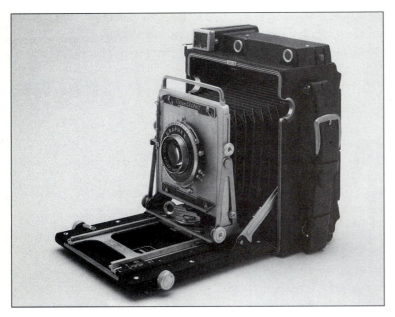

The Crown Graphic, Speed Graphic's look-alike with-out the built-in focal-plane shutter, was made until 1973. ■

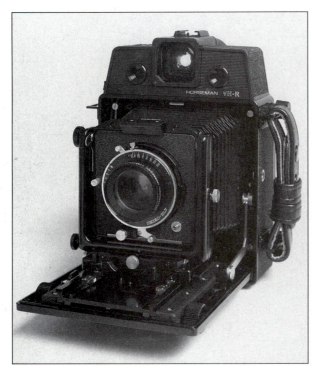

The Horseman Technical Camera has the features of a Linhof Technika but uses nothing larger than 120 and 220 roll film. ■

to augment the ground glass with a top-mounted viewfinder and a wire-frame sports finder, in addition to a focusing rangefinder.

Although by 1940 Graphic models included a front shift, movements on many press cameras are limited to those used most often: the front rise and the lens tilt. Most press cameras have a *drop bed,* the equivalent of a rear-standard bottom-axis tilt, to allow the use of a wide-angle lens without vignetting by the bed. But because the camera was most often hand-held, these movements were largely ignored. The history of the press camera in America is the history of the Speed Graphic. It was introduced in 1912 by the Folmer and Schwing Company, which had been a division of Eastman Kodak since 1905. As part of an antitrust settlement, Kodak divested themselves of the company, by then called Century-Folmer, and it became Folmer Graflex in 1926, and Graflex, Inc. in 1945.

The first Speed Graphic was a compact, fold-ing, large-format camera with a built-in focal-plane shutter to allow the use of barrel-mounted lenses. The mahogany bodies were made in four formats, from 3¼ x 4¼ to 5x7, and were covered with leather. The camera was probably introduced as a compact, portable large-format camera, but a model change in 1928 anticipated its use as an action camera by moving the handle from the top to the side and adding a wire frame finder. The Pacemaker series of Graphic cameras in 1947 added coupled-rangefinder focusing and introduced the Crown Graphic, a version made lighter by the omission of the focal-plane shutter. Production of the Crown Graphic continued until 1973, when the company folded.

Technical Cameras

Along with the press and field cameras, the technical camera evolved from the fixed-back flatbed camera design. It incorporates the best features of its prede-cessors into a versatile machine for contemporary uses. As opposed to the press camera, which was built for the action photographer and, almost as an after-thought, could be used on a tripod, the modern tech-nical camera was designed as a view camera with full movements with the option of being used hand-held.

Technical cameras all close in the same manner as press cameras: the bed folds into the back, form-ing a protective box. The spring back is connected to the body with four sliding pins, allowing each corner of the back to be positioned independently. This system gives the technical camera the back movements missing from otherwise similar press cameras.

The archetypal technical camera is the German Linhof Technika, which has been manufactured in Munich with constant improvements since 1936. Valentin Linhof began as a maker of shutters and by 1899 added cameras to his line. In 1910 Linhof began to make an all-metal folding camera that was the direct predecessor of the Technika. A burst of innovation produced the prototype Technika in 1936. It incorporated a fully adjustable swing back, which had been patented two years earlier. The Super Technika of 1946 introduced a built-in rangefinder with cams to couple it to interchangeable lenses of various focal lengths. The current Technika models, 6x7cm, 4x5, and 5x7, incorporate rear swing and tilt and a full-movement front with coupled-rangefinder focusing and an accurate viewfinder corrected for parallax error (parallax is the difference between what is seen by the lens and by the viewfinder due to the slight difference in their vantage points). Technika cameras are remarkable examples of engineering and manufacturing precision, and sell for almost as much as a new car. An option on the top-of-the-line Technika even offers automatic focusing (see p. 113).

A much less expensive 4x5 technical camera than the Technika is Wista's 45, the only similar large-format camera made today. It is made in versions with and without lens swing, interchangeable bellows, and coupled rangefinder. An optional 5x7 back is also available. The Horseman is a useful, smaller version of the technical camera, designed for 120 and 220 roll film only. Horseman also makes the HD Field in 4x5—like the Wista, but not available with a rangefinder.

If you need a portable camera with full movements, more sturdiness than a field camera, and the option of hand-held use, you will want to shop for a technical camera.

This all-metal Linhof folding camera from 1924 was the forerunner of the Technika series of technical view cameras. ■

Linhof's Master Technika is fully adjustable and includes coupled-rangefinder focusing and a parallax-corrected viewfinder. ■

Replacing the vertical process camera in many applications is an electronic camera, here a Leaf Lumina on a copy stand. The Lumina, a scanning digital camera, will digitize three-dimensional objects as well as any flat copy laid on the baseboard. ■

The conventional version of a vertical process camera, Polaroid's MP-4, called a copy camera, is well-suited to making slides and copy negatives from flat originals. ■

Nu-Arc's horizontal process camera seems distant from the nineteenth-century flatbeds, but the lineage is direct. These cameras have almost all been replaced by electronic scanners. ■

Process Cameras

The needs of the graphic arts industry generated a number of specialized camera designs based on the flatbed view camera, called *process* cameras. Sometimes called *copy, repro,* or *stat* cameras, vertical and horizontal process cameras were designed specifically to make reproductions near the original size of flat copy.

Before it was overwhelmed by electronics, the printing industry used process cameras to make *halftones* and *color separations.* Both are dot-patterned images on high-contrast litho film that can be "burned," or exposed, directly onto the printing plate for an offset press. Most of these halftone negatives are now generated, when they are needed at all, by specialized machines called image-setters, but at one time at least one of these dot-patterned negatives was necessary for every photograph reproduced in print. There were probably more process cameras in use than all other view cameras combined. These cameras were often permanently installed in a room with the bellows, lens, copyboard, and lights separated by a wall from the back. The back would be in a separate room, usually a processing darkroom. A process camera is used only for its ability to photograph onto large sheets

of film and is therefore designed to have no movements.

A small, freestanding, vertical process camera for a designer's office or typesetting shop might accommodate film up to 14x17, while a larger built-in horizontal model for a production printer would use film as large as 60 inches square.

Lenses specially designed for process work (*apochromats*, p. 127) are optimized by the lens designer for the most common reproduction ratios and carefully corrected against aberrations for the printer's specific primary colors. Process lenses were made in an array of very long focal lengths (commonly up to 1800mm and sometimes longer) to cover the large sheets of film common in the industry. These lenses were almost always mounted in barrel, since the exposure in process cameras is controlled by switching the lights on and off.

REFLEX CAMERAS

A *reflex* camera produces an image on a ground-glass surface parallel to the optical axis by placing a mirror at a 45° angle to the light path. This allows the film to be in place during viewing and focusing. Although the principle predates photography—it was introduced in the seventeenth-century camera obscura—the design emerged slowly. Today, however, (35mm) reflex cameras dominate the photography market.

The first camera with a reflex design was patented in 1861 by the English photographer Thomas Sutton. Sutton's camera had an internal mirror to reflect the lens image up to a horizontal ground glass set into the top of the camera. Before exposure, the mirror was swung on hinges from its viewing position into a position covering the opening for the ground glass, making the camera's interior lighttight. Sutton's camera was not popular, due in part to the wet-plate process then used. Because the plate needed to be sensitized immediately before use (and exposed and developed while wet), there was little advantage to making it possible to view and focus rapidly. With the emergence of practical dry plates in the 1880s came a flood of hand cameras and the reflex became a popular design.

In 1901, the Folmer and Schwing Company, which also made the Speed Graphic, introduced the Graflex, which became the most popular series of large-format single-lens-reflex cameras. First made in four sizes from 4x5 to 8x10, the Graflex family was manufactured in several incarnations until it was finally discontinued in 1963. In the six decades of its production, the features of the Graflex were modernized slowly, but its basic design remained

Paul Strand's photograph of Alfred Steiglitz from about 1929 shows him with his Graflex with which he probably made his Equivalent *series of cloud photographs.* ■

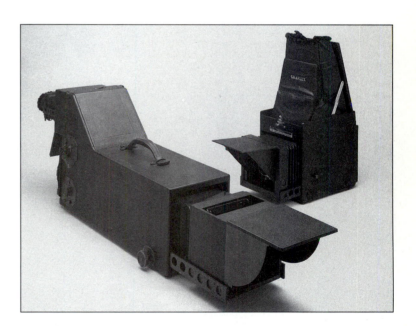

The Naturalist Graflex was a large-format single-lens-reflex Graflex with a 600mm lens. A similar camera called "Big Bertha" was a common sight with press photographers at sporting events. The standard Graflex shown here was the last model made: a Super D. ■

This photograph of Dorothea Lange taken by Paul S. Taylor in 1934 shows her with her 4x5 single-lens-reflex Graflex. She probably used this camera to make her famous photograph Migrant Mother *in 1936.* ■

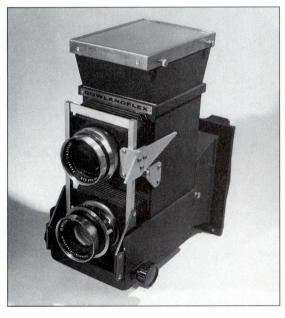

The only large-format twin-lens-reflex camera made today is the Gowlandflex. ■

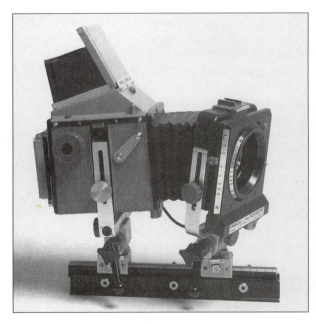

This odd-looking hybrid once made by Arca is a single-lens-reflex monorail view camera. ■

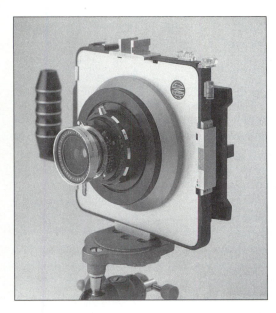

The Cambo-Wide is a special-purpose 4x5 camera made to take only a 90mm wide-field lens. ■

unchanged. It was similar to the Sutton camera, with a large internal reflex mirror, and designed so that its top viewing hood (to darken the area around the ground glass), lens, and bellows would fold into the body, forming a protective, portable box in the shape of a cube. Versions of the basic camera included double-lens stereo cameras and "Big Bertha" Graflexes adapted to lenses with focal lengths as long as 40 inches. The Super D was the last Graflex model and, in 4x5 format, remains a useful camera.

An unusual set of *twin-lens reflex* cameras is made and marketed currently by Peter Gowland in California. First made by Gowland in 1956 for his own use in photographing "glamour" models, the Gowlandflex is now made and sold in 4x5 and 5x7, with a wide-angle version available in 4x5. These cameras use matched lenses in pairs, one to form an image on a ground glass for viewing and the other to form an image on the film. With a twin-lens camera there need be no delay between final viewing and exposure because the presence of a film holder does not block the ground-glass screen. A cam on each camera corrects parallax error, which increases with decreasing object distance. A similar TLR 4x5 camera was made for a short time in Holland by Cambo.

THE ELECTRONIC VIEW CAMERA

Most advances in the equipment currently available for view camera photographers have been small refinements in a system that has been stable for more

than a century. Glass lenses now have fewer aberrations, mechanically-adjusted cameras are more precise, and silver-halide films are sharper and faster than ever before. But the basic character of camera, lens, and film is very much as it has been since the dawn of the dry plate era.

Recent innovations in electronics, however, are rapidly revising whole areas of the field of photography, for users of small-format and view cameras alike. The computer that was once used only for tasks having a mathematical bent, like accounting or engineering, has become essential to the printing and publishing industry. Every photographer whose work is destined for the printed page—almost every serious photographer—is affected. Most photographic images that end up printed in ink—for books, magazines, posters, or brochures—are converted into an electronic, digital form somewhere between the exposure and the making of the printing press's plate. For most images, that conversion is done by *scanning*, a way of reading the optical information from an original photographic print, negative, or transparency, often done by the printer just before making the plate.

Scanning an image before it leaves your studio and presenting it to the client in electronic form gives you more control over that conversion and makes it possible for you to further manipulate and alter the photograph. Image-manipulation software gives you the tools to repair defects, to remove unavoidable reflections or shadows, or even to merge objects and backgrounds from several different images. It is also possible now, and advantageous in some photographer's studios, to record (or *capture*) the photograph electronically, bypassing entirely the use of film. The photographer previews the image on a computer's monitor screen and then can transfer it by wire or telephone directly to the workstation of a designer, editor, or layout artist.

Digital Image Capture

Although it is somewhat more complicated than it sounds, a photograph may be made in digital form by replacing the film holder or spring back in a standard view camera with a device that records light electronically. These *digital camera backs* are made by several companies and, at the time of this writing, cost as much as a new automobile. Because the direct digital recording of an image saves the time and cost of film and processing, the technology has found its first practical use in high volume studios such as those that photograph for mail-order catalogs. As the technology improves and the cost declines, direct digital photography will become practical for other specialties.

The business workflow advantages of direct digital recording are certainly of interest to commercial photographers, but electronic recording offers a subtle but important qualitative improvement as well. The contrast, or range of brightness values, that can be captured on conventional film is about five stops (32:1) for transparencies and about seven stops (128:1) for negative films. With electronic capture, this measure of available contrast is called *dynamic range*, and some of the available digital adapters for professional cameras claim a dynamic range greater than 10,000:1, or more than nine stops. (See photo by Stephen Johnson, page 3.)

Digital camera backs fall into two distinct categories, based upon the light-sensitive recording mechanism. Currently all digital image recording uses some form of *charge-coupled device,* or CCD. Each CCD is made up of individual light-sensing cells that are the elemental building-block of a digital image. These cells may be arranged in a one-cell-wide line, called a *linear array,* that is moved across the image area in a *scanning back,* or they may be

arranged in a rectangular group, called an *area array,* or *area CCD,* that faces the lens like a sheet of film.

Scanning Back

CCD cells are essentially monochromatic—each converts the relative brightness of the whole spectrum of light into a single electronic value, as a spot meter does; for color information they must be used with filters in order to record the brightness of specific colors. Scanning backs for view cameras use three linear array CCDs, one filtered for each primary color, to render a full-color image in one pass (or scan) across the image surface. A typical scanning back for a 4x5 camera might have three 5000-element linear arrays that read in 7000 steps, meaning that the total scanned image would be a grid of 5000x7000 (or 35 million) discrete, measured spots. For a full-color image, each spot would have three recorded values, one for the brightness of each of the separation primaries—red, blue, and green—at that spot.

Storing a hundred million or so pieces of information takes a computer storage device of significant size, so current scanning backs must be connected with a wire to a host computer that both controls the scanning mechanism and stores the picture. The scan itself takes minutes, making undesirable any movement of subject or camera. These qualities make the scanning back unlikely, although not impossible, to prove useful in the field. In the studio, "hot" lights must be used for continuous illumination.

Area Array Back

A different approach to digitally recording an image, and one that is likely to dominate the near future of electronic photography, is the area-recording CCD. The area array is a grid of CCD elements that, like film, can record an image over its entire surface simultaneously. Area array chips with a light sensitivity equivalent to that of fast black-and-white film form the basis of digital cameras that can be hand-held. In the studio, area array film backs allow the use of strobe illumination.

An area array CCD is more expensive to manufacture than a linear array; defects in the manufacturing process cause a high rejection rate. And at the time of this writing, no area array CCDs larger than about 6x6 cm are available. These CCDs are fitted into backs for the view camera, but their small size necessitates shorter-than-normal lenses and gives the photographer a smaller ground-glass image for viewing and focusing. The file size is smaller than that of a scanning back, therefore the resolution is lower.

Producing an area array CCD camera back that

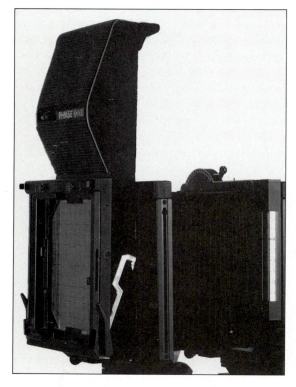

The digital PhotoPhase Plus scanning 4x5 back from PhaseOne fits any conventional view camera's spring back and produces an RGB picture file as large as 105MB from its 7x10cm recording surface. It will make a preview image in fifteen seconds and capture complete information in as little as three minutes. ■

can make a full-color image requires some inventive engineering. One method is to filter each CCD cell with one of the primary colors. More accurate color is attained, at considerable expense, by splitting the image into three after it passes the lens, with each recorded through a separation filter on its own area-array chip. Equally accurate color may be obtained with one chip by making three successive exposures, each through a different primary-color filter. Strobe illumination may be used with this system, but the subject must remain stationary through three successive pops of the flash.

Electronic Camera Control

Just as users of hand cameras have welcomed automatic exposure and focusing, view camera photographers can now turn over control of those important features to a computer. Linhof's technical camera, the 4x5 Master Technika 2000, is available with precise infrared automatic focusing that couples to lenses from 90mm to 300mm, making it practical to use the camera hand-held.

The top-of-the-line monorail camera from Sinar is outfitted with computer-assisted focus and depth-of-field calculation. Sensors built into the camera's standards send position information to an IBM-compatible PC mounted with single-purpose internal board. The camera's operator uses a wand inserted into the film plane to select a point on the subject by focusing on it. The computer remembers the position on the image plane and calculates the distance between the front and rear standards.

The computer can be given up to 24 points to define the subject, one at a time; it uses these points to build a model of the volume in front of the camera that the photographer considers to be the subject. Using programmed-in depth-of-field tables and Scheimpflug information, the computer calculates the correct position for the lens standard along with the maximum usable aperture to produce a photograph with the entire defined volume in sharp focus. The photographer is supplied with a graphic representation on the computer screen of the camera-movement information and merely dials in the calculated adjustment.

Sinar makes a model of this camera for use with conventional film and one for their CCD-array digital back. Both can use a video monitor, shown in the illustration, to show an enlargement of the spot being used to define a point on the subject. This extreme enlargement allows very precise adjustments of focus. The computer also calculates exposure information and, using Sinar's electronically-controlled shutter, makes a correct exposure automatically.

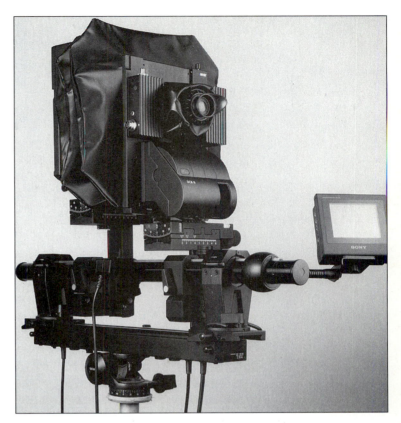

Sinar's top-of-the-line CapCam is a monorail camera with a computer-aided focusing system. It is shown here equipped with a Leaf DCB digital array back and a small viewing monitor that displays an area in the image as small as 1 cm² for extremely accurate focusing. ■

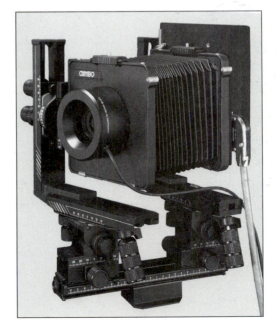

Mounted to the back of this Cambo view camera is an area array CCD back by MegaVision. Its capture area is only 31mm square, barely larger than a 35mm frame, but its 2048x2048 pixel chip generates a 12MB RGB file in less than five seconds. ■

MORE ABOUT LENSES

Although you needn't study optical engineering to be able to use a large-format camera, there are advantages to knowing the evolution of the modern lens and the constraints within which lens designers must work. This knowledge not only will enable you to be an enlightened consumer of used and new equipment, but will also help you understand the optical limitations you will face each time you make a photograph.

The first part of this chapter will familiarize you with the general anatomy of a lens and with the challenges facing lens designers. As in any other complex field, the terminology of lens design is very specific. Some of the specific terms have other or broader meanings in casual conversation, but they are defined for their technical meanings here. The second half of this chapter traces the history of modern camera lenses, with emphasis on those useful for large-format photography. To thoroughly

understand the evolution of lenses, you must know about the constraints and obstacles all lens designers have to face. If you are not ready to investigate lens choices in depth, you may wish to begin by skimming the second part of this chapter, turning to the first section for reference whenever a term or phrase is unfamiliar.

THE ANATOMY OF A LENS

A lens made from a single piece of glass is called a *simple lens*. Its faces may be concave, convex, or flat, but it must have at least one curved surface. This surface is almost always a *spheric section,* a surface that looks as though it were a disc sliced from the surface of a perfect sphere. Imagine, for example, a coin-sized disc cut from the skin of an orange. This piece and the same diameter disc cut from a larger sphere such as a basketball would both be spheric

The three shapes of convergent lenses are, from left to right, biconvex, plano-convex, and positive meniscus. ■

The divergent lens elements, used only in combination with positive elements, are negative meniscus, biconcave, and plano-concave. ■

sections, but the latter would have a flatter surface, due to its greater *radius of curvature.* A lens that can focus an image is called a *convergent* or *positive* lens; to do so it must be thicker in the center than at the edges. The reason a lens can focus an image is because the glass *refracts,* or bends, light passing through it. The amount of refraction depends on the angle the light makes with the glass surface and also on the *refractive index,* a measure of the light-bending power of a specific kind of glass.

A simple, convergent lens distorts the image it produces in a number of predictable ways. These distortions, known as *aberrations,* may be separated into seven broad categories (described on pp. 116–119), and have been well known to lens designers since the early nineteenth century. Lens aberrations can be corrected, or at least diminished, by adding other simple lenses into the light path. For example, a *divergent* (or *negative*) lens, which is thinnest in its center, is used only in combination with a convergent lens to correct an aberration. A set of simple lenses assembled along a common optical axis to focus an image forms a *compound lens.* The simple lenses are then referred to as *elements* or *components* and may be cemented together into *groups.* Any air space between elements and groups is as important to the design of a compound lens as the elements themselves; a fixed position of the elements and spaces is assured by a rigid lens *barrel,* its opaque outer shell. In a compound lens, a single element isolated by air spaces is also considered a group. Your normal lens probably has six elements in four groups.

Cardinal Points and Principal Planes

A lens is born in the imagination of a designer who tests out on paper each new theoretical arrangement of elements and groups by calculating the paths of different light rays through them. This *ray tracing* involves incredibly tedious and complicated calculations, and progress in lens design was predictably slow until the advent of the computer. The past four decades have seen remarkable advances in lens quality because these calculations can now be done much more rapidly, thus allowing designers to more thoroughly investigate possible arrangement variations.

Ray tracings, like most optical measurements, help define and make use of the *cardinal points* and *principal planes* of the lens. These are the various spatial positions of optical importance in a lens, some of which are defined here. By convention, diagrams are drawn showing points of light originating at the left of a lens coming to a focus on the right.

The plane slicing through the points on the left is the *object plane* and the plane through the focused

point on the right is the *image plane.* Some rays of light will leave a lens traveling parallel to the direction they entered, although displaced. The *forward nodal point* is the point on the optical axis at which all such rays entering the lens are aimed. They exit as though they emanated from the *rear nodal point.* The rear nodal point is the most important cardinal point for the user because it is from there that focal length is measured and because any rotation of the lens around that point (as in a lens swing or tilt) will leave the position of the image plane unchanged.

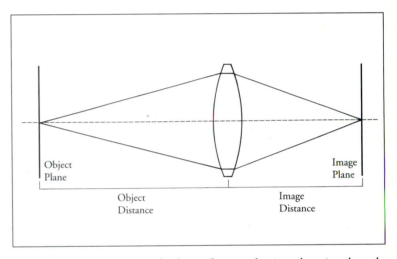

The plane on the left, perpendicular to the optical axis and passing through all the points in focus, is the object plane. Every point in the object plane is focused by the lens to a point in the image plane on the right. ■

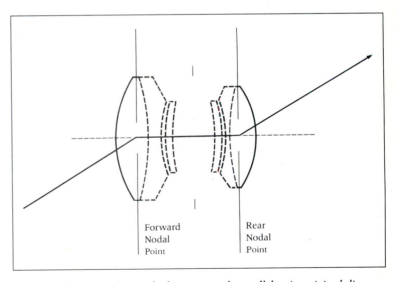

Any ray of light that leaves the lens in a path parallel to its original direction seems to enter aimed at the forward nodal point and leave from the rear nodal point. The position of the rear nodal point is very important to view camera users. ■

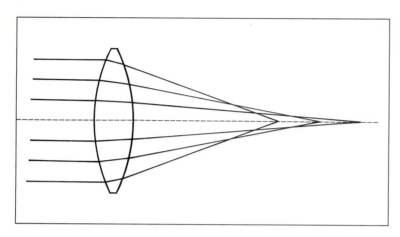

Spherical Aberration. *The rays from the periphery of the lens come to a focus closer than those passing through its center.* ■

The relative position of the rear nodal point defines three categories of lenses. The rear nodal point is within the lens for *normal* designs, in front of the lens for a *telephoto* design, and behind for a *retrofocus*. This means the telephoto lens itself is closer to the film than its focal length when focused at infinity and the retrofocus is farther away. Remember, the focal length is measured from the nodal point to the film. With a hand camera, having the rear nodal point farther from the film than is the lens makes a telephoto lens more compact. Having the rear nodal point closer to the film than with a normal design lens in a retrofocus makes it possible to use a short focal-length (wide-angle) lens on a reflex camera where a normal design lens of the same focal length would interfere with the reflex mirror. Because view cameras offer few physical obstructions to the use of very long and very short lenses, retrofocus lenses are never used with them and telephotos are used very rarely.

The Lens Aberrations

Ideally, a lens should cover a wide field (make a large image circle) with a sharp, evenly illuminated image and should do so for any object distance. Aberrations make these goals impossible to accomplish simultaneously and every lens design is a controlled compromise. Correcting for one aberration often aggravates another. The designer uses the number and shapes of elements and the optical behavior of different kinds of glass to control aberrations and

This photograph was made by Dutch photographer Hans Pielage. Light passing through a homemade plastic lens clearly reveals spherical aberration. ■

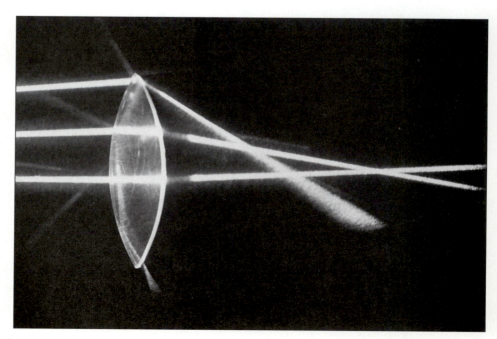

has to juggle all of the characteristics of a lens to *optimize* it for a certain use. For example, a process lens used in the graphic arts sacrifices sharpness at infinity for high performance at close range and gains good color correction at the expense of wide coverage.

Spherical Aberration. Light rays originating at one object point and refracted, or redirected, by a spheric surface are not, as we would like them to be, all focused at exactly the same image point. Light from the edges of a lens comes to a focus in a shorter distance than light from the central portion, and the farther the part of the lens refracting the light is from the lens axis (center), the more the focus strays. A simple lens exhibiting this *spherical aberration* performs better at small apertures, which restrict the light from the periphery of the lens. But trying to correct spherical aberration simply by stopping down also changes the position of the image plane. This is called a *focus shift*. The spherical aberration for any lens increases (and image quality decreases) as the object distance decreases. A lens designed for close-up work, then, must have much less residual spherical aberration than one designed for landscapes.

Spherical aberration can be controlled, but not eliminated, by adding a divergent lens to the light path. The ideal solution to the problem would be to change the spheric-section curvature of the lens surface, but only recently have mass production techniques been developed for curved surfaces of nonspherical shape. The production of the *aspheric* lens of Polaroid's SX-70 in 1972 was a manufacturing breakthrough which may lead to better view camera lenses in the future.

Coma. *Coma* is a blurring of the image in the direction of the edge. It is caused by an increase in magnification for light passing through the lens at an increased distance from the optical axis. The image of an off-axis point of light takes on the shape of a comet, hence the name. Because its effects increase with distance from the optical axis, it is a particular problem for wide-field lenses. Coma can be controlled somewhat by the designer with the position of the diaphragm. A smaller aperture reduces the problem.

Astigmatism. A lens evidencing *astigmatism* may show horizontal lines in focus while vertical lines are out of focus. Shaping a lens to correct spherical aberration often aggravates astigmatism. The first anastigmatic lenses, in which the aberration was corrected, were made after the development of barium crown glass in 1886 gave designers a wider choice of refractive indexes.

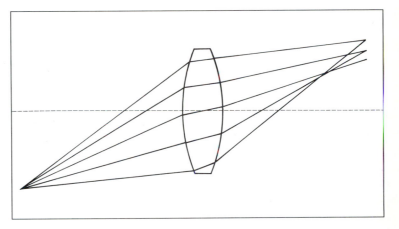

Coma. *This aberration makes points of light appear to blur outward, away from the optical axis.* ■

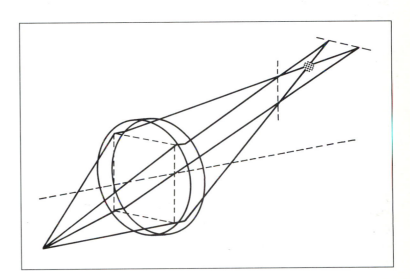

Astigmatism. *A lens evidencing this aberration changes its focus with the orientation of the subject.* ■

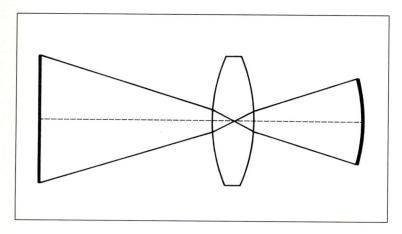

Field Curvature. *Without a flat field, it is difficult to get a sharp photograph on all parts of a flat sheet of film.* ∎

Field Curvature. *Field curvature* prevents the image of a flat object plane from lying entirely on the flat film plane. Instead, the image is focused on a curved surface. This is an especially significant problem in enlarging and in process lenses that are ordinarily used to image a flat surface, but field curvature can also make ground-glass focusing difficult if sufficiently present in a general-purpose camera lens.

Distortion. Six of the seven aberrations primarily affect the ability of a lens to focus an image precisely. *Distortion* affects its ability to focus an image accurately. To help visualize this distinction, a dirty mirror cannot make a precise image and a curved mirror cannot make an image that is accurate. *Pincushion* and *barrel* distortion are characterized by a curving of the image that increases away from the optical axis. They are more of a problem in telephoto and retrofocus designs than they are in *symmetrical* lens designs where the elements in front and back of the diaphragm are mirror images (or nearly so) of each other. Distortion is less of a problem if it appears in a landscape lens than in one used for graphic arts, enlarging, architecture, or aerial mapping. It is unaffected by aperture.

Barrel distortion and pincushion distortion are the two common ways a lens can render an inaccurate image. The distortion increases with the distance from the optical axis. ∎

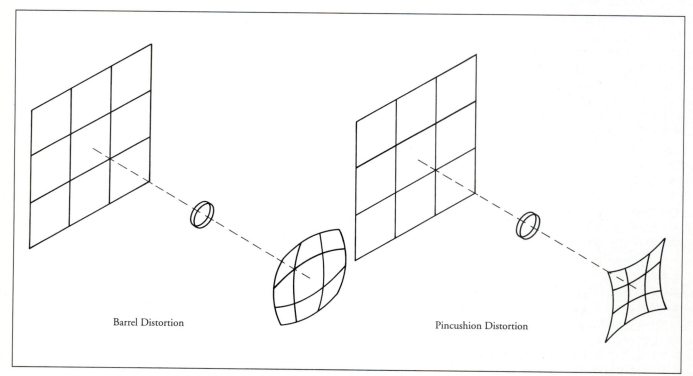

Barrel Distortion

Pincushion Distortion

Axial Chromatic Aberration. *Axial chromatic aberration* is a change in focus proportional to the color (wavelength) of light. Uncorrected, this aberration causes the longer wavelengths, such as red and yellow, to be focused behind the shorter blue and green wavelengths. Your eyes' chromatic aberration causes the perceptual effect (used to great advantage by many painters) that warm colors seem to advance while cool colors seem to recede. Axial chromatic aberration will cause colored fringes in a color photograph, and general unsharpness in black-and-white. The two chromatic aberrations, axial and *transverse,* are more noticeable in color photography than in black-and-white.

Lateral Color. *Transverse chromatic aberration,* also called *lateral color,* is a particular problem in long focal-length lenses of normal design (that is, not telephoto); therefore, it affects most process lenses. Lateral color causes the focal length of the lens to change with wavelength, which produces colored fringes on color film. The printing industry uses three black-and-white *color-separation* negatives to reproduce a color photograph. If these negatives are shot with a lens exhibiting transverse chromatic aberration, the images on the separations will be of different sizes and the resulting reproduction will be out of focus.

Other Lens Imperfections

As you have seen by now, no lens is perfect. The materials used to make lenses have properties that work against us. Aberrations are not the only undesirable properties that must be minimized by the designer and sidestepped by the cautious user; a few others are discussed below.

Flare. One undesirable property of the glass used in lenses is its tendency to transmit less than 100 percent of the light that falls on it. Some of the light, usually not much, is reflected back toward its source. Every surface of the lens transmits most of the light and reflects some, and some of the light reflected forward from the rear elements is reflected back again by the back surface of the front elements. This stray reflected light, called *flare,* is not focused into an image, but serves only to reduce contrast when it falls upon the film. Lower contrast reduces apparent sharpness and degrades the image.

A cemented surface between glass elements reflects about 1 percent and transmits 99 percent of any light falling on it. A glass-air surface, however, reflects as much as 6 percent and a compound lens can have eight such surfaces. Fortunately, a practical method to apply an antireflection coating (by vacuum deposition) was introduced in 1935 and the

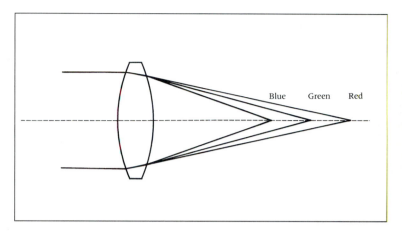

Axial Chromatic Aberration. *The lens changes its focal length slightly with the wavelength of light.* ■

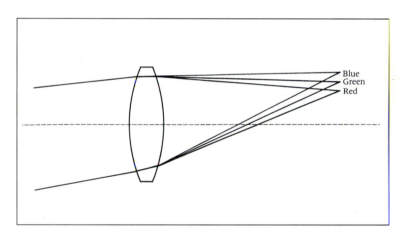

Transverse Chromatic Aberration. *The lens changes its magnification slightly with the wavelength of light.* ■

light loss in a well-designed compound lens was reduced to a total of less than 6 percent. Recent techniques in multiple coating have reduced total flare below 1 percent and new multicoated lenses are available for view cameras. Reduced reflection gives the lens designer freedom to use more elements in correcting aberrations.

Although controlled by coating, lens flare is aggravated by other sources of stray light, such as reflections from poorly darkened shutter and diaphragm blades, lens barrel, bellows, and internal camera parts. Even the surface of the film reflects as much as 20 percent of the light falling on it, which can be reflected back by the interior of the bellows and the rear of the lens and lensboard. Any surface imperfections on the lens such as chips, scratches, dust, or fingermarks, or light falling on the front of the lens from outside the subject area, will scatter light and contribute to flare. To minimize image degradation due to flare, keep your lenses clean and dust-free and shade the lens during exposure. Remember that using a lens with much more coverage than you need only produces troublesome extra light which must be absorbed by the bellows.

Diffraction. Light behaves in some ways like rays, or like beams of atomic particles, and in some ways like waves. One form of behavior best explained by a wave theory is that of light striking the edge of an object. The edge of the diaphragm, for example, causes the light striking it to *diffract,* or spread, in an unfocused way similar to flare, resulting in decreased contrast and resolution. Since it only happens at an edge, the extent to which it

affects the image depends upon the proportion of edge light to center light. Mathematically, the circumference of the diaphragm, its edge, is a multiple of its diameter; in other words, the circumference is directly proportional to the radius. The total amount of light transmitted through a circular opening depends upon its area, which is proportional to the *square* of the radius. This means that as the aperture size increases, the area will increase at a greater rate than the circumference, and the proportion of diffracted light will decrease. Diffraction is therefore only a problem of smaller apertures.

In practice, stopping down a lens increases sharpness by reducing residual spherical aberration and coma until the diffraction begins to reduce image quality at the very small apertures. The middle apertures of any lens are the ones that have the best combination of reduced residual aberration and diffraction with increased coverage and evenness of illumination and definition.

Field Illumination. Four different factors inhibit the ability of a lens to produce an evenly illuminated image across its entire covering circle, or field. First, the inverse square law tells us that illumination of a subject diminishes with the square of its distance from the light source. Since the lens functions as the light source for the film and the center of the film is closest to the lens, the illumination of the film will diminish toward the edges.

Second, for light entering the lens at an angle, the aperture is an ellipse rather than the circle it appears to be for light entering along the optical axis. As the angle away from the axis increases, the

Schneider makes this graduated neutral-density filter to correct uneven field illumination in their wide-field lenses. ∎

ellipse gets smaller in area. Again, this effect diminishes the illumination given the film in proportion to the distance from its center.

Third, for the same reason that the noonday sun is the hottest, any light that reaches the film at an angle loses intensity in proportion to that angle, resulting yet again in less illumination at the edges of the film.

Fourth, vignetting (or shading) by the lens barrel causes a difference in illumination between the center and edges of the field, resulting in diminished illumination away from the center.

The effects of these four factors compound each other and work against the designer, who is trying to produce a lens with an evenly illuminated field. It might seem to be a losing battle. Despite all these obstacles, however, uneven field illumination can be manageable, even inconsequential, with small field angles. Unfortunately, uneven illumination increases greatly with large field angles and becomes a significant problem in the design and use of wide-angle lenses. The introduction of extremely large lens elements in modern wide-field designs has helped to reduce vignetting and the use of smaller apertures improves uneven illumination considerably. But even the best wide-field lenses still show a noticeable exposure variation from center to edges.

Fortunately for wide-angle lens users, a photograph slightly lighter in its center than at its edges is aesthetically more comfortable than the reverse. And often, uneven illumination in an enlarger will compensate by being brighter in the center, where the uneven negative is most dense. Dependable correction of an uneven field can be assured by adding to the front of the lens a special neutral-colored filter graduated with increasing density from the edges to the center. These filters are available from Schneider in sizes for their Super-Angulon series of wide-angle lenses and cost almost as much as the lenses they fit. They can be adapted to fit the fronts of other lenses.

A HISTORY OF LENS DESIGN

Each of today's view-camera lenses is a member of a family, a descendant of well-documented nineteenth-century ancestors. Because the performance characteristics of a lens—contrast, sharpness, color correction, and coverage—are often predictable if you know its lineage, we will trace the development of photographic optics up to the establishment of the major lens design families. Now that you are

The simple "burning glass" biconvex lens was the first improvement over the pinhole in the development of camera lenses. ■

familiar with the problems and constraints of the lens designer's job, you can read this lens genealogy and investigate some possible lens choices for your own use.

Most nineteenth-century lenses are now only collector's items, generally inadequate for use by today's standards of optical quality. Until the 1950s, each new generation of lens designs was accompanied by significant advances in quality. Since then, with the advent of antireflection coating and computer design, we have seen not revolution but refinement. Since most of the postwar lenses can be considered viable for your use, many of the more common models you might find for sale second-hand will be introduced in this section. After you have read the design history, the section that follows on current lenses organized by their family trees will help you know the strengths and weaknesses of the available modern lenses based on their origins.

Origin and Development

The first improvement over the pinhole as a lens was developed for the *camera obscura* (the camera's antecedent) and resulted from the use of the simplest forms of a single-element glass lens. The

The plano-convex simple lens has somewhat less spheri-cal and chromatic aberration than the biconvex. ■

Wollaston devised a positive meniscus in 1812 for an improvement in astigmatism and coma over the plano-convex lens. ■

biconvex lens is a plain "burning glass" with convex faces on both sides (the word *lens,* in fact, is Latin for *lentil,* a biconvex legume). In a camera obscura, a glass biconvex lens greatly increased the intensity of light at the focal plane for a much brighter image than a pinhole could form. Because the biconvex is thicker in the center than the edges, it is a positive lens and causes light rays to converge to a focus. From the introduction of this simple lens, the history of lenses is a sequence of attempts to reduce its aberrations.

The biconvex lens suffers from such extreme chromatic and spherical aberration that it can be used only with very small apertures, and then only for a very small field angle. A *plano-convex* lens, one with one face flat and the other convex, reduces the spherical aberration somewhat. To improve the performance of the camera obscura, a positive *meniscus* lens, with one face convex and the other concave, was devised by British physicist William Hyde Wollaston in 1812. This shape reduces astigmatism and coma and provides the best compromise of aberrations available in a simple lens. The meniscus has been in continuous production during the entire history of photography for inexpensive box and folding cameras.

The Compound Lens. The Giroux Daguerreotype camera of 1839, the first camera to

be produced in multiples, used a meniscus lens made by Charles Chevalier, with an aperture of about f/15. Chevalier's meniscus was formed by cementing a negative biconcave element to a bi-convex. This group was positioned behind the diaphragm. Its overall shape was a positive meniscus so it would still bring an image to a focus. This lens introduced an additional element to control aberra-tions and was therefore the first successful com-pound lens for any camera. The two cemented elements were made of different kinds of glass selected to introduce color shifts in opposite direc-tions that cancelled each other, thus removing much of the chromatic aberration. Called *achromatic* for this reduced aberration, lenses of this design also became known as *landscape* lenses.

The next major step in the development of the modern lens was taken in Vienna by Josef Petzval, who designed a lens in 1840 by mathematically calculating its behavior before it was constructed. Not only was it the first time this technique had been applied to a photographic lens, but it was the first lens Petzval had designed. It turned out to be a milestone.

Petzval made this compound lens, commis-sioned for the all-metal Voigtländer camera of 1841, from a cemented two-element achromatic meniscus by adding opposite the diaphragm two elements

separated by an air space. It was the sharpest lens then available and at f/3.6 was almost 20 times faster than the meniscus lenses of the day. Sitting for a portrait in this era meant having one's head clamped still for the duration of an exposure that might last 30 seconds; any increase in the speed of a lens was welcomed by photographers and subjects alike. With a covering angle of only about 20°, the Petzval lens could not be considered normal (a lens must have a covering angle of about 52° for the diameter of the covering circle to equal the focal length), but because portrait photographers usually prefer to use a longer-than-normal lens, the narrow coverage proved not to be a limitation. The Petzval design became the standard portrait lens for more than 60 years.

The Symmetrical Lens Family. The 1860s saw the emergence of the first *symmetrical* lens designs. When two identical lenses or groups are mounted as mirror images around a central diaphragm, the three transverse aberrations—lateral color, distortion, and coma—will be positive for one side and negative for the other. These aberrations of opposite orientation act to reduce each other, leaving the designer free to concentrate on reducing the other four aberrations. The reduction of the three transverse aberrations is at its maximum at 1:1 reproduction; when object distance and image distance are equal the transverse aberrations totally cancel each other out.

In 1866, Munich's Steinheil introduced the *Aplanat* and Dallmeyer of London the *Rapid Rectilinear.* In these first successful symmetrical designs, a two-element achromatic meniscus was designed to suppress chromatic and spherical aberration. This compound lens was then used for both the front and rear groups around a diaphragm that was positioned to reduce astigmatism. These lenses covered a field of 50° at f/8 with excellent definition and free of distortion. This *rectilinear* design (no curvilinear distortion) dramatically improved architectural photographs. Prior to these early symmetrical designs, distortion was always noticeable in photographs of linear objects.

Despite the improvements brought by these rectilinear lenses, including significant reduction of several aberrations, astigmatism was still noticeably present and field curvature limited the maximum aperture. The ingredients needed to bring these problems under control were developed by Dr. Otto Schott of Jena, in eastern Germany. Beginning in 1884, his four-year investigations into new optical glass types gave lens designers the key to reducing astigmatism and flattening the field. *Anastigmatic* lenses were the next leap forward.

Chevalier's meniscus, made for Daguerre's camera, was the first successful compound lens. ■

Petzval lens. ■

Aplanat or Rapid Rectilinear. ■

Double Anastigmat. ■

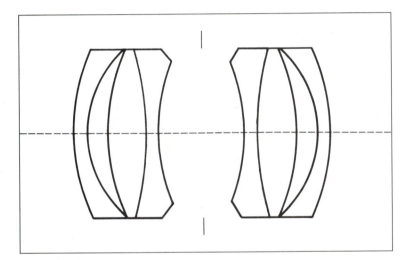

Double Protar. ■

Before Schott's experiments, opticians and lens designers were limited to using *crown* glass, a high-quality plate glass, and flint glass, made by adding lead. By adding other materials such as barium and zinc to the basic crown formula, the glass works at Jena produced new glasses with a wider range of refractive index and made possible the first anastigmat, the *Ross Concentric*. Patented in 1888, the Concentric showed improved performance from its reduced astigmatism, but its maximum aperture of f/16 made it too slow for practical use. The Concentric was rapidly eclipsed by the *Double Anastigmat*. Designed in 1892 by Emil von Höegh and manufactured by C. P. Goerz of Berlin, the Double Anastigmat had symmetrical front and rear groups each made of three cemented elements and it covered a field of 60° at f/6.8. After 1904, the Double Anastigmat became known as the *Dagor*. Lenses of this formula are still being produced.

In Jena, Carl Zeiss produced a lens similar to the Dagor, called the *Double Protar*, which was designed as a *convertible* lens. Each half of the lens comprised four cemented elements and could be separated and used independently. The four-element halves themselves had different focal lengths and connecting them resulted in a third. In theory, the photographer could have the utility of three lenses by owning one. Unfortunately, since much of the correction for aberrations provided by a symmetrical lens depends upon balancing positive error from one group with negative error from the other, the optical performance of the individual groups in a convertible lens is usually well below that of the complete lens.

This Busch Vademacum is a convertible lens set made in Germany about 1900. Interchanging elements resulted in seven different focal lengths. ■

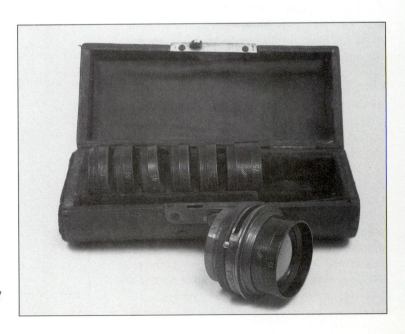

Three important variants of the cemented symmetrical lens were introduced around the turn of the century. By separating one of the three elements in each of the two groups by introducing an air space, the six-element Double Anastigmat design became the four-group *Plasmat* of Hugo Meyer and the Zeiss *Planar.* The former has an air space surrounding the inner two elements; the latter has the outer elements mounted singly. Also, the Plasmat uses negative groups on the outside and positive groups inside, while the Planar has its convergent groups on the outside. The Schneider *Symmar* (the predecessor to the current Symmar-S) was a convertible (three focal lengths) Plasmat. In 1898 Von Höegh made a four-element lens in which each half was an achromat meniscus with its two elements separated by an air space. This was the Goerz *Celor* f/4.5, later the *Dogmar.* Like the Planar, the Celor's outer elements are convergent, the inner ones divergent.

The basic concept of the symmetrical lens has continued to evolve and improve. The Opic, an f/2 lens of the Planar type produced in the 1920s by Taylor, Taylor and Hobson in England, began a design trend by showing that coma correction could be improved by making the front group larger than the rear. Although not strictly symmetrical, lenses of this type are still considered part of the symmetrical lens family. The Planar, Plasmat, and Celor designs are used as the basis for most of today's normal lenses for large-format photography.

The Triplet Family. A large family of lenses can trace its ancestry to the *Cooke* lens, introduced by Taylor, Taylor and Hobson in 1893. The Cooke was the first successful *triplet* lens, one whose elements form three distinct groups. The earliest triplet had been made in 1860 by Dallmeyer, but was displaced by the successful Rapid Rectilinear, which offered less distortion. The Cooke gained popularity, however, because of its good performance, low price, and wide f/4.5 aperture.

The most successful triplet design was calculated in 1902 by Paul Rudolph for Zeiss. Similar to the Cooke lens, Rudolph's *Tessar* substituted a cemented pair for the Cooke's single rear element, which flattened the field and improved spherical aberration. For its fast maximum aperture of f/4.5, the Tessar was the best corrected lens available at the time. Kodak's later *Ektar* and *Commercial Ektar* were popular Tessar-formula lenses.

Wide-Field Lenses. Very early experiments into wide-field design included an 1859 water-filled globe lens covering 120° and a 1900 lens incorporating a spinning propeller. The first well-corrected

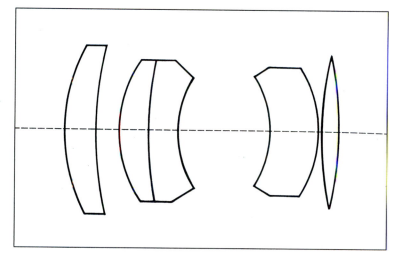

Planar. ■

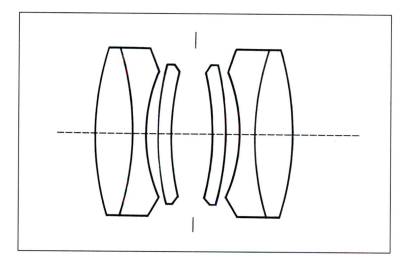

Plasmat. ■

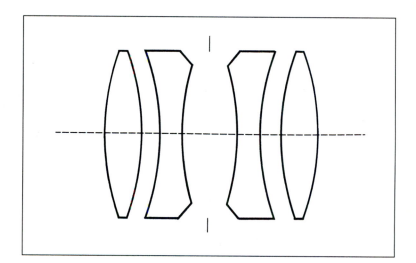

Celor. ■

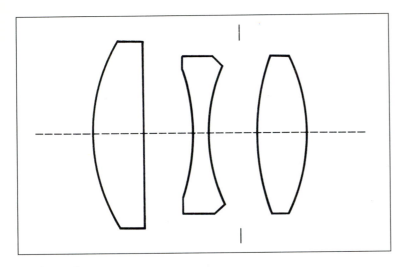

Cooke Triplet. ■

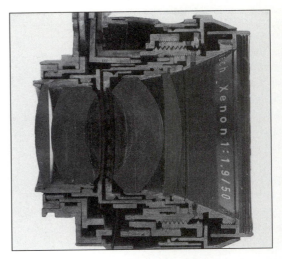

This cutaway section of a real lens reveals the accurate nature of schematic drawings. ■

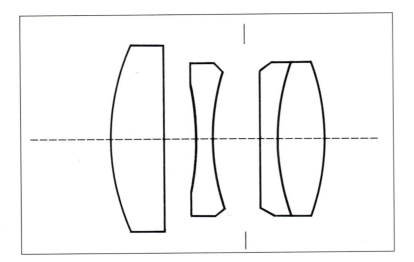

Tessar. ■

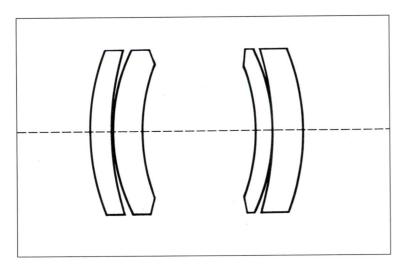

Gauss lens (Aristostigmat). ■

wide-field lenses appeared after the turn of the century based on the symmetrical *Gauss* design. The ancestor of these lenses was a pair of meniscus-shaped elements used as a telescope objective, designed by German mathematician K. F. Gauss. Hugo Meyer introduced the Gauss design as a photographic lens called the *Aristostigmat,* a symmetrical lens having two pairs of meniscus single elements. Many wide-field lenses from the recent past, including Kodak's popular *Wide-Field Ektar,* were similar four-element Gauss designs. Most of the modern wide-field lenses are derived from the Gauss formula, but have more than four elements.

Some early improvements in Gauss wide-field designs resulted in six-element, two group lenses, such as the Goerz *Wide-Angle Dagor,* a version of the Double Anastigmat. All wide-field lenses for view cameras are symmetrical designs with variations on the order of the elements and the inclusion of air spaces. The W. A. Dagor uses two groups, each with a negative element cemented between two positive components. The similar Schneider *Angulon* f/6.8, introduced in 1930, has a convergent element cemented between two divergent components. Like the W. A. Dagor, the Angulon is a well-corrected, compact lens. It covers a field of 85° and is readily available secondhand in focal lengths from 65 to 210mm. As with the Gauss-formula wide-angle lenses the maximum aperture in either of these two lenses is useful only for focusing because the field is only well-corrected below f/16.

MODERN LENS DESIGN

Symmetrical Designs. Lenses of symmetrical design in all focal lengths dominate today's available lens choices. If you wish to begin with a good all-purpose lens, a Plasmat design of near normal focal length should be your choice. Most have a maximum aperture of f/5.6, which under most circumstances is certainly wide enough to provide a bright image for focusing. The covering angle for a Plasmat, usually 60° at full aperture, increases to around 70° at f/22. Schneider's *Apo-Symmar,* the Nikkor *W,* and Rodenstock's *Apo-Sironar-N* are f/5.6 Plasmats with the front group slightly larger than the rear. Rodenstock's lenses are relabeled and marketed as Calumet's *Caltar II* and Sinar's *Sinaron.* Most of today's Plasmats are made in a range of focal lengths from 100mm to 360mm. The *Symmar-S* and the Apo-Sironar-N are also available in 480mm, and the Fuji *AS* has been made in 600 and 1200mm, although Fuji lenses are no longer imported to the United States. A 150mm Plasmat will project a covering circle with a diameter greater than 200mm at f/22—large enough for 5x7, or for 4x5 with lots of room for movements.

Rodenstock's *Apo-Sironar-S,* a version of their Apo-Sironar-N with a further enlarged front element, increases the field angle from 72° to 75°. Their *Apo-Sironar-W* (150, 210, and 300mm) and Schneider's *Super-Symmar HM* (120, 150, and 210mm) add a single-element group to the front and yield a field angle at f/22 of 80°. These new lenses offer superb sharpness, contrast, and coverage at a cost commensurate with very professional equipment.

Schneider's *Xenotar,* no longer made, is a five-element Planar design, covering 56°. Only the longest focal length, 150mm, is suitable for 4x5. Compared to the Plasmats, the Xenotar's coverage is limited, but a maximum aperture of f/2.8 makes the lens desirable for any low-light or high-speed application.

A lens with careful three-color correction is called an *Apochromat.* These lenses are carefully corrected for three primary colors (the specific red, green, and blue used in conjunction with the process ink colors of cyan, magenta, and yellow to reproduce color photographs in print) and therefore cannot be simultaneously well-corrected for a large aperture or wide field. The turn-of-the-century Celor four-element design has been in production recently as an apochromatic process lens. Rodenstock's current *Apo-Ronar,* the Schneider *Apo-Artar,* and its forerunner, the Goerz *Red Dot Artar,* are

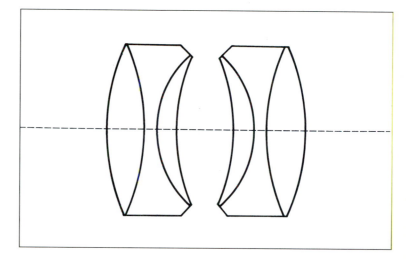

Wide-Angle Dagor. ■

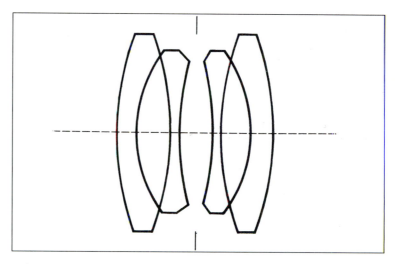

Schneider Angulon. ■

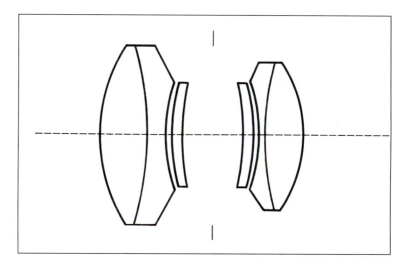

Nikkor-W. ■

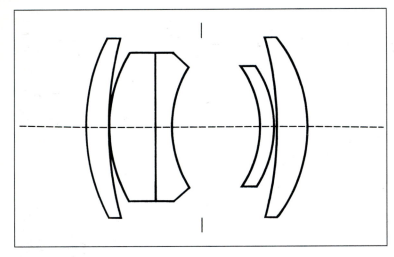

Schneider Xenotar. ∎

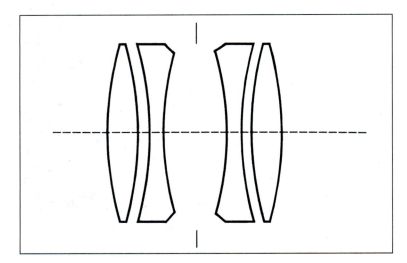

Rodenstock Apo-Ronar. ∎

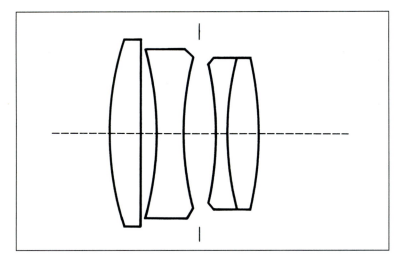

Fujinon-LS or Schneider Xenar. ∎

Celor designs optimized for reproduction ratios near 1:1.

Electronic scanning has almost entirely replaced process cameras in the graphic arts, so current flat-field repro apochromats are coming to be known as *macro lenses,* indicating their advantage in reproduction ratios between 1:4 and 4:1. Schneider's *Makro-Symmar HM* (80, 120, and 180mm), Nikon's *Nikkor-AM ED* (120 and 210mm), and Rodenstock's *Apo-Macro-Sironar* (180mm only) are current examples. Maximum apertures often no greater than f/9 and field angles from 45° to 65° usually make them impractical for general use.

Triplets. Rodenstock's economical *Geronar,* a classic 1893 three-element Cooke formula lens in 210 and 300mm versions, was the last of the Triplet family. Another recent Cooke Triplet was the Fujinon *SF,* a controlled-soft-focus lens. The SF was designed to introduce controlled aberrations for a soft-focus effect, mainly for portrait photographers. Rodenstock's *Imagon* (200, 250, and 300mm) remains available for this use, though it is an even more anachronistic two-element achromatic meniscus.

Rudolph's classic Tessar formula lives on in the current Schneider *Xenar* and Nikkor-*M,* along with the older Fujinon *LS* and Caltar *Pro.* Covering 50° to 60°, they are an alternative to the Plasmats for a general-purpose lens if your applications require few movements or a longer-than-normal focal length. The four-element Tessar has fewer surfaces to generate flare than the six-element Plasmat and will therefore usually produce a higher-contrast image.

Wide-Field Lenses. All wide-field lenses made today for view cameras are symmetrical designs. Although current symmetrical lens designs for normal lenses are little different from their progenitors, wide-field lenses have benefited from great improvement. Reducing aberrations is much more difficult for wider field angles and the introduction of additional elements to control these aberrations has always been inhibited by the additional flare that results from extra reflecting surfaces. The greatest benefit of recently developed multicoating techniques has been to those lenses with many elements: zoom lenses (not made for large-format cameras) and lenses with extremely wide fields. Designers are now free to use as many as eight elements to produce a well-corrected wide field without loss of illumination or image degradation from flare. The only drawback is cost: modern wide-field view-camera lenses are among the most expensive pieces of professional gear. But for the working photographer whose reputation depends on an image of quality, today's wide-field lenses are a godsend.

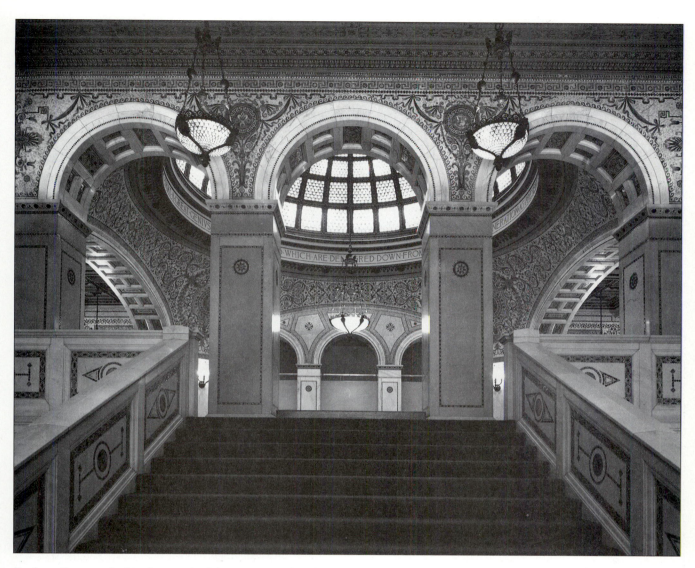

Barbara Crane made this photograph of the staircase to the Chicago Public Library's Preston Bradley Hall in 1976. With her wide-field lens, she used a front rise to keep the columns vertical while the view seems to be looking up the stairs. The building is now the Chicago Cultural Center. ■

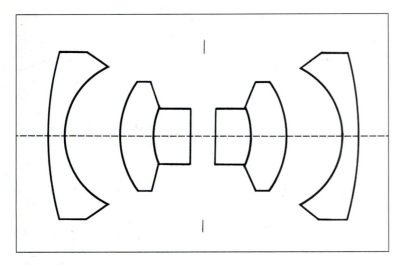

Schneider Super-Angulon. ■

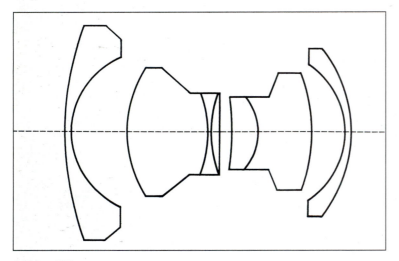

Nikkor-SW. ■

The first truly modern wide-field lens for large-format was the Schneider *Super-Angulon* f/8, introduced in 1956. Available in focal lengths from 65 to 210 mm, this six-element symmetrical lens design has a useful field angle of 100°. The Fujinon *NSWS* has the same design and much the same performance. The longest focal length of the Fuji wide angles, now discontinued, was the immense (weighing over three kilograms) 300mm. At f/22, the 300 covered a 720mm circle, big enough for 18x22-inch film.

A 1966 addition to Schneider's wide-field line is the *Super Angulon f/5.6 Series,* with eight elements and a 105° field. Available in focal lengths from 47 to 90mm, these lenses are larger, heavier, and more expensive than the f/8 versions. But in addition to ease of viewing and focusing from the additional stop of brightness, improvements are apparent in field illumination and sharpness at the edges of the image circle. The Rodenstock *Grandagon-N* f/4.5 has the same design and performance, and is almost a full stop faster. Nikon's *SW* f/8 lenses, in 90 and 120mm, are also the same design and offer the same performance, although they are slower. Schneider's newest version of the Super-Angulon, the *XL,* pushes the field angle to 110° for the 58 and 90mm lenses, 115° for the 72mm version, and an astonishing 120° in 47mm. The 47 is fully useful (with its 166mm image circle) for 4x5.

Nikon's SW series includes an unusual asymmetrical design. With seven elements in four groups for the 65mm f/4 and the 75 and 90mm f/4.5, these lenses reach 105° at f/16. None of these lenses, or any wide-angle lens for that matter, should be used for photographing at its maximum aperture. The

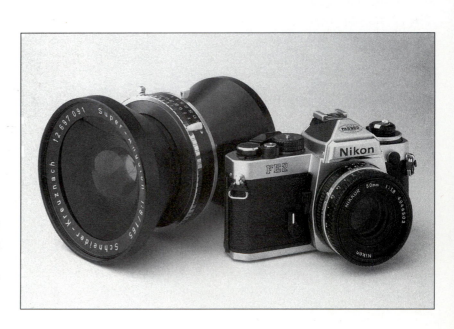

This 165mm wide-field Super-Angulon dwarfs a modern 35mm camera. The large lens is a wide-angle when used with 8x10 film. ■

Jim Dow makes contact prints from the 8x10 color negatives he takes with his Deardorff camera and wide-field lens. This is Dow's Rear Display Room, Dyson's Jewellers, Leeds, West Yorkshire, England, 1983. *Original in color.* ∎

ground glass will be almost four times as bright for focusing and viewing with an f/4.5 lens as with an f/8, but in both cases only the center of the image is usable at the widest aperture. The Nikon indicates a significant design advancement, reaching optimum performance at f/16 instead of the usual f/22.

Wide-field lenses for view cameras, despite their shortcomings, have a distinct advantage in their symmetrical design over the retrofocus wide-angles necessary for single-lens reflex cameras. The mirror that must be interposed between lens and film in an SLR requires the use of a wide-angle lens whose *back focus* (or image distance at infinity focus) is longer than its focal length. A retrofocus lens (sometimes called an inverted, or reversed, telephoto) cannot be made with a symmetrical design. The quality of such a lens suffers because it is much more difficult to correct, requires more elements, and is more expensive to manufacture than a symmetrical design of equal focal length and coverage. If you are accustomed to using wide lenses on small cameras, you will be very pleased to see how much better the optical quality can be from using a wide lens on a view camera.

Arch Construction III, Moscone Site, 1981, *by San Francisco's Catherine Wagner, who documented that city's construction of a new convention center with a 90mm wide-field lens on her 4x5 field camera. A short focal length wide-field lens is a necessity when working in an area like this with severely restricted vantage points.* ■

When Jim Dow's 165mm Super-Angulon lens doesn't provide a large enough angle of view, he carefully pieces together multiple prints from the same vantage point, as here: Reading Room, The British Library, Bloomsbury, London, 1983. *This photograph, like the one on page 131, shows Dow's use of the descriptive powers of a large-format photograph to reveal a precise, detailed catalog of everything that was visible to the lens (original in color).* ■

8

ACCESSORIES AND OPTIONS

In addition to your camera, lens, and shutter, you will need or may want to use a number of accessories. Most large-format cameras cannot be used without a tripod, hand-held light meter, and cable release, all of which are considered advanced options in the use of smaller cameras. As with lenses, these and other accessories are invariably manufactured by a different company from the one that made your camera, giving you the pleasure of a wide range of choices but also the responsibility of ensuring that each accessory is compatible with the rest of your equipment and suitable for your needs.

This chapter discusses camera stands, light meters, and other items not supplied with the view camera and includes further information about some accessories already discussed, such as film holders. The last section of the chapter describes those parts of your camera, such as the bellows, ground glass, and lensboard, for which options are available from your camera's manufacturer. With all these options and accessories you can tailor the versatile view camera exactly to your specific personal or professional photographic needs.

ACCESSORIES

Camera Stands

Few large-format cameras were designed to be hand-held. The longer focal-length lenses necessary to cover large sheets of film require smaller apertures for adequate depth of field, and small apertures require shutter speeds too slow for the camera to be held steadily. The few large cameras designed for hand-held use were a poor compromise in an era that gave the photographer no satisfactory options. Back then, if you couldn't get the picture with a large-format camera, you didn't get the picture. Today, with high-quality 35mm equipment satisfying any need for speed and portability, your reasons for using large-format equipment probably do not include any good excuses for hand-held work.

You will also find it impossible to learn to use the camera or control its movements if it is not held still for you. The first accessory for you to consider, then, is a camera stand to get the camera out of your hands.

Tripods. The most common camera stand is a *tripod*, which consists of three legs joined at their tops with a platform to support the camera. Like the early cameras, the tripods that held them were made of wood. Surveyors still use wooden tripods to support their optical equipment because the wood

The shorter tripod is more compact but requires more time to set up. Both will place a camera at about the same maximum height. ■

construction makes them resistant to binding caused by dust and dirt. The few wooden tripods still made for cameras are particularly useful for work in the field around dirt or water.

Most camera tripods currently available are aluminum, with tubular legs and a cast platform. An aluminum tripod can be adjusted more precisely and easily and is much lighter than a similar wooden one. Each tubular leg is made of concentric segments that can be extended independently and locked in place. The number of leg segments is a compromise between portability and maximum height. Unless you need an extremely compact tripod for portability, or one taller than you, three-segment legs should be sufficient. Setting up and collapsing a tripod with four- or five-segment legs can be time consuming and tedious. Most tripods have an extendable center column to allow easy vertical adjustments and to increase the maximum height permitted by the legs alone. For heavy cameras, this center column should be geared and have a crank handle to raise and lower the camera. A reversible center column allows you to suspend the camera below the tripod for low-angle shots. Increasing the height of the camera with the center column rather than by extending the legs makes the camera less stable, so use the center column only for small adjustments in height.

Conventional wisdom dictates that your tripod should weigh at least as much as your camera so it can resist vibration from air movement and provide a solid base of support. The larger the diameter of the leg segments, the more the tripod has of both stability and weight. If you must use a lightweight tripod in the field, you can increase its resistance to wind by hanging a weight or heavy bag below the center column.

Monostands. During the first century of photography, the itinerant photographer carried a tripod for camera support while his indoor counterpart used a special table. This table, with its tilting top and wheeled legs, is the direct ancestor of today's *monostand.*

Whenever portability ceases to be an issue, sturdiness is the most important attribute of a camera stand. Monostands are much heavier and consequently sturdier than tripods. A monostand is a heavy column resting on a wide, low base. A horizontal arm extends from the column to hold the camera. The arm is usually counterbalanced with weights or springs so you can move it easily up and down the column while it supports a heavy camera. Optional locking wheels on the base allow you to move the heavy monostand easily and lock its position for shooting. You may also select arms and

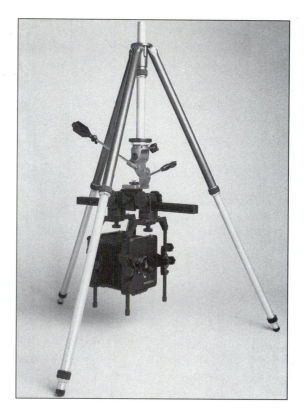

Some tripods allow the center column to be reversed for low-angle photographs. ■

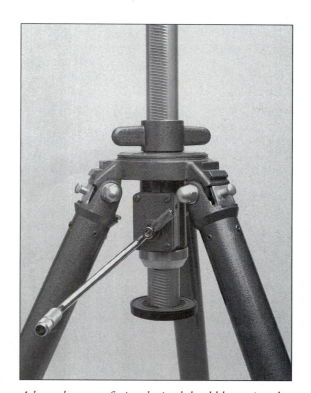

A large, heavy professional tripod should be equipped with a geared crank on the center column to make vertical adjustments with a heavy camera easier. ■

A monostand is the best camera support for a view camera that stays in the studio. ■

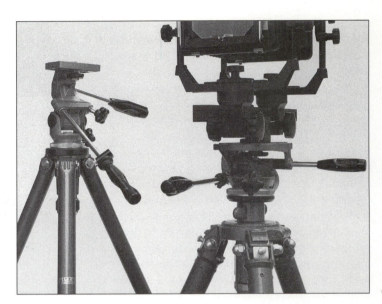

A double-tilt tripod head allows easy adjustment of the camera position around three axes. ■

A ball head is more compact and easier to transport than a double-tilt head, but not as convenient to use. ■

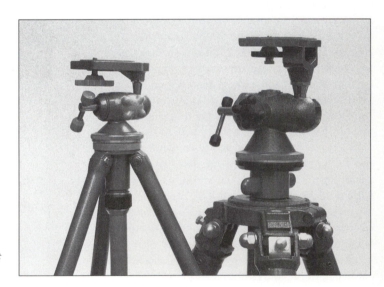

columns of different lengths to suit your needs. An optional accessory tray on the arm or column provides a convenient resting place for film holders or a light meter. In the studio, you will probably prefer a monostand to a tripod. It adjusts more easily, occupies less floor space, and allows the camera to be positioned against or cantilevered over a tabletop surface.

Tripod Heads. All monostands and tripods large enough to be used for view cameras are made by suppliers of professional photographic equipment. One indication of a professional tripod is that it is sold as a set of legs independent of a support

platform and its adjustment mechanism—the *tripod head*. In addition to clamping the camera firmly to the tripod or monostand, the head allows you to adjust the position of the platform and camera. You will have a choice of several different heads to fit your choice of camera stand.

Three types of tripod heads are available: single-tilt, double-tilt, and ball. *Single-tilt* heads allow adjustment only around a horizontal axis (similar to a tilt of the entire camera) and are most often used for cinema and video. They are made to *pan,* or rotate smoothly during a shot, a quality unnecessary for most still-camera work. A *double-tilt* head, the

most common for still photography, provides two levers to adjust the angle of the platform around two perpendicular horizontal axes, tilting front to back and side to side. A *ball* head works much like a human shoulder joint—it is a ball-and-socket. Only a few ball-heads are sturdy enough for constant use with a view camera, but their light weight and compact construction make them desirable for field work.

All three types of tripod head are available in different sizes, each based upon the weight of the largest camera it is expected to support. When you select a tripod head, be sure the platform is large enough for your camera, that its movements are smooth, and that it can securely lock your camera in place, even at an angle. A larger head will lock any camera more securely and its longer levers give you more control when adjusting it, but it will also weigh more and take up more room.

Your tripod head will have a threaded mounting bolt projecting through its platform. Make certain the threads match those of the corresponding hole in your camera's baseplate. The bolts come in two standard sizes: ¼-20 (¼-inch diameter, 20 threads per inch) is the smaller of the two, and that thread size is used in the tripod mounting hole on most hand cameras; the larger ⅜-16 is called the European thread and is safer for use with larger, heavier cameras. The camera mounting platforms on larger tripods often come with two interchangeable bolts, one in each of the standard sizes. You can buy a threaded adapter to fit the smaller bolt into the larger hole, but it makes a weaker connection than using the correct size bolt.

Tripod Adapters. If you need to connect and disconnect your camera and its tripod frequently, you might consider using an accessory two-part bracket available for rapid mounting. One part of this *quick-release* adapter couples with the camera and nests into the other part, which is held to the tripod head. The two parts then clasp or bayonet together firmly and release with the press of a button or catch. A quick-release adapter does not make as strong and secure a connection between camera and tripod as the standard mount and can fail when used with heavy cameras in unusual camera positions.

Another accessory adapter, sometimes called a *twin bracket* or *twin head,* can be handy when you use a monorail camera for extreme close-ups or with long focal-length lenses. You will find that these situations greatly increase the distance between lens and film and cause balance problems for the camera and tripod. With a large heavy lens and a long

You should consider using a quick-release bracket if you need to disconnect and reconnect your camera and tripod frequently. ■

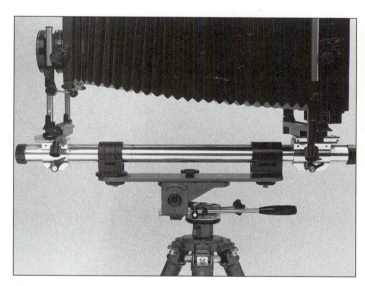

This twin-bracket adapter can help ease the strain that a long bellows extension and heavy camera place on the monorail. ■

bellows extension, you can put great strain on the monorail and tripod head. A long rail, particularly one made up of shorter sections, may be forced out of alignment inadvertently.

To compensate for the bending force on the rail, use a tripod adapter such as the one shown here to hold two rail clamps (you can buy a second rail clamp as an accessory for most monorails). Twin bracket adapters are often sold for the purpose of mounting two cameras side by side on one tripod,

For extreme bellows extensions, your rail should be supported by two tripods. ■

but one can be used to provide two points of support for the monorail instead of the usual single point. Use caution when positioning the camera, for the adapter will increase the distance between the tripod head's platform and the camera. This additional distance will raise the center of gravity of your camera and make it more difficult for the tripod head to hold an inclined camera. The farther from level you position the rail, the more strain there will be on the head and the greater the likelihood you will tip the entire tripod. For extremely long extensions, or situations where a two-clamp adapter proves inadequate, you should use two tripods. Setting up a camera on two tripods is awkward, but will result in a setup unlikely to vibrate or fall.

Cable Release

A *cable release* is a flexible plunger that triggers your camera's shutter. Its tip threads into the proper fitting on your shutter and a release button that fits your fingers caps the plunger at the other end. An internal spring returns the plunger when you stop pressing on it. You must have a cable release for most view camera operations.

Start with one about 16 inches (40cm) long. You should be able to release the shutter with your hand far enough away from the camera that you don't risk jarring it. If you cannot stand next to the

camera, or for some reason need to operate the shutter from a distance, there are cable-release extensions as long as 10 meters, rubber bulb air-tube releases twice that length, timed releases, and even radio-controlled and infrared-triggered remote control releases. If your shutter has no T (for Time) setting to keep the shutter open for a longer exposure than its slowest setting, you may wish to use a locking cable release, one that can be set to remain in the extended position until you release it. Before buying any cable release, try it with your lens to make sure the tip at the shutter end extends far enough to trigger your shutter. It is not uncommon for a photographer to have a cable release for each lens and to leave them attached during storage.

Light Meters

When you are photographing with any camera, the correct exposure for a situation is most easily determined by measuring the light intensity with a *light meter*. Most hand cameras are now equipped with built-in meters and many amateur photographers are unaware that there is an option. With a view camera, you must use a separate light meter. Hand-held light meters are of two types: *reflected* light meters, which you point at the subject from camera position to read the light reflected from the subject, and *incident* meters, which you point at the camera from the subject position to read the light falling on

A good cable release is a necessary accessory to your view camera. For releasing the shutter from a distance, an air release is better. Air tube extensions are available. ■

Light meters have become more accurate and easier to use with developments in electronics. The three major types are (clockwise from the top) incident/reflected, spot, and strobe. ■

(or incident upon) the subject. Both are equally useful in the hands of an experienced photographer. Some meters are designed to measure light both ways.

Some reflected light meters are designed to read only a very narrow angle of the incoming light. These are called *spot* meters, many of which read a tiny circle at the end of an imaginary one-degree cone. Spot meters are most useful for black-and-white shooting in which tonal values of different parts of the same scene must be determined independently, such as with the Zone System. Another group of meters, mostly designed as incident-reading, can measure a short burst of light. These are called *flash* meters (or strobe meters) and are a tremendous help in the studio for use with electronic flash.

Designed especially for 4x5 view cameras (and for larger cameras with reducing backs) are several other meters and meter attachments that read directly from the ground-glass image. Some will read flash as well as continuous light; all have the virtue of compensating directly for light loss due to bellows extension.

Darkcloth

Even with your lens at full aperture, the inverted image on the ground glass is too dim to be seen well without surrounding it in darkness. A *darkcloth* made from a simple one-yard (one-meter) square of black cloth can be used to cover the camera and your head simultaneously and is sufficient to allow easy viewing. An improvement on the simple black

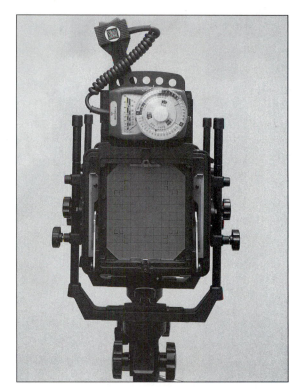

A probe connected to this light meter reads directly from the spot the film will be during exposure. ■

cloth is the addition of a light-colored facing on one side. A white or silver side used facing out will reflect sunlight instead of absorbing it and will make focusing much more comfortable outdoors on warm, sunny days. The second layer of cloth also

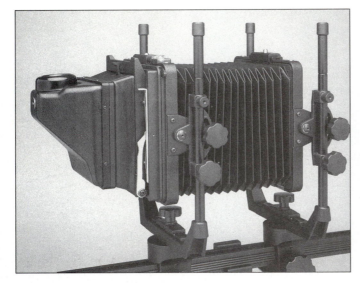

This accessory hood makes viewing easier by reinverting the image, magnifying it, and darkening the area around the ground glass. ■

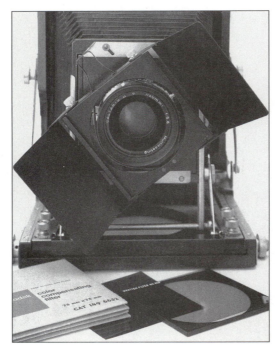

The gel filter holder on the lens incorporates adjustable black flaps to help shade the lens and reduce flare. ■

makes the darkcloth more opaque for viewing and the light side can be used as a reflector for bouncing light into a scene. You can also use the darkcloth to wrap and protect your camera between uses.

When it's windy, keeping the cloth secure on the camera requires some ingenuity. Here are some possible solutions: fasten the darkcloth to the camera with added clips; use Velcro strips on camera and cloth; sew a circle of elastic into one end of the cloth; or tie the cloth around your neck like a cape and then secure the bottom around the ground glass with a clothespin.

Viewing Hoods

If the darkcloth seems like a burden, you might use one of a number of accessory viewing and focusing hoods that attach to the back of the camera. The simplest hoods merely replace the darkcloth with a rigid metal or plastic clip-on shade. Some, similar to a compendium, have a built-in eyepiece (sometimes a magnifying eyepiece) so that viewing admits no stray light to the back of the ground glass. More sophisticated (and expensive) are *reflex* viewers that invert the ground-glass image for right-side-up viewing of the normally upside-down image. Unfortunately, none of the accessory viewers wraps and protects your camera between uses as well as a darkcloth.

Filters and Holders

The professional view camera user is likely to need a variety of filters for contrast control, color correction, and lighting compensation. Rather than buy one screw-in glass filter of each color for each different-sized lens, most photographers use *gel* filters. These gels, actually thin sheets of dyed gelatin, are available in squares of several sizes for a fraction of the cost of glass filters.

If you use a filter infrequently, tape the filter over the front of your lens when you need it. Be careful not to get the tape in the light path. Outdoors where wind and the elements threaten the gel, tape it to the rear of the lens where it is protected inside the bellows. Gel filters are expected to succumb to use, becoming scratched and damaged with age and use. If you use filters more regularly, or need more than one at a time, you should have one of the several different kinds of filter holders available to hold them to the lens. Even though gels are less expensive than glass filters, you still will not want to replace them too often; they will last much longer if you use a filter holder instead of tape.

Some filter holders simply hold the filter in front of the lens; some include flaps to function as a lens shade. Other holders clip onto the lens and will

fit lenses of several different diameters. The most
secure connection is made by screwing a filter
holder into the threaded front of the lens, but this
requires an adapter for each lens diameter. A
compendium bellows (p. 153) also includes a provi-
sion for holding filters.

Camera Cases

Unfortunately for the user, view cameras present an
awkward problem when they have to be shipped or
stored. Many cameras are irregularly shaped and the
ground glass is fragile. Most monorail cameras
cannot be set down in a stable position on a flat
surface. If your camera stays in the studio, you may
just want to leave it on a tripod draped with the
darkcloth when not in use. If you work on location,
a field or press camera is desirable because they fold
into a compact, protected box.

A monorail camera must be at least partially
disassembled to assume a compact shape, and some
manufacturers provide attaché-like cases to carry the
pieces conveniently. If you want to take the camera
out of its case ready to go on the tripod, it must be
suspended upside down by its rail in a specially
made box. These cases are available from camera
manufacturers and accessory companies or you may
have one custom-made by a trunk or case maker.
Fiberboard, aluminum, and plywood are commonly
used for constructing camera cases; you will find
increased protection comes with either higher price
or greater weight. Wheels on a camera case will also
help you.

*If you have the time to disassemble your camera before packing it, you can
store or carry it in an attaché case like this one.* ■

*Protective but bulky, a camera case
like this stores the camera ready to
be mounted on the tripod.* ■

Film Holders

Double Sheet-Film Holder. The standard film for view cameras is sheet film and the standard holder is a sheet-film holder. The double sheet-film holder pictured here is ubiquitous, but as you will see in the next few sections, it is by no means your only option. Film holders are designed to prevent stray light from striking the film during use or storage. They are most often made of plastic; metal holders are available at three times the price but do not function any better.

Each of the double sheet-film holder's two faces holds one sheet of film under a darkslide to protect the sheet until you are ready to expose it. Each film holder will hold no more than two sheets of film and must be unloaded and reloaded in the dark before reuse. When you are shooting in the studio, you can have ready as many holders as you care to own. In the field, excess film adds considerable unwanted weight and bulk.

The main function of this and any other film holder is to hold the film flat and in place, that is, in the same plane as the front surface of the ground glass. Plate holders, similar in appearance to film holders, are designed to hold an emulsion-coated glass plate at the film plane. Trying to use a plate holder for sheet film will result in poor focus because the thinner film will be held in the wrong position. Be careful when buying used holders not to confuse the two types.

Each face of your film holder has a flap at the bottom to fold down out of the way so you can slip in the film. At the top of each side of the holder is a slot lined with a light trap of black cloth. The darkslide is inserted through this slot and seated in the bottom flap. The bottom flap and the light-trap slot can leak light if worn, as can the darkslide if cracked or chipped. Carefully inspect these areas on any holders you buy used and occasionally check all your holders as they age. See how to test and repair holders in Chapter 9.

On the top edge of each double film holder is a pair of small wire clips. These clips safeguard against the unintentional removal of a darkslide. After you load each holder, rotate the clips into a position that

Other than their size, double sheet-film holders are basically identical from 2¼ x3¼ (top) through 11x14. ∎

The small wires at the top of each holder can be used to lock the darkslide against inadvertent withdrawal. ∎

blocks the movement of the darkslides. Move the clip out of the way before withdrawing a darkslide for exposure and relock that side afterwards. You may wish to use the locks only for exposed film, since a forgotten lock may cause you to move the camera out of position inadvertently when you try to withdraw a locked darkslide before exposure.

Grafmatic Film Holders. No longer manufactured, but readily available second-hand, a *Grafmatic* film holder can be loaded with six sheets of film, but is only slightly thicker than a double sheet-film holder. Each sheet of film is held in a *septum*—a thin metal separator—and is cycled to the back of the holder after exposure. After six sheets have been cycled, the holder locks to prevent double exposures. The Grafmatic is a boon to any itinerant photographer since it offers a tremendous saving in space and weight over double sheet-film holders.

Before purchasing a used Grafmatic, check for the label *"45" Graphic,* which will ensure compatibility with any contemporary spring back. Grafmatics were also made to fit an earlier clip-in (nonspring) back, and are marked *"45" Graflex.* These holders are unlikely to be useful unless you are using an older Graflex camera. Before you commit important film to exposure in a Grafmatic, practice working with an unloaded holder in the light until you understand its mechanism and idiosyncrasies.

Roll Film. Although your view camera was designed to use sheet film, it may be easily adapted to use convenient roll film with a *roll film adapter.* The widest commonly available roll film is 120 size, and the adapters are made to fit 4x5 Graflok or other 4x5 spring backs, so using roll film means you will be reducing your large-format camera to medium-format. You will sacrifice the quality of the larger film for the convenience of roll film but still retain the other advantages of a view camera.

There are two basic styles of roll film adapters for the use of 120 film in a 4x5 camera. One style threads the film from one end of the adapter to the other, around it and back, so that both the supply and takeup spools of the film are at one end of the adapter. This kind of adapter can be made thin enough to fit in the spring back like a sheet-film holder. The other style, with the spools at opposite ends of the holder, replaces the spring back in a Graflok (or universal) back. The former is harder to load, but may be used without removing the ground glass each time after focusing. These adapters are made to accommodate 120 and 220 film, which are the same width but different lengths, and to make negatives in 6x7, 6x9, and 6x12cm formats.

If you wish to use roll film in a camera larger than 4x5, your camera may have a *reducing back* available as an option. A reducing back is made to fit the back of some 5x7 or 8x10 cameras and provide a 4x5 spring back in the center of the larger frame. These backs are necessary if you wish to use 4x5 Polaroid products (see the following section) in a larger camera.

A very few highly specialized aerial cameras use roll film in widths of 70mm (the same as 120), 5 inch, and 9½ inch. A discussion of their use is beyond the scope of this book.

This roll-film adapter from Sinar fits a 4x5 spring back and can vary its format to make 4.5x6, 6x6, 6x7, 6x9, or 6x12cm negatives on 120 or 220 roll film. ∎

Minor White took this photograph in 1973 on Type 52 Polaroid film. The finished print can be viewed in 20 seconds, allowing the results of one photograph to contribute to the next. ▪

Polaroid Films

Photography really came out of the dark ages in 1947, the year Dr. Edwin Land used an 8x10 view camera to demonstrate the first Polaroid self-developing film. It is difficult to comprehend, let alone summarize, the effect instant photography has had on the medium. Within ten years, Polaroid had firmly established an amateur market, selling well over a million cameras. By now nearly everyone, worldwide, has had some experience with Polaroid's amateur products as the photographer, subject, or observer of a pictorial near-miracle. Using instant film, people no longer need to wonder whether the picture will "come out."

Much less well known, yet responsible for dramatic changes in the lives of professional photographers everywhere, are Polaroid's large-format prod-

ucts. Before Land's introduction of a 4x5 holder and sheet film in 1958, a photographer's test exposure was always followed by a lengthy interruption for processing. In the studio, this limitation dampened enthusiasm for exploring lighting options, especially in the presence of a client. On location or in the field, the photographer always felt the need to ensure results with redundant exposures made with several different apertures and several different filters. Now a black-and-white print in 15 seconds (color in 60 seconds) gives us all the information we need about lighting, exposure, focus, and composition—indeed, it may give us the final product itself.

4x5 Sheet Film

The first system of products Polaroid developed specifically for professional and technical use was the sheet film and holder for 4x5 cameras. Still in

production, this film system uses single-exposure lighttight packets, each containing a positive sheet, negative sheet, and development chemical (Polaroid calls it a *reagent*) pod. These packets are sold in boxes of 20, and each packet may be removed from the box, loaded, and developed in the light.

The original #500 film holder was supplanted by the #545 in 1968 and the current #545i in 1993. These holders were designed to be inserted into the spring back of any standard 4x5 camera. Each holder contains a pair of stainless steel rollers to break the chemical pod and spread the processing *goo* (an unofficial Polaroid term) evenly between positive and negative for development. The rollers are engaged by a lever on the outside of the holder.

To load a sheet of 4x5 Polaroid film, set the lever on the film holder to L, for Load. Notice that one end of the film sheet has a metal clip. Insert this end of the film into the open end of the holder and slide the film down until the clip clicks into place and will go no farther. One side of the film packet, imprinted with the phrase "This side toward lens" should be visible through the open face of the holder when the film is properly loaded. Handle the film only by its edges and be particularly careful with the area of the packet surrounding the chemical pod. This area is slightly thicker than the rest of the sheet and is printed with a warning label.

When your camera is set for an exposure, insert the Polaroid holder as you would a standard holder into the spring back of your camera, making sure the open side of the holder faces the lens. The #545i holder can also clip into the place of the spring back in a universal (or Graflok) back. After checking to make sure the shutter is closed and the holder is properly seated, pull the exposed end of the film packet straight out until it stops. You have withdrawn the lighttight envelope that contains the positive sheet and left the clip, negative, and chemical pod inside the holder. This is equivalent to withdrawing the darkslide from a sheet-film holder.

Make the exposure, then push the film envelope back into its original position and remove the holder from the camera. Swing the lever on the holder to P, for Process, and lay the holder on the edge of a flat surface as shown. Setting the lever to P engages the roller assembly at the top of the holder, pressing the rollers together. Secure the holder with one hand, grasp the end of the film packet with the other, and pull the packet straight out of the holder through the rollers. The pulling motion should be very steady and neither too slow nor too fast; it should take about half a second to slide the packet all the way through the rollers. Pulling the packet

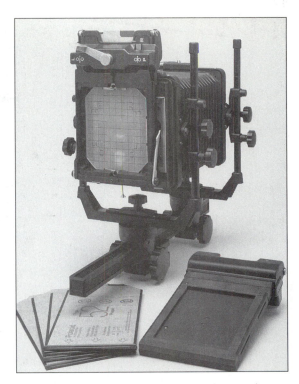

The Polaroid #545 film holder adapts their single-sheet films to a 4x5 spring back. ■

Place the holder on a steady flat surface and hold it in place firmly as you pull the packet through the rollers for processing. Leaving the holder in the camera for this operation risks jarring the camera out of position. ■

In Laura's Feet, 1973, *Rosamond Wolff Purcell takes advantage of the ability of Type 52 film to render delicate light tones.* ■

through the rollers breaks the pod of chemical reagent and spreads it between negative and positive as they are pressed together. As the negative develops, a process called *diffusion* transfers the image across the developer layer to the positive.

Begin timing the development just as the film leaves the rollers. Each type of film has its appropriate development time printed on each packet. A few seconds before the processing time elapses, peel apart the packet to reveal the negative/positive sandwich inside. Peel up a corner of the white positive sheet and separate it from the rest of the sandwich with a snap of your wrist at the moment the development time should end. Take care not to get any of the caustic developing reagent on your hands or clothing and wash it off immediately if you do.

Available Sheet Films. Polaroid makes a wide range of sheet films to work with their 4x5 film holder. Their most popular self-developing films for proofing in the studio are print films in black and white and color that match the ISO 100 film speed of the most popular conventional transparency films used by professionals. Useful for scientific and technical applications is a very fast (ISO 3000) black-and-white print film, and there is even a film (Type 55) that produces both a print and a usable negative after a 20-second development.

Pack Films

The roll film used in Polaroid's first amateur cameras required the negative and positive to remain in contact for development inside the camera. With the introduction of the pack film format in 1963, it was no longer necessary to wait for complete processing before making another exposure. Once a sheet of this pack film is exposed, the negative/positive sandwich can be pulled out of the camera through rollers, beginning the processing outside the camera. The packs, containing eight positive and eight negative sheets, were originally made to fit only Polaroid cameras containing built-in roller assemblies.

Polaroid introduced the Model #405 film pack adapter in 1974 to extend the usefulness of what by then was a full line of pack films. This adapter enabled photographers to use the series 100 (now series 600) pack films in conventional 4x5 cameras. The finished prints from pack films are smaller than 4x5 (about 72x95mm, or 2⅞ x 3¾ inches), so with the purchase of each film holder Polaroid includes an acetate template made to fit a 4x5 ground glass with position marks for the pack film format. The #405 holder incorporates a darkslide to allow removal of the holder from the camera for focusing and adjustment between exposures.

Mark Klett's 1983 photograph Picnic on the edge of the rim, Grand Canyon, AZ *is an enlargement made from a Type 55 instant negative. He used a lens tilt to move the plane of focus into a horizontal position stretching from his feet in the foreground to the opposite rim of the canyon.* ■

This Polaroid #405 Pack Film Adapter is held to the camera by the clips on the universal (Graflok) back. ■

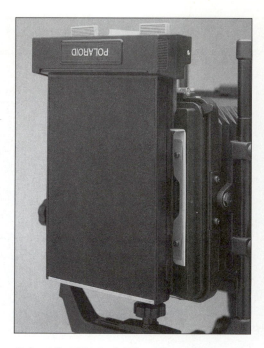

Polaroid's #550 Pack Film Adapter holds packs that each make eight instant 4x5 prints. ■

Because the film packs were adapted to and not designed for the view camera, the holder is too thick to fit easily into all spring backs. And when it does fit, its thickness demands that you take special care when inserting the holder to avoid jarring the camera. The holder was designed with side slots to allow it to clip into a universal back in place of the spring back.

Polaroid films available in packs correspond to their 4x5 films: there are black-and-white and color print films and a black-and-white positive/negative film.

4x5 Pack Film. In 1981, Polaroid introduced a larger version of pack film specifically for the professional market. These convenient pack films in full 4x5 size require the Model 550 film holder to adapt them to a conventional 4x5 spring (or universal) back. Films available for use in the Model 550 include Type 552 black-and-white and Type 559 color print film. Like the Model 405 holder, the 550 loads rapidly with pre-packaged packs, has a built-in roller system that is removable for cleaning, and incorporates a darkslide. The product illustrations for this book were made on Type 552 (and 52) film and are reproduced directly from the 4x5 Polaroid prints. This process saved the author countless hours of darkroom work.

The 8x10 System

Professional photographers who need a finished product without delay can use Polaroid's 8x10 system. Like the other professional products from Polaroid, the 8x10 system includes both positive and negative sheets, development chemicals in a pod, a roller assembly to burst the pod for processing, and an adapter to fit the system to a conventional view camera. The resulting 8x10 prints can go home with the client, be placed on display immediately, or be used as the original for high-quality offset lithography. An 8x10 print is large enough to be a satisfactory final product for many of the needs of portrait or commercial photographers, and an instant 8x10 print is also useful for making proofs for critical 8x10 work with conventional films.

Although the positive and negative sheets are packaged separately, each film available for Polaroid's 8x10 system is basically a larger version of one of their 4x5 products. The 8x10 system's film holder (Model 81-06) accepts one sheet of negative material at a time for exposure in a conventional 8x10 camera. After exposure, you slip the positive sheet with its attached chemical pod into the holder and insert the package into the electrically powered 81-12 Processor. Rollers large enough to distribute the developing reagent evenly across the eight-inch

The 8x10 system from Polaroid uses a separate motor-driven processor to ensure correct roller pressure and even development. The film holder shown here with the processor adapts the Polaroid negative to a standard 8x10 spring back. ■

width are too heavy to be incorporated into the holder, and the separate motor-driven processor ensures that the film will pass through the rollers at a constant and correct speed. Its built-in timer starts automatically and informs you when the selected processing time has elapsed.

OPTIONAL CAMERA PARTS

Bellows

The bellows on your camera is not an accessory but a necessary part of the camera. Your camera probably was supplied with an accordion-fold standard bellows as original equipment. The standard bellows for 4x5 cameras is square in cross section (it is also called a *square* bellows) and is the same size at the front and rear. Larger cameras most often have tapered standard bellows, still square in cross section but smaller at the front. A tapered bellows will collapse into a shorter package than a square bellows.

Bag Bellows. If your camera's bellows is removable and sold as part of a modular camera system, you will have the option of buying and using a *bag* or *wide-angle* bellows. Bag bellows is an appropriate name for the amorphous mass of black material that replaces the traditional accordion folds of a square bellows. It is needed when you use short focal-length lenses because the short back-focus distance (image distance) of a wide-angle lens requires that the front and rear standards be quite close together—close enough that most accordion bellows would be compressed almost totally. A

Not available in camera stores yet no longer a research lab curiosity, this huge view camera was built by Polaroid's technicians to make instant 20x24-inch color prints. This photograph of the author using the camera was made by John Reuter, the manager of the New York studio in which the camera is based. ■

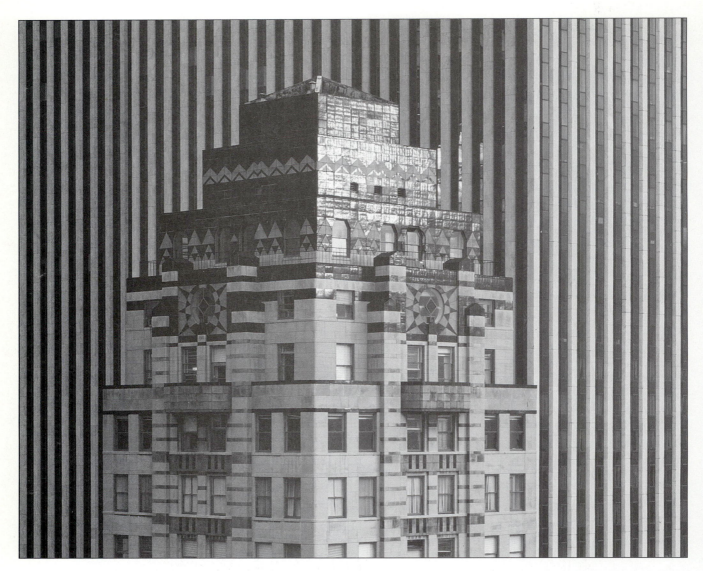

This photograph of the Fuller Building, with the General Motors Building in the background, was made by Reinhart Wolf for his 1980 book New York *(original in color).* ∎

German photographer Reinhart Wolf is shown photographing the top of a skyscraper. His 1000mm lens required an extra standard and bellows on his 8x10 Sinar. The third bellows at the extreme left is a compendium lens shade. This photograph is by Geoff Juckes. ■

square bellows closed all the way becomes quite rigid and prevents use of the camera movements. In fact, very short focal-length lenses often cannot be brought close enough to the film plane to focus at infinity with the square bellows in place. The bag bellows, however, offers no restrictions on movements and will allow the front and rear standards to be as close together as the design of the camera permits. Use of the bag bellows is limited to short focal-length lenses because of its short maximum extension.

Extra Bellows. Very long lenses or extreme close-ups can require another bellows option available only for a modular monorail camera. When one bellows will not extend enough for a particular use, a second may be added by sliding another standard onto the rail into a position between the front and rear standards. Since the clips on both sides of the standards are the same, this center standard may be used to connect the rear of one bellows to the front of another.

Compendium Bellows. Another optional bellows, called a *compendium* bellows, fits over the lens to be used as a shade and works to accommodate the camera movements in a way that a fixed lens shade cannot. While you view through the ground glass, you may adjust the compendium's

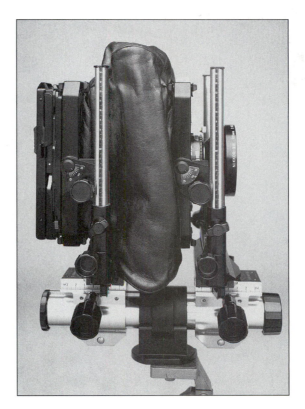

Using a wide-angle lens is much more convenient with a bag bellows and short monorail like on this Toyo. ■

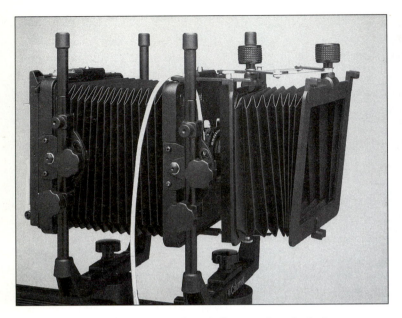

The compendium bellows is a lens shade that is adjustable to accommodate camera movements. ■

A magnifying loupe makes precise focusing easier. ■

extension to the correct length for a lens of any focal length and match any camera movements with the compendium's own front swing and tilt. Keeping stray light from falling on the front of the lens during exposure will reduce image-degrading flare; the compendium should shade the lens by being extended as far as possible without vignetting (blocking part of the image). Vignetting can be seen in the corners and edges of the ground glass as shaded parts in the image itself. Once adjusted, the compendium can be moved on its hinges up out of the way of the lens so you can adjust the aperture and set and wind the shutter. The black accordion folds of its inner surface, like the interior of the camera's bellows, act as a baffle to reduce unwanted light reflection. Many models of compendium bellows include a convenient drawer across the front of the bellows for holding a filter, but they require a larger, more expensive gel than those you can attach to the front of the lens.

Ground Glass

The ground glass supplied with your camera is relatively easy to replace. And since it is the most fragile part of your camera, it may not be long before you need to find out just *how* easy. You may also want to replace the screen with one of the optional styles to better suit your needs.

The most simple ground glass is a plain, unmarked rectangle cut in the correct dimensions to fit into the spring back's frame on your camera's back. Many plain ground-glass screens have cut corners that serve two purposes. First, if your camera does not incorporate lighttrap air vents in the standards, these cuts are necessary to allow air to flow in and out of the camera's interior when the bellows is moved during setup or focusing. Second, you may look through these triangular openings to see the rear of the lens.

By looking at the shape of the diaphragm visible from a corner of the back, you will be able to identify vignetting by the lens barrel, filter, lens shade, or a bend in the bellows. Vignetting is often the result of using camera movements too extreme for the coverage of the lens; some of the ground glass will be outside the image circle. When there is no interference, the open diaphragm set at the working aperture should appear oval and symmetrical when viewed from a corner. Vignetting will cause this oval to be shaded, to be asymmetrical, or to have pointed ends. In an extreme case, the diaphragm may not be visible at all. If your ground glass does not have cut corners, you can do the job yourself if you are handy with a glass cutter.

Unfortunately, cut corners also remove part of the image from view.

A less common ground-glass style has a clear, unground spot or circle with fine cross hairs in its center for aerial image focusing. You focus while looking at the cross hairs, and the lens image is projected through the glass and focused directly by your eye. When the cross hairs and *aerial image* (the one from the camera's lens) are in focus simultaneously, the image distance (or focus) is correct. A low-power magnifier, or *loupe,* will aid in focusing with either screen. Some photographers, particularly in technical or scientific work, find aerial image focusing to be more precise than plain ground-glass focusing.

All lenses project less light to the edges than to the center and light at the edges of the frame is angled away from your eyes. An accessory *fresnel* lens, or screen, attached to the rear of your ground glass, or an optional ground glass incorporating such a screen, will more evenly illuminate the entire image area. The screen is actually a simple plano-convex lens sectioned into flat, concentric rings, and it directs the light leaving the ground glass into parallel rays. Without a fresnel (pronounced frĕ-nĕl´) screen, you may have difficulty seeing the corners of your ground-glass image.

Another useful addition to the standard ground glass is a grid of horizontal and vertical lines etched or printed on its surface to aid in precise image alignment. A transparent plastic overlay with the same rulings can be taped in place to serve the same purpose, and can be removed when not needed. Other ruled lines are also useful to mark the borders of another film size or format, such as Polaroid 4x5 film, which produces an image that is slightly smaller than 4x5 and is not centered in the frame.

You may be able to find an accessory ground glass with the appropriate markings or you may have to add them to yours with a permanent marker. Temporary marks may be made directly on the ground glass with a china-marking crayon. Advertising photography often requires making a photograph to match an art director's layout exactly. To make this job easier, a china-marking crayon or washable felt-tip pen can be used to sketch the layout with removable marks on a plastic overlay or upside down directly on the ground glass.

Lensboards

Since it is much easier to replace the board in the camera than the lens in the board, you will need one *lensboard* for each lens you use frequently. Most lensboards are square and symmetrical and clip

Loupes intended for viewing slides are satisfactory for view camera focusing. The compact loupe on the left, designed for view camera use, can be worn around your neck on a string. ■

This replacement 4x5 ground glass has an etched grid, cut corners, and framing marks for roll film. ■

This complicated montage was planned out methodically in advance. The art director sketched the placement of objects on the ground glass and photographer Steve Grohe made the final image with multiple exposures on a single sheet of film. ◾

The final use of Grohe's photograph, a magazine cover, shows how areas in the photograph were deliberately held open for type. The empty space at the lower left is for the mailing label. ◾

easily into the front standard of the camera for which they were made. Each board should have a center hole of the correct diameter drilled or punched for the shutter to be mounted in it. There are three standard shutter sizes:

#0 35mm #1 42mm #3 65.5mm

Many shutters use the head of a small screw as an alignment pin. The screw fits into a small hole in the lensboard just outside the edge of the center hole. This arrangement prevents the shutter from rotating in its mount.

Lensboards are made in a variety of mutually incompatible sizes and contours. Unlike the film back, no universal design for lensboards has ever been accepted. Only occasionally are the boards of one manufacturer interchangeable with another—for example, Sinar with Horseman, Linhof with Wista and Tachihara, and Graphic with Toyo. Many manufacturers make adapter boards which can be invaluable to anyone owning more than one camera. Usually they adapt a smaller board, such as a 4-inch-square Calumet to a larger opening for an 8-inch-square Toyo board. If you interchange lenses among several cameras, it is often wise to mount all your lenses on identical small boards, such as Toyo/Graphic or Calumet, and use an adapter to mount the small boards onto each camera.

Many times the design of a camera or the bulk of a bellows prevent the front and rear standards from being placed closely enough to focus a wide-angle lens. Special recessed lensboards accommodate very short focal-length lenses. A recessed lensboard holds the lens behind the normal position, preventing the bellows from compressing into inflexibility. Access to the shutter settings and cable-release mount can be restricted by a recessed board, sometimes necessitating special linkages and extensions.

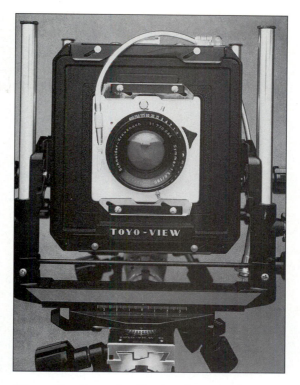

The smaller silver-colored lensboard is a Graphic board, which also fits an early Toyo Field. Here it is clipped in place in an adapter lensboard on a Toyo View. ■

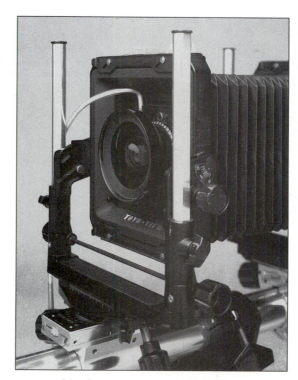

A recessed lensboard can overcome some of a camera's physical obstructions to the use of short-focal-length lenses. ■

David Graham used a front tilt on his 8x10 camera to make the plane of focus cut through the toys and hose and the figure in the background (original in color). ∎

9

MAINTENANCE

Once you have acquired the equipment for large-format photography, you will want to keep all of the pieces in good working order. Well-made cameras, lenses, and accessories have a long working life, but careless operation and the lack of routine maintenance can degrade the quality of your work and shorten the useful life of your expensive equipment. Occasional but regular attention should be sufficient, but the cardinal rule is this: keep it clean. Dust and dirt will paralyze shutters and focusing gears, create annoying marks on film, and impair the sharpness of a lens. A few simple precautions will protect your investment in equipment and ensure quality in your results.

LENSES

The front and rear surfaces of your lens are exposed and fragile. Keep them covered with lens caps whenever the lens is not in use and dust the lens only when necessary. Try a gentle blast from a compressed gas sprayer or an air syringe to remove loose dust. Be very careful with any sprayers that might contain a propellant. If you don't hold the can vertically, the gas can come out as a very cold liquid, leaving a permanent frost mark on your lens. Never blow on a lens. Your breath is never free of tiny bits of saliva that will leave spots on your lens.

If compressed air doesn't remove the dust, you can use a brush on your lens. Use only a very clean, very soft camel's hair brush and brush gently. To avoid transferring oil to the lens, don't touch the bristles with your fingers. Never use a cloth or tissue to remove dust. Dust particles trapped under a cloth create a fine sandpaper which will abrade the lens' delicate surface. Modern lenses have a fragile antireflection coating that can be damaged more easily than the glass itself.

Never use silicone-treated eyeglass or record cleaning cloths on your photographic lenses. They will smear and degrade the coating. If a fingerprint or greasy smear appears on your lens, clean it with an untreated lint-free tissue (such as Kodak lens-cleaning tissue) and a few drops of a good lens cleaning liquid (also Kodak) or pharmaceutical methyl alcohol. Since liquids dripped on the lens can seep past the edge seal into the lens barrel, apply the liquid to the tissue, not directly onto the lens.

When using compressed gas spray dusters to clean your camera equipment, be very careful to hold the can vertically to avoid spraying the propellant in liquid form. ■

Store your lenses in plastic bags when not in use. ∎

Use a spanner wrench to remove and replace the retaining ring that holds a lens to its board. ∎

Dust your lens with compressed air before attempting to remove a fingerprint and don't allow any fingerprints to remain on the lens for long. The natural acidity of your skin trapped in a greasy print will etch the lens coating, making the mark permanent.

Handle your lenses carefully to avoid dropping them. When installing a lens, make sure the lensboard is properly seated and clipped into place. Vibration or jarring can loosen lens elements in the barrel or separate cemented groups. If an element moves slightly out of its correct position, the lens has *decentered* and its optical performance will suffer. A professional repair service can test a lens for proper centering. Whenever your lenses are not in use they should be stored in a plastic bag to keep out dust. For further protection, wrap the plastic bag containing the lens with soft cloth, leather, foam, or bubble-wrap.

If you wish to mount or remove a lens from its board, use a *spanner wrench*. This wrench is a special tool used to remove the retaining ring that holds the shutter or barrel to the lensboard. Its two blades fit into opposing slots on the perimeter of the retaining ring, allowing you to unscrew the ring without unnecessary hazard to the lens. It is easy to damage an expensive lens trying to remove a retaining ring with an improper tool. The spanner wrench can be adjusted to fit retaining rings on any common lens. Along with the spanner in your studio toolbox should be a set of small jeweler's screwdrivers. These are handy to keep all the tiny screws on your shutter-mounted lenses properly tightened.

The back of the lensboard and lens, the side facing the film, should be nonreflective. The original black surface will eventually wear or chip, leading to image flare. Keep a small bottle of flat black paint on hand for touch-ups. Sherwin-Williams Opex dead flat black lacquer, M60 B 16, is recommended for this application.

SHUTTERS

Dust is your shutter's worst enemy. Always store all your shutter-mounted lenses in plastic bags. Disuse can cause your shutter to slow and stick, but a few cycles of winding and releasing can sometimes remedy these problems. Never store your shutters in the wound position. The tension on the spring will eventually cause it to stretch and slow the speeds.

Some shutters, notably early Compurs, use an extra spring to provide sufficient tension for their highest speed. Your shutter has this extra spring if the highest speed setting on the dial is spaced farther apart from the others and if turning the dial to this

Never pull on an attached cable release. The attachment point is the most vulnerable part of a shutter. ∎

setting requires more force to set the additional spring. These shutters can be severely damaged by changing the speed setting when the shutter is tensioned. To avoid damage with this shutter, always release it before changing speeds.

Shutters have two particularly vulnerable points. The cable-release attachment point is easy to damage on most shutters, particularly by pulling on the cable release. Either remove the cable release or make sure there is no pressure on the attachment point when wrapping the lens for storage. A shutter's other weak spot is the threaded lens mount. Pushing on or jarring a lens, particularly a wasp-waisted wide-field, can bend or twist the mount and leave the lens out of alignment. Always handle your lenses gently and store them carefully.

Never attempt to repair, dismantle, or lubricate a shutter yourself. Always take it to a trained professional in a repair shop. It is embarrassing to bring in a bag containing most of the shutter's parts after you have removed the faceplate and watched the springs fly across the room. A professional repair shop will usually test the shutter speeds for accuracy for a nominal fee. A shutter's inaccuracies are usually consistent and, if you know those for your shutter, you can compensate for them in exposure.

FILM HOLDERS

Light can leak into holders from worn felt light traps and cracked darkslides. If you suspect that one of your holders leaks, or if you buy used holders, test them before you entrust them with an important exposure. To test a film holder for leaks, cut a sheet of black-and-white printing paper to size, insert it in the holder, and leave the closed holder in a brightly lit place for an hour or two, turning the holder occasionally to expose all sides to light. Unless you test only one side of one holder at a time, mark the back of the sheet with a permanent marker or cut a corner to identify the holder and side. You can use film for your testing, but paper is less expensive and can be handled in safelight. Any holders to be used with infrared film should be tested for leaks with that film before using; infrared radiation can penetrate some darkslides that are opaque to the visible spectrum.

After developing the test paper or film, inspect it for dark areas that indicate unwanted exposure. The presence of streaks or fog indicates light leaks and their position will reveal the location of a crack, chip, or pinhole. If you find that a holder leaks light, repair or discard it. Black photo tape can be used to patch the bottom flap and new darkslides are available from the manufacturers of film holders. Replacement darkslides in uncommon sizes, such as those for banquet cameras, can be fabricated from sheets of black phenolic plastic available from a commercial plastic supplier.

Dust in the holders can settle on the film during exposure and produce tiny *pinholes* or clear specks on negatives and black marks on prints and

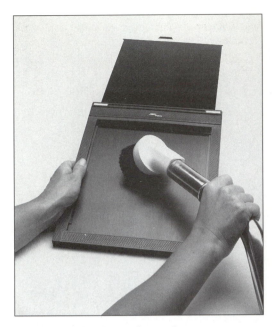

Keep a spare brush attachment for your vacuum cleaner for cleaning only your photography gear. ∎

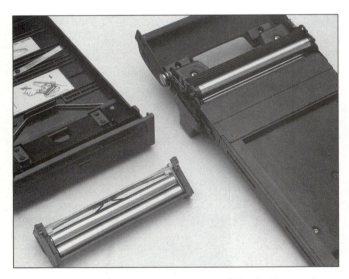

The roller assemblies in Polaroid film holders need frequent cleaning. Fortunately, they are easily accessible. ∎

transparencies. Store and transport your film holders in plastic bags and dust each holder before loading. For thorough cleaning, buy a new brush attachment for your vacuum cleaner and use it only on camera equipment.

Polaroid holders need to be maintained regularly as well. Dust or vacuum them as you would any other holder. Before each use, inspect the rollers for bits of developing reagent that occasionally leak out of the film packs. Open the holder and clean the rollers with a damp lintless cloth or tissue. You can easily remove the roller assembly from a #405 or #550 pack adapter for cleaning, and, although it is not convenient to remove the rollers from a #545i sheet-film holder, you can easily release a pair of clips to disengage them from each other for cleaning. Always store a #545i holder with its processing lever in the L position (that is, with its rollers disengaged).

BELLOWS

Dust from the inside of your bellows can settle on film during exposure. Stretch out the bellows periodically and vacuum the inside. Leather bellows should be treated on their outer surface with a leather preservative to prevent cracking. Light leaks in a bellows can be difficult to diagnose, producing degrading flare in some photographs but not in others. To check the bellows, set up your camera in a darkroom and extend the bellows. Remove the back and hold a flashlight inside the bellows, covering your arm and the back with a darkcloth. Pinhole leaks will be visible as you move the flashlight. You can patch them with a dab of black silicone caulk or a small piece of black electrical tape.

TRIPODS

For tripods, too, dust is the enemy. If possible, remove dust from the leg segments of your tripod each time you put it away. After a year or two of use, the tripod head may not move as smoothly as it should. Using simple tools, you can dismantle the head, clean it, lubricate its sliding parts with a little auto grease, and reassemble it. The leg section clamps are usually designed to operate without additional lubricant, but you can rejuvenate them occasionally with a thorough cleaning. Naphtha or small amounts of a nonabrasive household cleanser will remove grease and oil. To avoid corrosion, never wash your tripod or immerse it in water.

Photo Credits

Unless otherwise credited, all photographs by the author and equipment from the author's collection.

Pages viii, 93, 95, 97, 98 bottom, 99, 101 bottom, 109 bottom, 124, 126: Equipment courtesy of the Jack Naylor Collection

Page x: New Orleans Museum of Art, New Orleans, Louisiana

Pages 1, 18, 74, 113 top, 145: Courtesy of Sinar Bron Imaging, Inc.

Page 3: Copyright 1994 Stephen Johnson

Pages 6–13, 15–17, 19–25, 32–33, 36–37, 40, 50–51 54 top, 56–57, 79, 100, 106 bottom, 140 bottom,, 141 bottom, 142, 143 top, 154–155: Equipment courtesy of Calumet Photographic, Inc.

Pages 26, 27: Copyright Harry Callahan, Courtesy PaceWildensteinMacGill, New York

Page 38 top: U. S. Geological Survey, Denver, Colorado

Page 38 bottom and 39: Rephotographic Survey Project

Page 70 top right: Equipment courtesy of Ed Kostiner

Page 70 bottom: Courtesy JOBO Fototechnic, Inc.

Page 76: Fogg Art Museum, Harvard University

Page 96: The Denver Public Library, Western History Department

Page 97 top: Smithsonian Institution, Washington, D. C.

Page 100 top: Cameras courtesy of William Crawford

Page 100 bottom left: Toyo camera courtesy of Neal Rantoul

Page 100 bottom right: Courtesy of Mike Coppes and Bromwell Marketing

Page 101 top: Courtesy of K. B. Cancham Cameras, Mesa Arizona

Page 102–3 bottom: The Humanities Research Center, University of Texas at Austin

Page 104: The Weegee Collection

Page 105: New York Daily News

Pages 94, 106, 110 bottom right, 111, 139: Equipment courtesy of E. Philip Levine, Inc.

Page 107: Courtesy of Linhof GMBH

Page 108 top left: Courtesy of Leaf Systems, a Scitex Company

Page 108 top right: Courtesy of Polaroid Corporation

Page 108 bottom: Courtesy of nuArc Company, Inc.

Page 109 top: The Paul Strand Foundation

Page 110 top: Copyright The Oakland Museum, The City of Oakland, 1982

Page 110 bottom left: Courtesy of Peter Gowland

Page 112: Courtesy of Phase One United States, Inc.

Page 113 bottom: Photograph courtesy of Calumet Photographic, Inc.

Pages 136–139: Equipment courtesy of Karl Heitz, Inc.

Page 138 top: Photograph courtesy of Bela Kalman, Studio 350

Pages 146, 148: Courtesy of the Polaroid Collection

Page 152 top: Equipment courtesy of Stanley Rowin, Stanley Studio

Page 156: Courtesy of Digital Equipment Corp.

Courtesy of the Beverly and Jack Wilgus Collection

INDEX